CULTIVATED LANDSCAPES

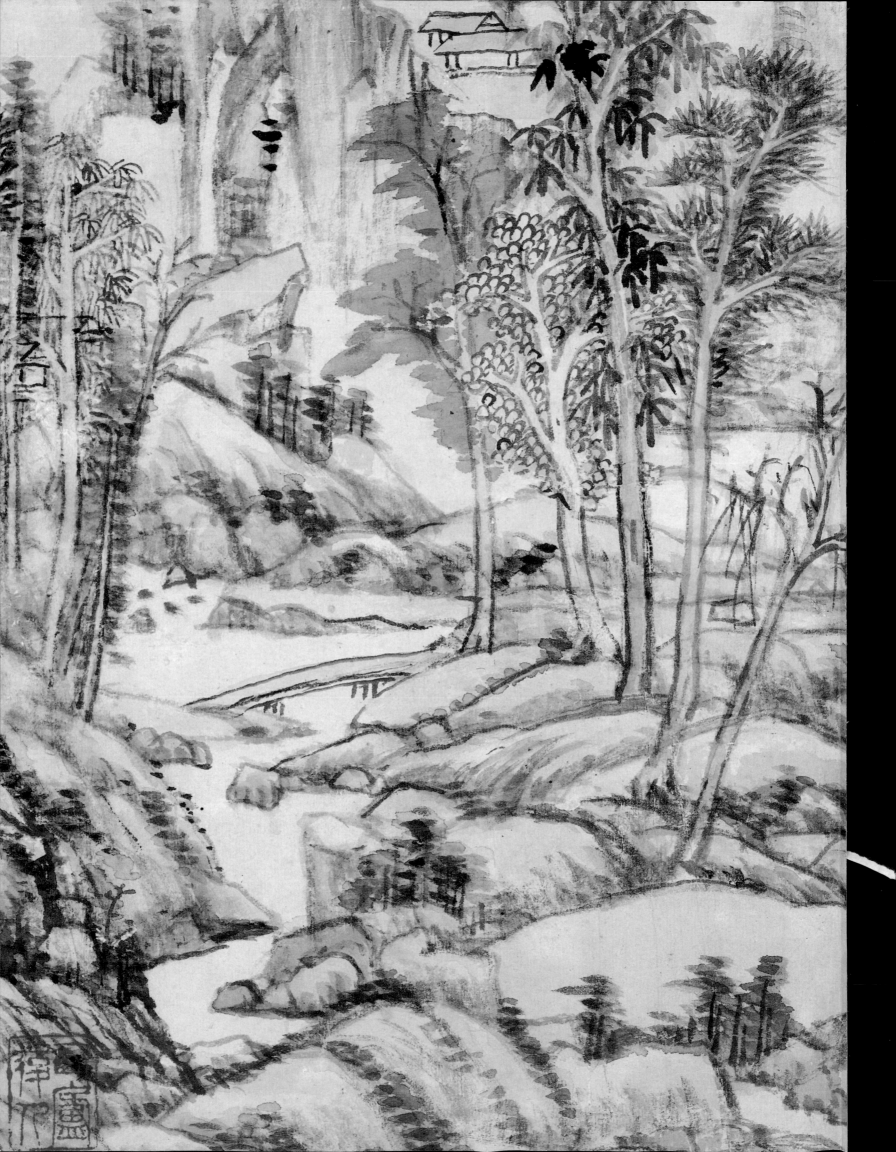

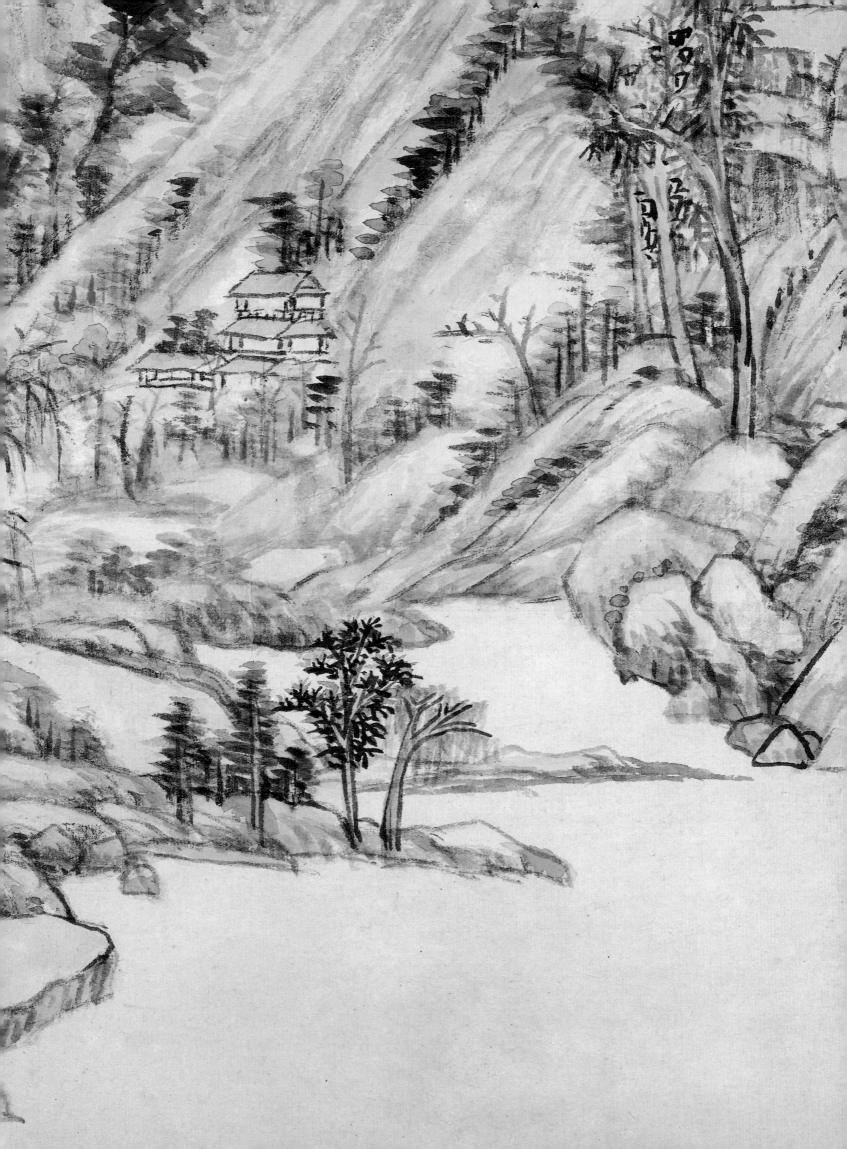

Cultivated Landscapes

Chinese Paintings from the Collection of Marie-Hélène and Guy Weill

Maxwell K. Hearn

The Metropolitan Museum of Art, New York
Yale University Press, New Haven and London

This catalogue is published in conjunction with the exhibition
"Cultivated Landscapes: Reflections of Nature in Chinese
Painting with Selections from the Collection of Marie-Hélène
and Guy Weill," held at The Metropolitan Museum of Art,
New York, September 10, 2002 – February 9, 2003.

The exhibition is made possible by The Dillon Fund.

This publication is made possible by
The Miriam and Ira D. Wallach Foundation.

Edited by Judith G. Smith

Book design and production by Binocular, New York
Chinese characters typeset by Birdtrack Press, New Haven, CT
Printed by Meridian Printing, East Greenwich, RI
Bound by Acme Bookbinding, Charlestown, MA
Map by Adam Hart, Design Department, The Metropolitan
Museum of Art

Color photographs in this publication are by Oi-Cheong Lee,
The Photograph Studio, The Metropolitan Museum of Art

Jacket/cover and pages xvi and xvii: Liu Yu (active ca. 1660s –
ca. 1690s), *Remote Valleys and Deep Forests*, dated 1678.
Detail of plate 3

Frontispiece: Wang Yuanqi (1642 – 1715), *Landscape for
Zhanting*, dated 1710. Detail of plate 7

Library of Congress Cataloging-in-Publication Data
Hearn, Maxwell K.
 Cultivated landscapes : Chinese paintings from the Collection
of Marie-Hélène and Guy Weill / Maxwell K. Hearn
 p. cm.
 Includes bibliographical references.
 ISBN 1-58839-055-1 (hc. : alk. paper) —
ISBN 0-300-09782-4 (Yale)
 1. Landscape painting, Chinese. 2. Weill, Marie-Hélène--Art
collections. 3. Weill, Guy A.--Art collections. I. Metropolitan
Museum of Art (New York, N.Y.) II. Title.

ND1366.7 H43 2002
759.951'074'7471--dc21
 2002067780

Contents

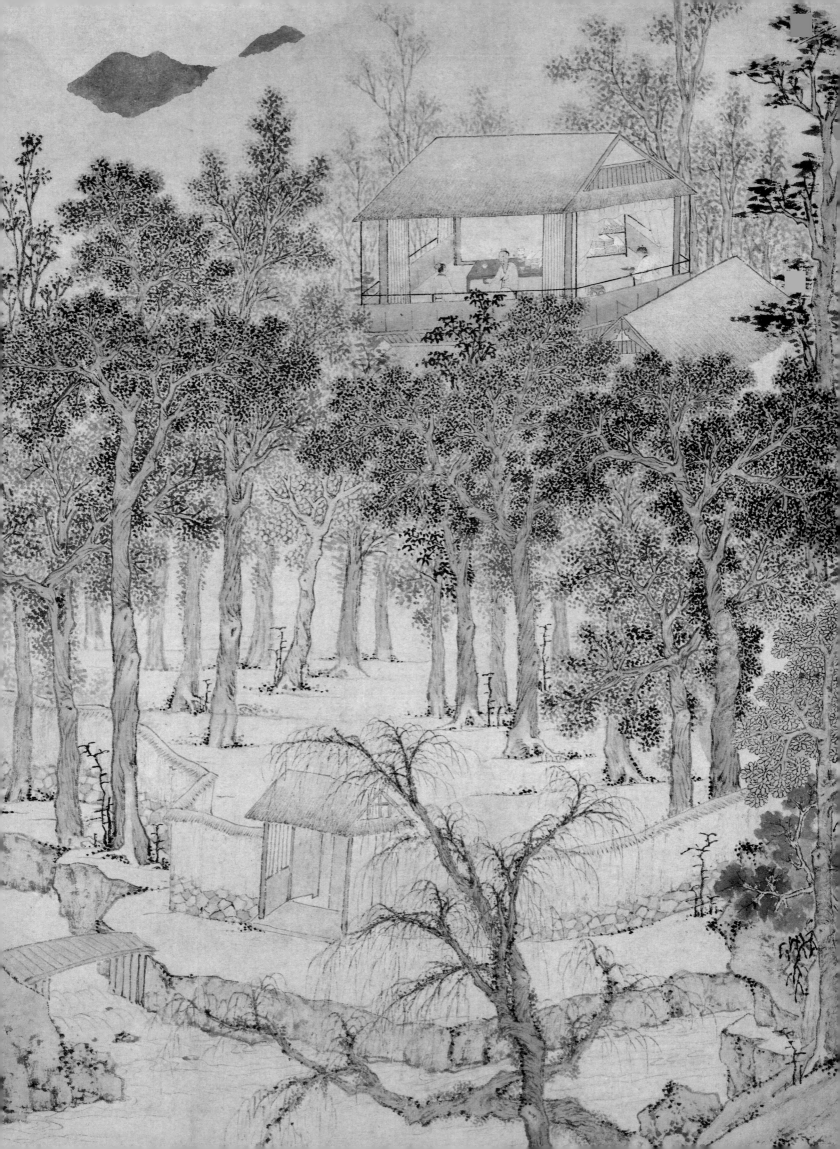

DIRECTOR'S FOREWORD

The Chinese painting collection of Marie-Hélène and Guy Weill encompasses important works by many of the leading masters of the Ming and Qing dynasties. Perhaps the best known of their paintings is the landscape scroll *Living Aloft: Master Liu's Retreat*, created in the sixteenth century in the cosmopolitan city of Suzhou by the preeminent scholar-artist of the day, Wen Zhengming. The Metropolitan Museum was the underbidder for the painting when it appeared at auction in 1979. But our loss became our gain. That experience at auction led Wen Fong, then Consultative Chairman of the Museum's Department of Asian Art, to seek out the Weills, who subsequently became loyal friends and supporters of the Museum—a felicitous relationship that has continued to today. In addition to their role as generous patrons, evidenced by the works donated and promised as gifts commemorated in this catalogue, the Weills have been active participants in the Museum as volunteers and as members of the Friends of Asian Art since the group's founding in 1983. Marie-Hélène Weill is also a member of the Department of Asian Art Visiting Committee and Museum lecturer specializing in South and Southeast Asian art.

Living Aloft, an imaginary portrait of a gentleman in his yet-to-be-built retirement garden, is the quintessential embodiment of the Ming literati preference for modest understatement over ostentation and opulence. This spirit of modesty is shared by the Weills, who, while always willing to make their collection available to students, scholars, and others interested in Chinese painting, were at first reluctant to have works from their collection be the subject of an exhibition and catalogue. We are grateful that, in the end, they agreed to this undertaking. The Weills have collected at a level of excellence and with a passionate enthusiasm that rival that of distinguished Chinese connoisseurs. Their collection offers stunning testimony that the connoisseurship borne of a lifetime steeped in the Chinese tradition of scholarly art can be acquired by individuals who come from a very different cultural background. Through their generous gifts and promised gifts to this institution, the Weills help to ensure that future generations will be given the opportunity to gain an even deeper appreciation of traditional Chinese culture.

This project would not have been possible without the enlightened support of The Dillon Fund and The Miriam and Ira D. Wallach Foundation, to whom we remain deeply indebted for their ongoing generosity toward our Asian Art Department.

Philippe de Montebello
Director

PLATE 2 Detail

At a recent gathering of the Metropolitan Museum's Friends of Asian Art, a fellow collector observed, "I have often wondered which you two enjoy more — art or this life we have together." His challenge made us realize that for us art is, and always has been, life. After decades of studying and collecting Western art, we discovered in the Chinese ideal of connoisseurship — "sharing appreciation" — an expression of our instinctive belief that enjoying art is a communal act. "This life we have together" is enriched when art is shared.

We were both privileged to have grown up in a cosmopolitan environment in Switzerland where visual art, music, and literature were an integral part of our existence. The splendor of the Swiss landscape provided a backdrop that allowed us to cultivate a sensitivity to beauty that was as natural and necessary as breathing fresh air.

We pursued art with passion. From an early age, Guy studied drawing and painting. He began collecting European paintings as a young man. Marie-Hélène studied art history at Radcliffe College. Our marriage consummated a collaboration of like minds, and we continued to collect together. When Abstract Expressionism exploded on the New York art scene, we embraced it. We joined the Whitney Museum during its formative years and Guy was appointed to the acquisitions committee. Our world changed with the emergence of Pop Art, which did not touch our sensibilities. We turned our attention elsewhere.

The Asian chapter of our lives began in the summer of 1967 when we visited the Asian Art Museum in San Francisco. We were struck by the simple beauty of Neolithic pots and Chinese bronzes. We wanted to immerse ourselves in Chinese art. When we returned to Manhattan, we joined China Institute and the Asia Society. Our introduction to Chinese painting was the landmark exhibition "Wintry Forests, Old Trees: Some Landscape Themes in Chinese Painting," curated by Richard Barnhart at China Institute in 1972. To aid our studies, Guy took slides of the paintings, which Marie-Hélène used to illustrate docent lectures on the exhibition. Through our readings and discussions with curators and other scholars and collectors, we began to absorb the essence of Chinese philosophy. The aesthetic riches we discovered inspired a lifelong process of self-education.

When "Friends of Wen Cheng-ming: A View from the Crawford Collection" was exhibited at China Institute in 1974, we fell in love with the literati ideal because its philosophy of life and celebration of simple pleasures resonated with our own passions.

We sought to create a literati environment, where friends could drink tea or wine, discuss a painting, and listen to music. One memorable occasion, when the literati ideal was achieved, was on a spring outing along the James River in Virginia. We gathered in the garden of a friend's eighteenth-century home to drink fruity wine under an apple tree. Our friend hung scrolls on the blossoming branches, and we admired them in the soft air, unfettered by walls or the impediments of the dusty world.

Our initial involvement with the Department of Asian Art at The Metropolitan Museum of Art fortunately coincided with the growth of that department's stature under the leadership of Professor Wen Fong. His enthusiastic dedication and support allowed us to expand and deepen our understanding of Chinese painting. We would not have been as successful in our studies without the generosity of Mike Hearn, Freda Murck, and so many others who have encouraged us by sharing their knowledge. Our dear friend Mike Hearn's scholarly expertise, the meticulous editing of Judith Smith, and the support of James Watt, Brooke Russell Astor Chairman of the Department of Asian Art, have given us this magnificent catalogue.

Our gift to the Metropolitan Museum carries with it a message to those who love art as much as life: to enjoy art, you must share it. Chinese painters understood this even before the concept of public museums arose. That is the reason so many of their paintings depict ideal gatherings in which lovers of art and poetry and wine discuss art and compose verse. Today, museum openings, lectures, and symposia recreate the literati ambience of communal viewing and study. In such a supportive environment, even unfamiliar terrain like Chinese painting can be conquered by the discerning student. By looking, thinking, and talking to others, you can learn to trust your eye and follow your heart.

Our collection is not a large one, but it reflects our taste and judgement about what is worth living with day after day. We did not collect as an investment, but as a way to learn and be surrounded by beautiful things that resonate quality and depth of spirit. We hope that with this gift of our treasured paintings, generations of museum visitors will share the study and appreciation of art that has enriched our life together.

Marie-Hélène and Guy Weill

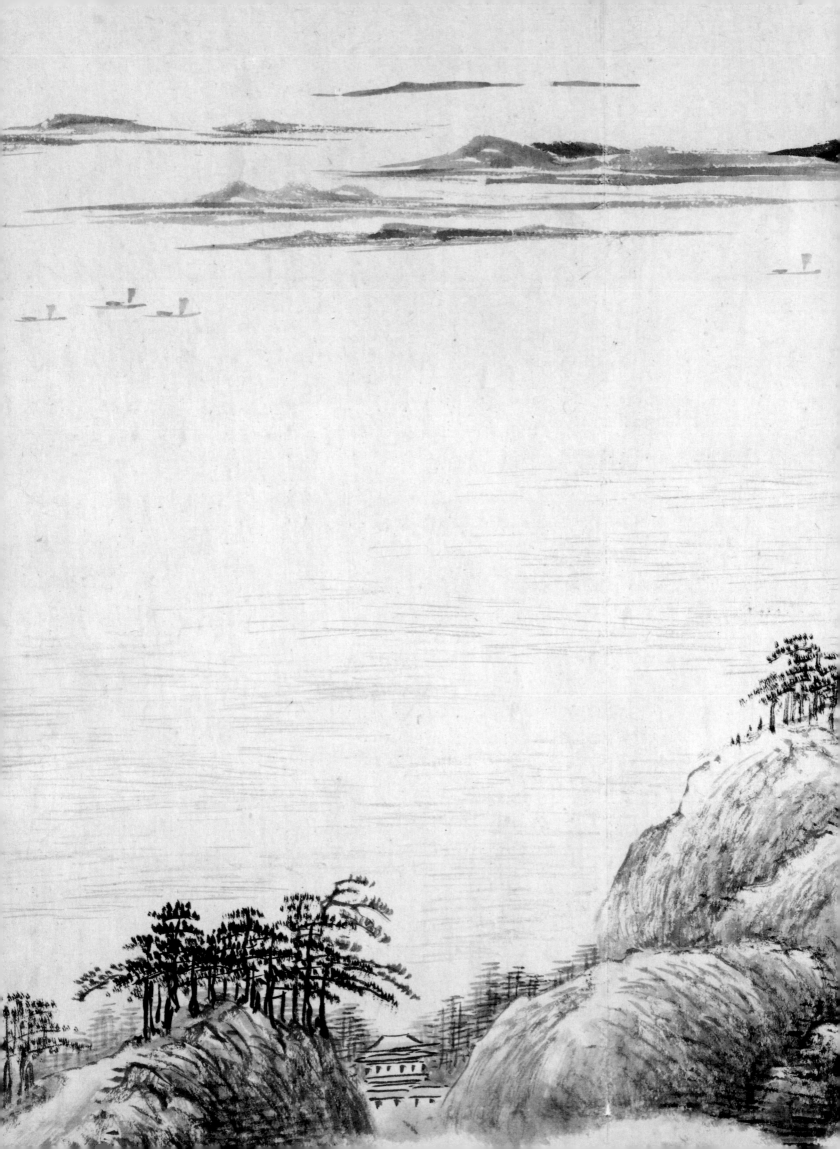

ACKNOWLEDGMENTS

This catalogue celebrates an association between The Metropolitan Museum of Art and the collectors Marie-Hélène and Guy Weill that has continued more than two decades. In authoring this publication, it has been my privilege not only to share in that association but to benefit from the extraordinary human resources that make the Metropolitan a great museum and sustain the curatorial task of researching, exhibiting, and publishing works of art.

Philippe de Montebello, Director of the Metropolitan Museum, has taken a personal interest in the Weill catalogue as part of his ongoing support for the Department of Asian Art, which under his guidance has become a veritable "museum within a museum." Working tirelessly with trustees, curators, and donors, Director de Montebello has established a standard of excellence for the Museum's holdings that any collector would be proud to uphold. Wen Fong, Professor Emeritus of Princeton University and former Consultative Chairman of the Department of Asian Art, was the first to reach out to Marie-Hélène and Guy Weill and welcome them into the Metropolitan's family of supporters. For more than twenty years he has offered encouragement to the Weills in their collecting and study of Chinese painting, and, as both mentor and colleague to me, has provided a curatorial and scholarly example that remains an inspiration.

James Watt, Brooke Russell Astor Chairman of the Department of Asian Art, is an eloquent spokesman for the department and a strong advocate for filling gaps and adding masterpieces to the Museum's holdings of Chinese painting and calligraphy. From the outset he has taken a keen interest in this project, providing enthusiastic encouragement as well as a ready source of advice and counsel.

In addition to her responsibilities as Administrator of the Department of Asian Art, Judith Smith graciously agreed to serve as editor and production coordinator of this volume. In that capacity she has dedicated her wealth of editorial experience and exceptional literary and organizational skills to insuring the successful translation of the manuscript into a finished book. She is also responsible for involving Joseph Cho and Stefanie Lew of Binocular, the talented and professional team who created the book's elegant design, effectively integrating images and text, and were responsible for managing all aspects of its production. The superb color images in the catalogue reflect the

PLATE 6c Detail

contribution of Oi-Cheong Lee, Senior Photographer in the Museum, who applied to this assignment his passion for excellence and exacting professional standards.

Many other colleagues in the Department of Asian Art have lent their expertise and time to this project. In researching the collection, I have benefited from the invaluable advice and expertise of Zhixin Sun, Associate Curator; Yangming Chu, Research Associate; and Shi-yee Liu, Andrew W. Mellon Fellow. All three patiently and knowledgeably answered my innumerable inquiries about the transcription of inscriptions and seals as well as helped to translate many of the poems and other texts that appear in the Catalogue. Hwai-ling Yeh-Lewis, Collections Management Coordinator, and Alyson Moss, Collections Management Associate, worked with the Department's technicians, Michael Rendina, Damien Auerbach, and Beatrice Pinto, the Registrar's Office, and the Photograph Studio to coordinate the safe movement of the Weill paintings within the Museum for photography, study, and storage. Takemitsu Oba, C. V. Starr Conservator, and Sondra Castile, Conservator, of the Asian Art Conservation Studio, performed condition checks and provided conservation expertise. Joyce Fung, Collections Management Assistant, scanned all the color transparencies, and Linda Shulsky, a loyal departmental volunteer, assisted in locating and retrieving library books, making photocopies, and cheerfully attending to numerous other tasks associated with producing a book.

It is particularly fitting that the funding for this publication has been provided by The Miriam and Ira D. Wallach Foundation, as the Wallachs are longtime friends and neighbors of the Weills. We are especially grateful to Miriam and Ira Wallach for their commitment to the Museum and their generosity in establishing an endowment fund to support Asian art publications and educational programs.

For the many weekends and late nights I spent at the Metropolitan happily immersed in studying the Weill collection, I owe a special debt of gratitude to my wife, Vera, and to our children, Garrett and Alex, who were exceptionally understanding and, when my excesses surpassed understanding, were still indulgent and forgiving. Without their loving encouragement, the challenge of confronting my own ignorance would have been far more painful.

Most of all, I am indebted to Marie-Hélène and Guy Weill for their nurturing friendship, *joie de vivre*, and unsurpassed generosity in both spirit and deed. Sharing their hospitality, most often around the dinner table, I have come to appreciate that for Marie-Hélène and

Guy life itself is a celebration. It was the prospect of commemorating their sixtieth wedding anniversary, on November 15, 2002, that inspired this catalogue and accompanying exhibition. For twenty-three of those years, they have shared their passion for Asian art with me and with the Metropolitan Museum, helping the Museum to acquire works of art and donating others. They are a reminder that any institution is only as vital as the people who support it. This publication is offered as a humble tribute to two extraordinary people who are not merely generous donors but the best of friends.

<div align="right">

Maxwell K. Hearn
Curator
Department of Asian Art

</div>

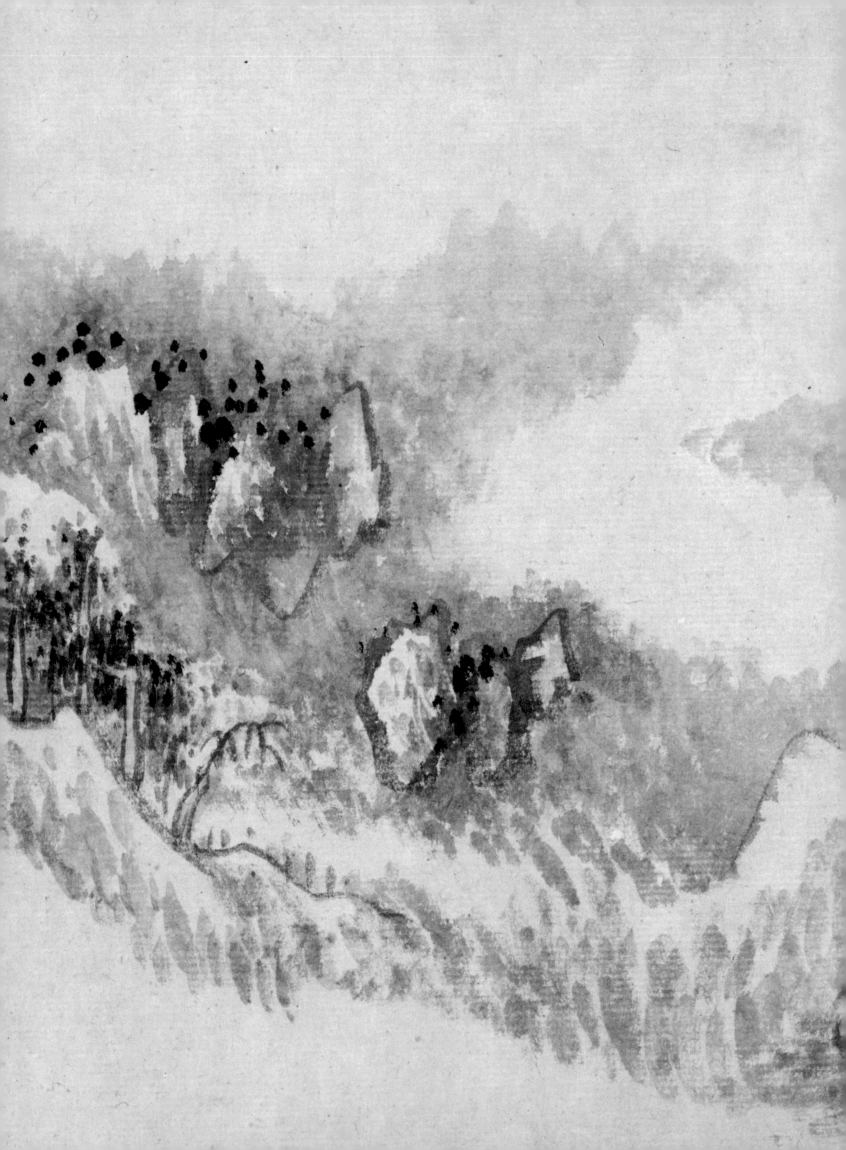

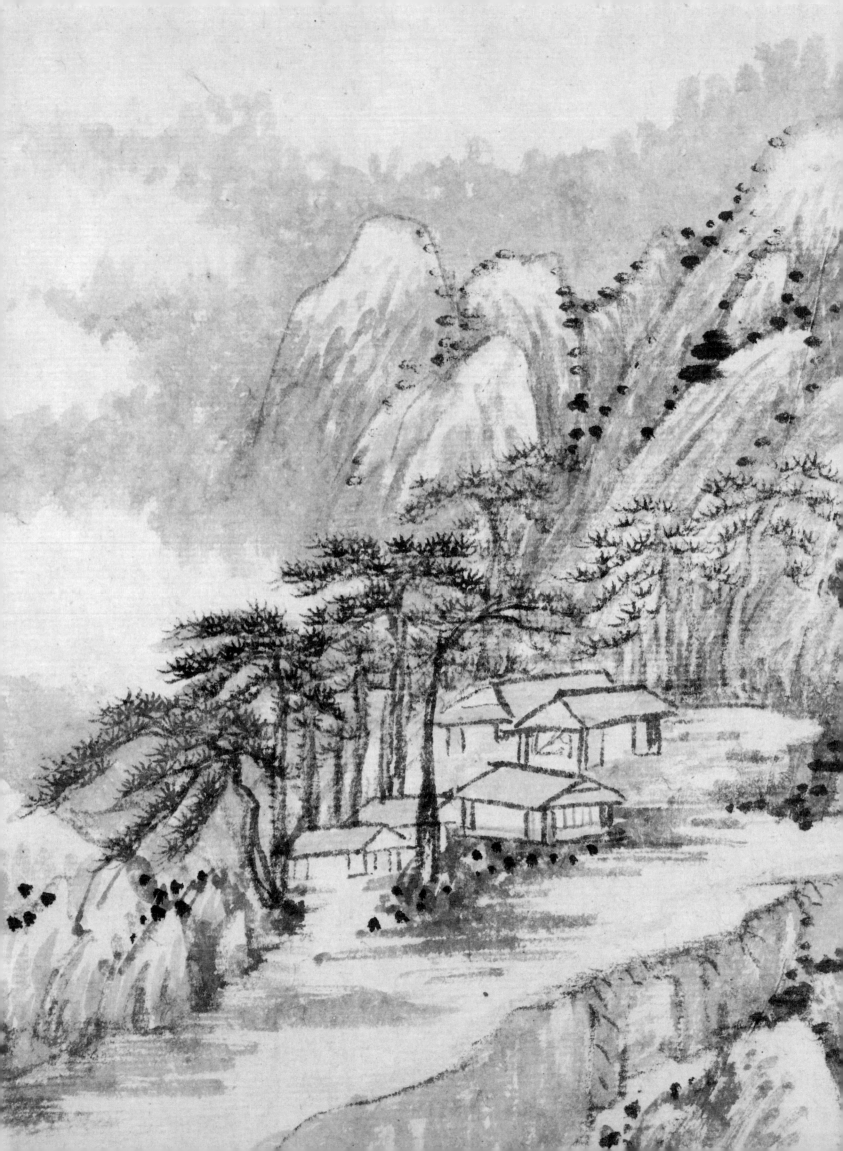

CULTIVATED LANDSCAPES

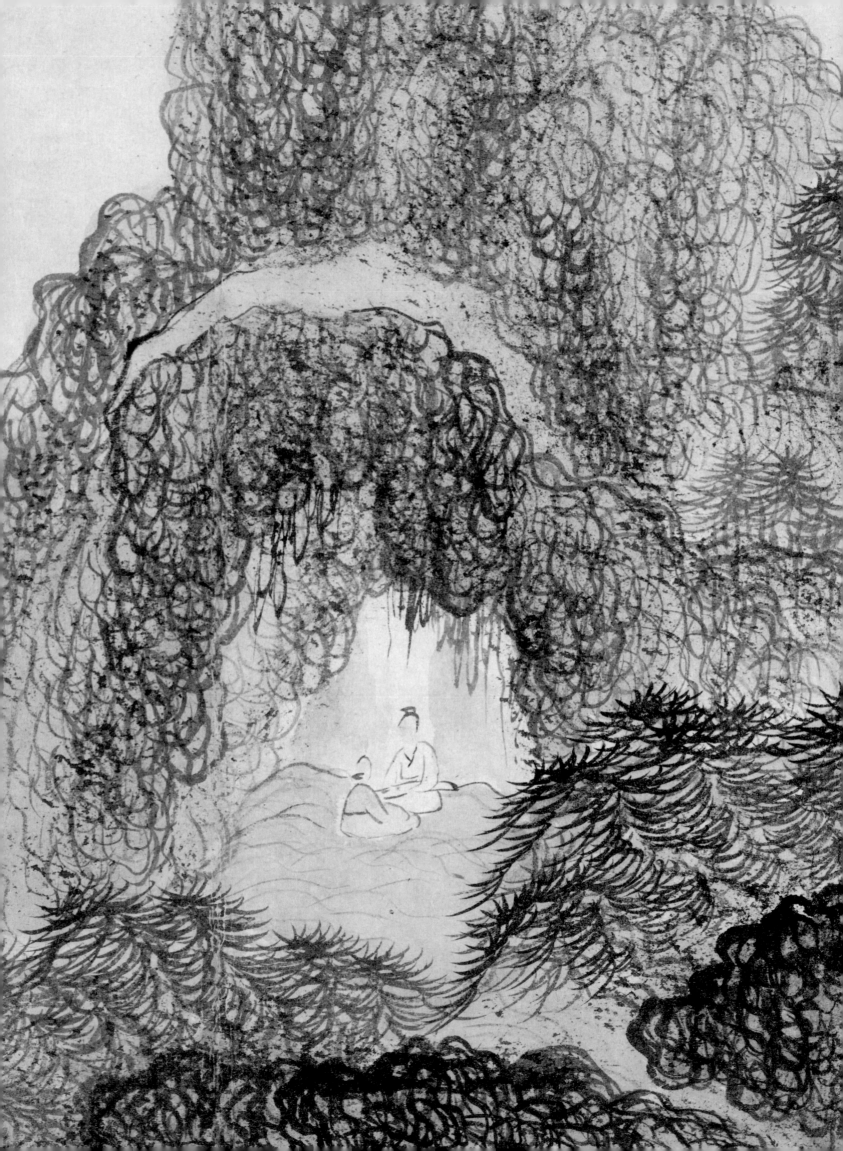

Cultivated Landscapes

THE HUMAN LANDSCAPE

In no other cultural tradition has landscape played a more important role in the arts than in that of China.[1] And "few landscapes are more human."[2] Since Neolithic farmers first tilled China's soil in the sixth millennium before the common era, hundreds of generations have left their mark on the land. To this day China remains an agrarian society, and the seasonal rhythms of planting and harvesting are deeply engrained in its traditional lunar calendar. But the landscape cultivated by the farmer is only one way in which the topography of China has been altered and humanized by man. Beyond the cultivated fields rise the mountains, the mythical abode of immortals. In the Chinese imagination, mountains are powerful manifestations of nature's vital energy (*qi*). They not only attract the rain clouds that water the farmer's crops; they also conceal medicinal herbs, magical fruits, and alchemical minerals that hold the promise of longevity. Mountains are pierced by caves and grottoes that serve as gateways to other realms — "cave heavens" (*dongtian*) leading to Daoist paradises where, like Shangri-la, aging is arrested and inhabitants live in harmony.

From the early centuries of the common era men wandered in the mountains not only in quest of immortality but to purify the spirit and find renewal. Daoist and Buddhist holy men gravitated to sacred mountains to build meditation huts and establish temples. They

PLATE 5I Detail

3

were followed by pilgrims, travelers, and sightseers: poets who celebrated nature's beauty, city dwellers who built country estates to escape the dust and pestilence of crowded urban centers, and, during periods of political turmoil, officials and courtiers who retreated to the mountains as places of refuge. Over the centuries, these visitors left behind paths and steps to aid their ascent, pavilions to mark scenic vistas, and poetic inscriptions to commemorate visits. Mount Tai, the sacred mountain of the east, for example, has been a destination for pilgrims for over two millennia, as evidenced by the numerous ceremonial arches, gateways, temples, stelae, and the seven thousand stone steps that mark the way to the summit (see fig. 33). So ubiquitous is man's imprint on China's landscape that a mountain void of human traces seems strangely alien and incomplete.

THE CULTURAL LANDSCAPE

Just as Voltaire observed in saying "we must cultivate our own garden" (*il faut cultiver notre jardin*), the metaphor of cultivation in China implies far more than the physical act of gardening. And just as the present is inconceivable in China without a knowledge of the past,[3] so too is the Chinese landscape unimaginable without reference to the legacy of visual and literary images that has been built up over the course of time. Indeed, because artistic creation in China implies self-cultivation and self-expression, natural imagery has long been read as a metaphor for the individual's values and beliefs. Flowers and plants may symbolize moral virtues; landscapes celebrating the natural order might laud the well-governed state; wilderness hermitages can suggest political isolation or protest; and gardens may be emblems of an ideal world. In every sense, therefore, images of landscape in China are reflections of both the culture and the artist's own cultivation.

As early as the Han dynasty (206 BCE–220 CE), mountains figured prominently in the arts. Han incense burners typically resemble mountain peaks, with perforations concealed amid the clefts to emit incense, like grottoes disgorging magical vapors. Han mirrors are often decorated with either a diagram of the cosmos featuring a large central boss that recalls Mount Kunlun, the mythical abode of the Queen Mother of the West and the axis of the cosmos, or an image of the Queen Mother of the West enthroned on a mountain.

While they never lost their cosmic symbolism or association with paradises inhabited by numinous beings, mountains gradually became a more familiar part of the scenery in depictions of hunting parks, ritual processions, temples, palaces, and gardens. By the late Tang dynasty (618–907), landscape painting had evolved into an independent genre that embodied the universal longing of cultivated men to escape their quotidian world to commune with nature. Such images might also convey specific social, philosophical, or political convictions. As the Tang dynasty disintegrated, the concept of withdrawal into the natural world became a major thematic focus of poets and painters. Faced with the failure of the human order, learned men sought permanence within the natural order, retreating into the mountains to find a sanctuary from the chaos of dynastic collapse.[4]

During the early Song dynasty (960–1279), visions of the natural hierarchy became metaphors for the well-regulated state. At the same time, images of the private retreat proliferated among a new class of scholar-officials, who gained their status through a system of civil service examinations that rewarded intellectual achievement with official rank. These men extolled the virtues of self-cultivation—often in response to political setbacks or career disappointments—and asserted their identity as literati through poetry, calligraphy, and a new style of painting that employed calligraphic brushwork for self-expressive ends. The monochrome images of old trees, bamboo, rocks, and retirement retreats created by these scholar-artists became emblems of their character and spirit.[5]

Under the Mongol Yuan dynasty (1279–1368), when many educated Chinese were barred from government service, the model of the Song literati retreat evolved into a full-blown alternative culture as this disenfranchised elite transformed their estates into sites for literary gatherings and other cultural pursuits. These gatherings were frequently commemorated in paintings that, rather than presenting a realistic depiction of an actual place, conveyed the shared cultural ideals of a reclusive world through a symbolic shorthand in which a villa might be represented by a humble thatched hut.[6] Because a man's studio or garden could be viewed as an extension of himself, paintings of such places often served to express the values of their owner.[7]

The Yuan dynasty also witnessed the burgeoning of a second kind of cultivated landscape, the "mind landscape," which embodied both learned references to the styles of earlier masters and, through calligraphic brushwork, the inner spirit of the artist. Going

MAP Central China showing modern provinces and principal sites mentioned in the text

beyond representation, scholar-artists imbued their paintings with personal feelings. By evoking select antique styles, they could also identify themselves with the values associated with the old masters. Painting was no longer about the description of the visible world; it became a means of conveying the inner landscape of the artist's heart and mind.

During the Ming dynasty (1368–1644), when native Chinese rule was restored, court artists produced conservative images that revived the Song metaphor for the state as a well-ordered imperial garden while literati painters pursued self-expressive goals through the stylistic language of Yuan scholar-artists. Shen Zhou (1427–1509; pl. 1), the patriarch of the Wu school of painting centered in the cosmopolitan city of Suzhou, and his preeminent follower, Wen Zhengming (1470–1559; pl. 2), exemplified Ming literati ideals. Both men chose to reside at home rather than follow official careers, devoting themselves to self-cultivation through a lifetime spent reinterpreting the styles of Yuan scholar-painters.

Morally charged images of reclusion remained a potent political symbol during the early years of the Manchu Qing dynasty (1644–1911), a period in which many Ming loyalists lived in self-enforced retirement. Often lacking access to important collections of old masters, loyalist artists drew inspiration from the natural beauty of the local scenery. Dai Benxiao (1621–1693; pl. 4), an ardent loyalist from Anhui Province, saw in the rugged cliffs and craggy pines of Mount Huang (Yellow Mountain) and other scenic areas of China a world free from the taint of Manchu occupation.[8] Inspired by the Yuan-dynasty recluse-artist Ni Zan (1306–1374), who was known for his lofty moral character, Dai and other Anhui painters emulated Ni's minimalist compositions and dry-brush painting style, features that became hallmarks of the so-called Anhui school. Mei Qing (1624–1697; pl. 5), another Anhui artist, survived the Manchu conquest by withdrawing to his family's country estate, but eventually left retirement and attempted to join the Qing civil service. After repeated failures in the examination, Mei resigned himself to a life as a gentleman-artist, taking both the local scenery and the styles of earlier masters as sources of inspiration.

Nanjing, the secondary capital of the vanquished Ming dynasty, remained an active center for the arts under the Qing. Liu Yu (active ca. 1660s–ca. 1690s; pl. 3), a native of

the city, specialized in long landscape handscrolls that integrated contemporary stylistic influences from local loyalist painters, such as Gong Xian (1619–1689), and artists working in a more traditionalist manner, such as the Orthodox school painter Wang Hui (1632–1717; pl. 6).

The Orthodox school is the name attached to a group of artists from the Taicang area of Jiangsu Province, whose art was relatively unaffected by the Manchu conquest. Focusing on artistic renewal, they sought to revitalize painting through the creative re-interpretation of an Orthodox canon of models. During the early-Qing period this traditionalist approach became the foundation of a new "Orthodox" style under the leadership of Wang Shimin (1592–1680) and his friend Wang Jian (1598–1677). But these senior members of the Orthodox school were soon outshone by their brilliant pupil, Wang Hui, and Wang Shimin's grandson, Wang Yuanqi (1642–1715; pl. 7). Wang Hui made it his objective to integrate the descriptive landscape styles of the Song dynasty with the calligraphic brushwork of the Yuan dynasty to achieve a "great synthesis." In accepting the commission to create a pictorial record of the Kangxi emperor's (r. 1662–1722) 1689 inspection tour to south China, Wang helped to adapt this style for use by other artists working at the court. Wang Yuanqi, the youngest of the so-called Four Wangs, developed a rigorously abstract style in the manner of his grandfather's mentor, Dong Qichang (1555–1636), achieving a personal idiom that could accommodate learned references to the past without sacrificing his own artistic identity. For the last fifteen years of his life, Wang Yuanqi held high offices at the court of the Kangxi emperor. Both through his government posts and his art, Wang Yuanqi, like Wang Hui, contributed significantly to the adoption of the Orthodox school approach to painting as the official court style.

Ultimately, it was the ability of the Manchu rulers to foster political stability and economic prosperity that unified the Qing state and solidified their rule. The success of this endeavor is exemplified by the city of Yangzhou. Burned by Manchu troops when it vainly resisted capture in 1645, the city was rapidly rebuilt, largely with the wealth generated by the salt distribution network administered there. In the eighteenth century, Yangzhou was China's leading commercial center, boasting a large population of bourgeois patrons whose eagerness to acquire the trappings of culture was colored by their taste for ostentation and eccentricity. Artists catering to this clientele frequently created

iconic images of nature that conveyed lofty symbolic messages or auspicious sentiments, images that were also amenable to bold, calligraphic interpretations that enhanced their visual impact. Among these painters, Li Fangying (1696–1755; pl. 8) was particularly esteemed for his dynamic renditions of blossoming plum.

Eighteenth-century urban gardens, epitomized by the Daguan Garden described in *The Story of the Stone* (*Dream of the Red Chamber*), conveyed the prosperity and material splendor of Qing society at its zenith.[9] And no gardens of this period were more splendid than those built under the Qianlong emperor (r. 1736–95). These grandiose constructions, including the various summer residences on the outskirts of Beijing and further north in Chengde, Hebei Province, were intended to be microcosms of the empire, where the treasures of China's culture were gathered together for the emperor's delectation and displayed as a demonstration of his hegemony over the cultural traditions of the empire. One such expression of Qianlong's cultural ambition is the Tower for Viewing Antiquity (Yuegu Lou), a two-story hall situated on White Dagoba Hill in the imperial gardens adjacent to the Forbidden City, Beijing, in what is now Beihai Park. There Qianlong enshrined 495 stones engraved with copies of 340 model calligraphies selected from the imperial collection, which were subsequently used to make sets of rubbings (pl. 9). Thus, the emperor literally changed the landscape of the imperial precincts by embedding an emblem of cultural power on the side of a hill.

Images of nature have remained a potent source of inspiration for artists down to the present day. In the summer of 1937, on the eve of the Japanese invasion of China, Wang Jiqian (born 1907; pl. 12), better known as C. C. Wang, painted an image of pine trees in a wintry landscape that since the eleventh century had been read as an emblem of the longevity of the state and survival in the face of adversity. And in 1950, Zhang Daqian (Chang Dai-chien, 1899–1983; pls. 10 and 11) saw in the lush beauty of an Indian species of orchid the promise of loyalty and renewal at a time when he had fled China and sought sanctuary abroad.

While the Chinese landscape has been transformed by millennia of human occupation, Chinese artistic expression has also been deeply imprinted with images of the natural world. Viewing the paintings assembled by Marie-Hélène and Guy Weill, it is clear that Chinese depictions of nature are seldom mere representations of the external world. Rather, they are expressions of the mind and heart of the individual artists — cultivated

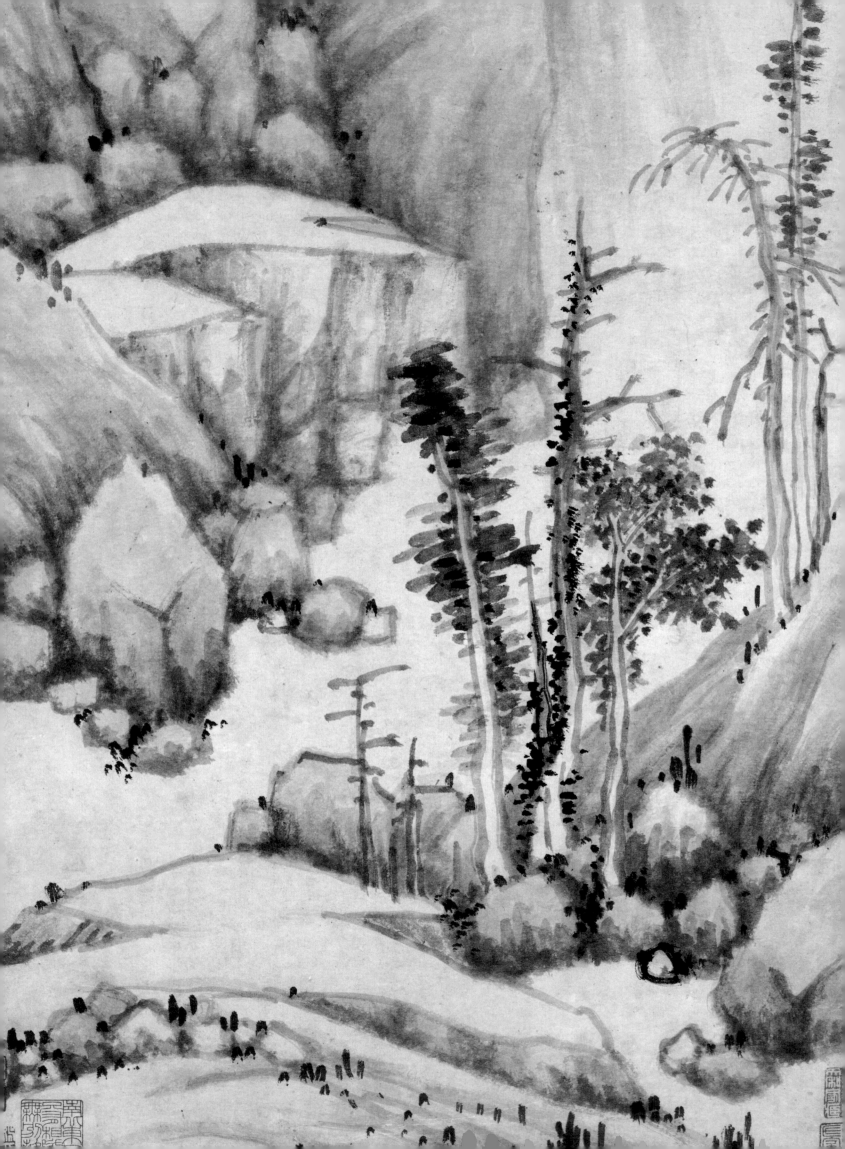

landscapes that embody the culture and cultivation of their makers. As a group, these works also convey something of the spirit of the collectors.

SHEN ZHOU

One of the high points of Ming-dynasty art was the revival of Yuan scholar-painting styles during the late fifteenth and early sixteenth centuries in the Wu region, centered around the cosmopolitan city of Suzhou, the cultural capital of Ming China. The Weill collection is distinguished by two works painted by the preeminent masters of the Wu (Suzhou) school of literati painting, Shen Zhou and Wen Zhengming.

Shen Zhou (1427–1509) is revered as the patriarch of the Wu school.[10] Born into a wealthy landowning family, Shen Zhou followed in the footsteps of his father, Shen Heng (1409–1477), and grandfather, Shen Cheng (1376–1463), in choosing to enjoy a private life of self-cultivation rather than pursue an official career. Using as an excuse the filial responsibility of caring for his mother, who lived until 1506, Shen devoted himself to the practice of poetry — publishing his first volume of poems in 1491 — collecting, and painting.[11]

Radiating a mood of subdued introspection, *Anchorage on a Rainy Night* (pl. 1), dated 1477, mirrors Shen Zhou's state of mind less than two months after his father's death, when he found solace in a friend's company. The painting presents a view of a stream or inlet framed by an embankment with tall trees and a ridgeline that rises precipitously from the mist that hovers above the water. Shen's inscription, in the upper right, places his visual tone poem in context:

> *East of the ancient city in the setting sun's slanting rays,*
> *Swallows fly low over the overflowing pond.*
> *Thus I know that tonight the spring rain will be plentiful,*
> *How fitting that fish should leap and ducks alight.*

> *On the twentieth day of the last [lunar] month of spring in the*
> *dingyou year (May 2, 1477), I lodged on a boat to the east of*
> *the city with Weide. After the rain, everything grew quiet. I did*
> *this picture and poem to capture the mood.*[12]

PLATE 1a Detail, pl. 1

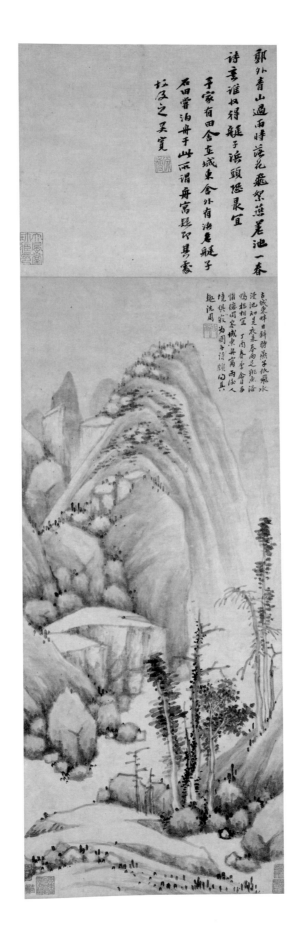

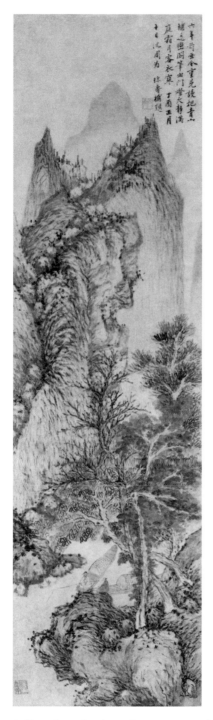

The person mentioned in Shen's dedication and the presumed recipient of the painting is very likely Zhou Weide, a man for whom Shen executed an important album of twenty-two paintings that he began in 1477 and completed five years later, in 1482, at which time he added a lengthy dedication.[13]

In executing his painting Shen first sketched out the main components of the composition in pale ink. He then went over these contours in darker ink, but not so as to conceal the lighter lines (pl. 1a). The result of this double outlining is to impart a softening of forms as if blurred by a moisture-suffused atmosphere. Mountains are given added mass through the application of broad strokes of light wash, with more densely inked areas suggestive of shadowy crevices. The foreground slope and cluster of trees stand out from the background— a calculated effect to heighten further the feeling of atmospheric distortion. The darkest ink is reserved for foliage dots, accents that serve to emphasize the pale luminosity of the scene, which appears to be illuminated by moonlight and veiled in mist.

Painted when he was fifty, *Anchorage on a Rainy Night* marks the beginning of Shen Zhou's mature period. Shen's earlier compositions are often characterized by a profusion of texturing and finicky detail that make them appear overworked. Six years earlier, in 1471, for example, Shen painted *Boating on an Autumn River* (fig. 1), a composition similar to *Anchorage on a Rainy Night* but following the brush manner of the Yuan master Wang Meng (ca. 1308–1385).[14] Not only does the Wang Meng idiom lead Shen to create denser, more complex landscape forms,

PLATE 1 Shen Zhou (1427–1509). *Anchorage on a Rainy Night,* dated 1477, with colophon by Wu Kuan (1436–1504) mounted above the painting. Hanging scroll, ink on paper; painting, 31 ⅜ × 13 ⅛ in. (79.7 × 33.3 cm). The Metropolitan Museum of Art. Promised Gift of Marie-Hélène and Guy Weill **FIGURE 1** Shen Zhou (1427–1509). *Boating on an Autumn River,* dated 1471. Hanging scroll, ink on paper, 44 ¾ × 12 ½ in. (113.8 × 31.7 cm). Honolulu Academy of Arts, Gift of Mrs. Robert P. Griffing, Jr., 1961 (2994.1)

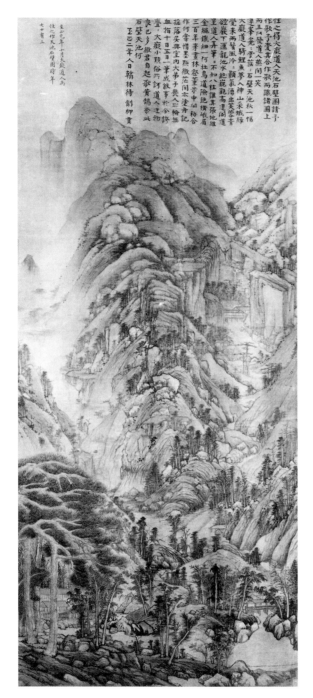

but the narrative content is also fuller, with two boats inserted in the narrow waterway between the tree-studded foreground and middle-ground mountains.

In *Anchorage on a Rainy Night,* Shen Zhou has drastically simplified his pictorial vocabulary, achieving a new sense of clarity and monumentality. In place of Wang Meng, he has taken as his principal model the Yuan artist Huang Gongwang (1269 – 1354), whose textured slopes, open plateaux, and clusters of round boulders are the basic building blocks of Shen's composition (fig. 2). These motifs are introduced in the foreground, where a broad, lightly toned bank is separated from a densely shaded slope by a line of massive boulders. A second cluster of smaller and paler boulders buttresses the embankment. This formula of mountain-building is repeated in the peaks above. The group of trees — each of a different type — serves to bridge the gap between foreground and middle ground, helping to unify the composition while providing a visual counterpoint to the mountain.

Shen, however, has introduced some important modifications to the Yuan master's model. He has dramatically simplified both the structure and the repertoire of dots and texturing used to describe his forms. Huang Gongwang's richly varied application of dry and wet ink is limited to a narrow range of ink tonalities in order to evoke more effectively the feeling of a nighttime scene in which a heavy rain has left the atmosphere laden

FIGURE 2 Huang Gongwang (1269 – 1354). *Stone Cliff at the Pond of Heaven,* dated 1341. Hanging scroll, ink on paper. Palace Museum, Beijing

with moisture. Shen has similarly reduced Huang's complex brush idiom to a few simple brush conventions, describing landscape elements with outlines and texture strokes of virtually uniform thickness and tonality. The dark foliage dots that Shen uses as accents are also conventionalized: vertical dots are simplified from those used by Huang, and horizontal dashes are derived from those in the works of Ni Zan (1306–1374). Finally, Huang's complex compositional structure and illusionistic treatment of space are reduced to a geometric scheme of repeated diagonals in which the wedge-shaped foreground, receding stream, echelon of successively taller trees, and distant mountain slope all point toward the upper right, where Shen has added his poetic inscription.[15]

In addition to simplifying his pictorial structure, Shen has pulled the entire composition closer to the viewer so that the mountains appear to loom out of the middle distance. This compression of the picture space has the added effect of flattening the landscape forms; thus, the balance between spatial illusion and calligraphic pattern maintained by Huang Gongwang has been strongly shifted toward abstraction. This patternization heightens the dynamic visual interaction between the blank surfaces of the level plateaux and the textured surfaces of the tilted slopes, which appear alternately three-dimensional and flat. Shen has deliberately abandoned the stability and illusionistic logic of his model. Except for the undefined plane of water, no surface in the picture appears level; everything tilts, curves, or slopes, undercutting the quiet mood of the simple brushwork and pale ink tones with an instability that imparts a subtle dynamism to all the forms.[16]

In contrast to the simple vocabulary of pictorial forms, Shen's inscription, written in dark ink with a fine-tipped brush, shows a great variety of brushstrokes, some with broad, blunt endings, others with sharp points or delicate connecting ligatures (pl. 1b). The occasional elongated vertical or diagonal stroke reveals the growing influence of the Northern Song calligrapher Huang Tingjian (1045–1105) on Shen's style. When compared with his inscription on the album for Zhou Weide, dated five years later (fig. 3), where the influence of Huang Tingjian is far more pronounced, Shen's writing style here is still evolving. He vacillates between standard and cursive scripts, between squat forms and elongated ones, and between attenuated, delicately formed brushstrokes that recall the style of the Tang calligraphers Ouyang Xun (557–641) and Chu Suiliang (596–658) and those that are coarse and heavy in the manner of Song calligraphers. This fluctuation between different manners is not found in Shen Zhou's inscription of two months

earlier on *Boating on an Autumn River* (fig. 4). While that inscription does not exhibit the pronounced mannerisms associated with Huang Tingjian found in Shen's postscript of 1482 to the Zhou Weide album, it is more consistent in style and character structure than the inscription on *Anchorage on a Rainy Night*. Shen's irregular writing here is possibly the product of emotional distress over the recent death of his father.

Shen's close friend, the noted literatus Wu Kuan (1436–1504), added a poem of his own above the painting (pl. 1c), perhaps as a further embellishment, either before the work was presented to Zhou Weide or later at Zhou's behest:

> When it rains on the green mountains beyond the city wall,
> Flowers fall, catkins fly, and swallows flutter across the pond.
> The poetic feeling of spring—who is able to capture it?
> Boatman's Creek is the most fitting place.[17]

> My family has fields and a house to the east of the city. Beside the house
> is Boatman's Creek. Shitian [Shen Zhou] once anchored a boat at this

PLATE 1b (left) Detail, pl. 1. Shen Zhou (1427–1509) inscription, dated 1477 FIGURE 3 (right) Shen Zhou (1427–1509). *Landscapes for Zhou Weide*, datable to 1477–82. Album of twenty-two paintings and a one-leaf postscript, ink and color on paper. Formerly Zhang Xueliang Collection, Taipei. Detail. Shen Zhou postscript, dated 1482. (After facsimile reproduction, n.d.)

place, his so-called boat lodging. I suspect that it is just this place that he has [painted].

Wu Kuan's addition of a poetic colophon to Shen's painting represents the continuation into Ming times of the custom of embellishing paintings with poetic inscriptions that was at the heart of Suzhou literati culture from the late-Yuan period onward. This practice served to underscore the connection between friends and reaffirm the close-knit social circle to which they belonged. In this case, Shen and Wu created a joint work of art for a third party, Zhou Weide, who may have been a patron as well as a friend. Such collaborative ventures, combining separate contributions by a painter and one or more calligraphers, became a standard practice among the next generation of Wu school artists, who would often jointly create a multifaceted work for a single patron.[18]

FIGURE 4 (left) Detail, fig. 1. Shen Zhou inscription, added in 1477 **PLATE 1c** (right) Detail, pl. 1. Wu Kuan (1436–1504) colophon

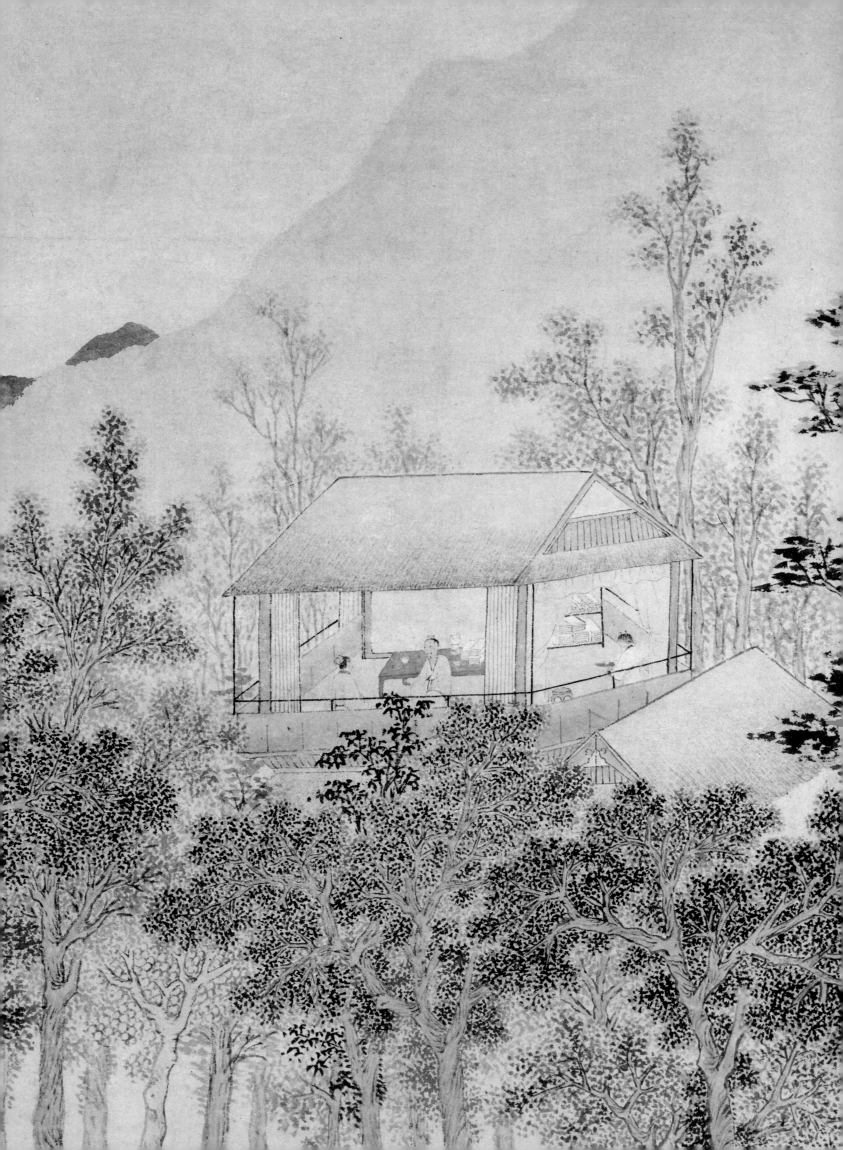

In 1477 Shen Zhou and Wu Kuan had the leisure time to undertake such joint works as both were observing the three-year period of mourning for their fathers. The two men had known each other from their childhood, but had taken very different career paths. While Shen chose to live in retirement as a gentry landowner, Wu, who came from a wealthy family in the textile business, pursued an official career, taking first place in the "presented scholar" (*jinshi*) civil service examinations of 1472. He went on to hold a succession of high-level government posts, as well as serving as advisor to two heirs apparent.[19] Shen and Wu had an opportunity to renew their relationship in 1476 when Wu returned to Suzhou from Beijing to observe the mourning rites for his father, Wu Rong (1399–1475). A year later Shen Zhou's father died, and the two friends often saw each other during this period of mutual bereavement. Shen even asked Wu to compose his father's epitaph.[20] In return, he presented Wu with a monumental handscroll composition that he finished in 1479 on the eve of Wu's return to the capital.[21]

Wu Kuan's inscription (pl. 1c), with its plump, squat characters composed of alternately broad and thin strokes, epitomizes his mature writing style. Eschewing the orthodox manner of the Ming court, which was based on Zhao Mengfu's (1254–1322) reinterpretation of the Wang Xizhi (303–361) tradition, Wu took as his model the individualistic style of the great Northern Song poet, theorist, and calligrapher Su Shi (1037–1101) and became the most famous practitioner of the Su style during the Ming.[22] This stylistic choice of models resonates with that of Shen Zhou who chose to emulate the bold individiualistic manner of Su Shi's friend, Huang Tingjian. Just as Wu Kuan's poem echoes the rhyme scheme and themes of Shen's poem, the two men's calligraphy reveals them to be kindred spirits whose friendship and mutual understanding still resonate today.

WEN ZHENGMING

Through discipline, talent, and sheer longevity, Wen Zhengming (1470–1559) became the leading master of the Wu school of literati painting and the most famous artist of sixteenth-century China.[23] Born into a scholarly family that prospered in the city of Suzhou, Wen Zhengming was tutored by some of the most illustrious members of that society. In 1478 he was instructed in the classics by Wu Kuan, a family friend, and by

PLATE 2a Detail, pl. 2

1489 was studying painting with Shen Zhou. From 1495 to 1522 Wen tried and failed the provincial civil service examination ten times before being granted an honorary appointment to the Hanlin Academy in Beijing in 1523. Disillusioned with official life, Wen retired from government service after only three years, returning to Suzhou where he spent his remaining thirty-two years painting, practicing calligraphy, and becoming one of the leading cultural figures of the city.

Wen Zhengming painted *Living Aloft: Master Liu's Retreat* (pl. 2) in 1543 for his friend Liu Lin (1474–1561). Lin, then at the age of sixty-nine (seventy *sui*), had retired from government service but had not yet built a home suitable for his new life. In his painting Wen presents an idealized vision of life in retirement: separated from the outside world by a stream and a rustic wall, two friends enjoy each other's company in a two-story hall that is further isolated in a grove of tall trees (pl. 2a). The friends face each other beside the balustrade at the front of the upper story. Behind them an archaic tripod vessel, several volumes of books, and two other objects — perhaps an incense burner and a box of incense — have been set out on an elegant red lacquer table. A large unpainted screen serves as a room divider, but the artist has thoughtfully given us a glimpse behind the screen from the side window. There, heavy curtains have been pulled back to reveal a bookshelf stacked with books and scrolls. A servant has risen from his stool and is preparing to serve cups of wine, which he carries on a red lacquer tray. The roofline and balustrade of the hall have been drawn with the aid of a straightedge, but Wen's complete disinterest in spatial logic is clear from the angle at which the rear balustrade intersects the railing at the side of the hall. The lower story of the hall is almost completely hidden from view by the dense screen of trees. The rough, twisted bark and densely clustered foliage identify most of these trees as a kind of cypress or cedar, a species of tree that Wen particularly admired and often incorporated into his paintings.[24] The thick foliage of these evergreens stands in sharp contrast to the pair of bare willows that grow from the foreground bank. The outstretched branches of the willows frame a view of the front gate, which has been left open to welcome other guests. The gate and the bridge that spans the stream are symbolic transitions between the private realm of the garden and the world beyond. The screening wall of mountains behind the hall performs a similar function and indicates that Liu's place of retirement has been well situated geomantically, at the base of a hill along the edge of a swiftly flowing watercourse.

PLATE 2 Wen Zhengming (1470–1559). *Living Aloft: Master Liu's Retreat*, dated 1543. Hanging scroll, ink and color on paper, 37 ½ × 18 in. (95.2 × 45.7 cm). The Metropolitan Museum of Art. Promised Gift of Marie-Hélène and Guy Weill

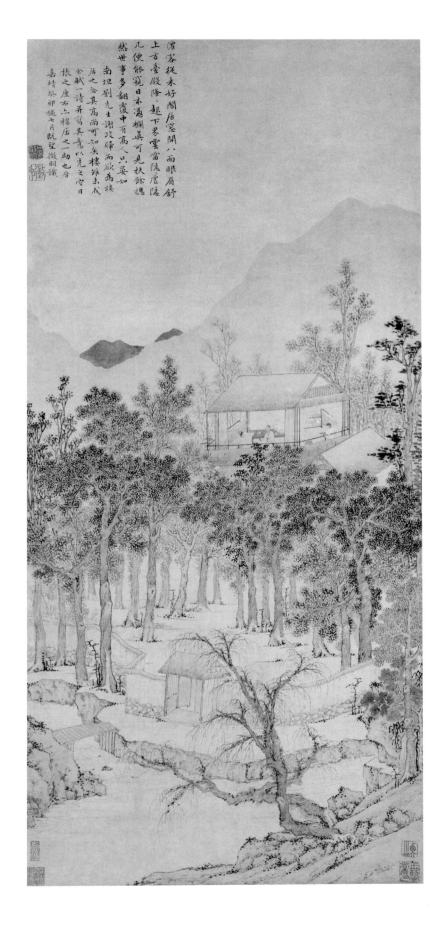

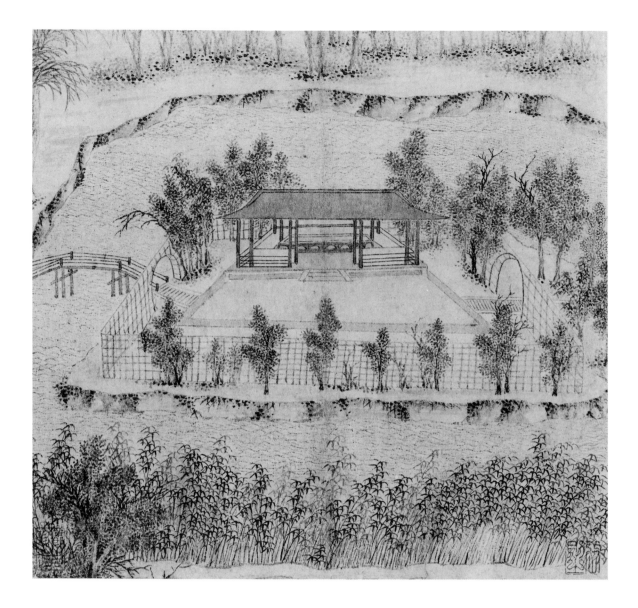

In his accompanying poem, Wen elaborates on the pleasures of life in such a pavilion:

Immortals have always delighted in pavilion-living,
Windows open on eight sides — eyebrows smiling.
Up above, towers and halls well up,
Down below, clouds and thunder are vaguely sensed.
Reclining on a dais, a glimpse of Japan,
Leaning on a balustrade, the sight of Manchuria.
While worldly affairs shift and change,
In their midst a lofty man is at ease.

FIGURE 5 Wen Zhengming (1470–1559). *Garden of the Clumsy Administrator*, dated 1551. Album of eight paintings with facing pages of calligraphy, ink on paper, 10⁶/₁₆ × 10¾ in. (26.6 × 27.3 cm). The Metropolitan Museum of Art. Gift of Douglas Dillon, 1979 (1979.458.1). Detail. Leaf A, Hall of Distant Fragrances (Yuanxiang Tang)

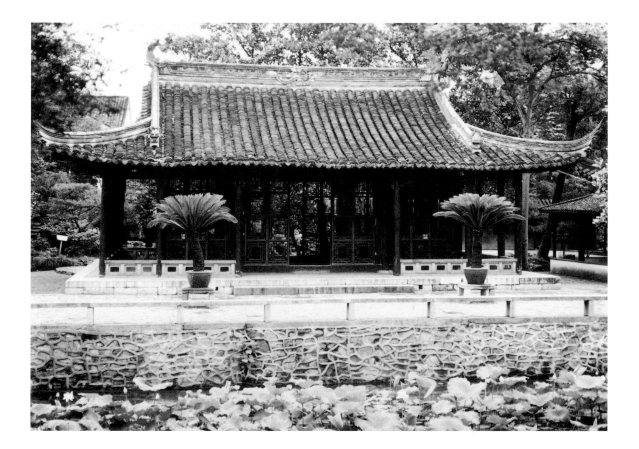

Mr. Liu Nantan [Liu Lin] retired from government, and upon his return home, he planned to build a dwelling—so you will know his noble character. Although the building is not yet completed, in anticipation of it I have composed a poem and sketched its concept. Another day he can hang it at his right hand to enrich that pavilion-living.[25]

Liu Lin, a native of Anren, Hunan Province, was known as one of the "Five Hunan Recluses." Together with Gu Lin (1476–1545) and Xu Zhenqing (1479–1511), both of whom were also acquaintances of Wen Zhengming, he was known as one of the "Three Talents East of the River." It is recorded in the *Ming History* (*Ming shi*) that Liu Lin, "unable to realize his own home . . . suspended a bamboo sedan chair from a beam, and reclining on it, called it the 'spirit pavilion' (*shenlou*)."[26] It is also recorded there that Wen did a painting to bequeath to a "Mr. Liu."[27] An inscription by Liu Lin on a piece of calligraphy by Shen Zhou dated 1497 suggests that he had long been familiar with the leading members of Suzhou literati culture.[28]

FIGURE 6 Hall of Distant Fragrances, Garden of the Clumsy Administrator, Suzhou, Jiangsu Province. Photograph by Maxwell K. Hearn

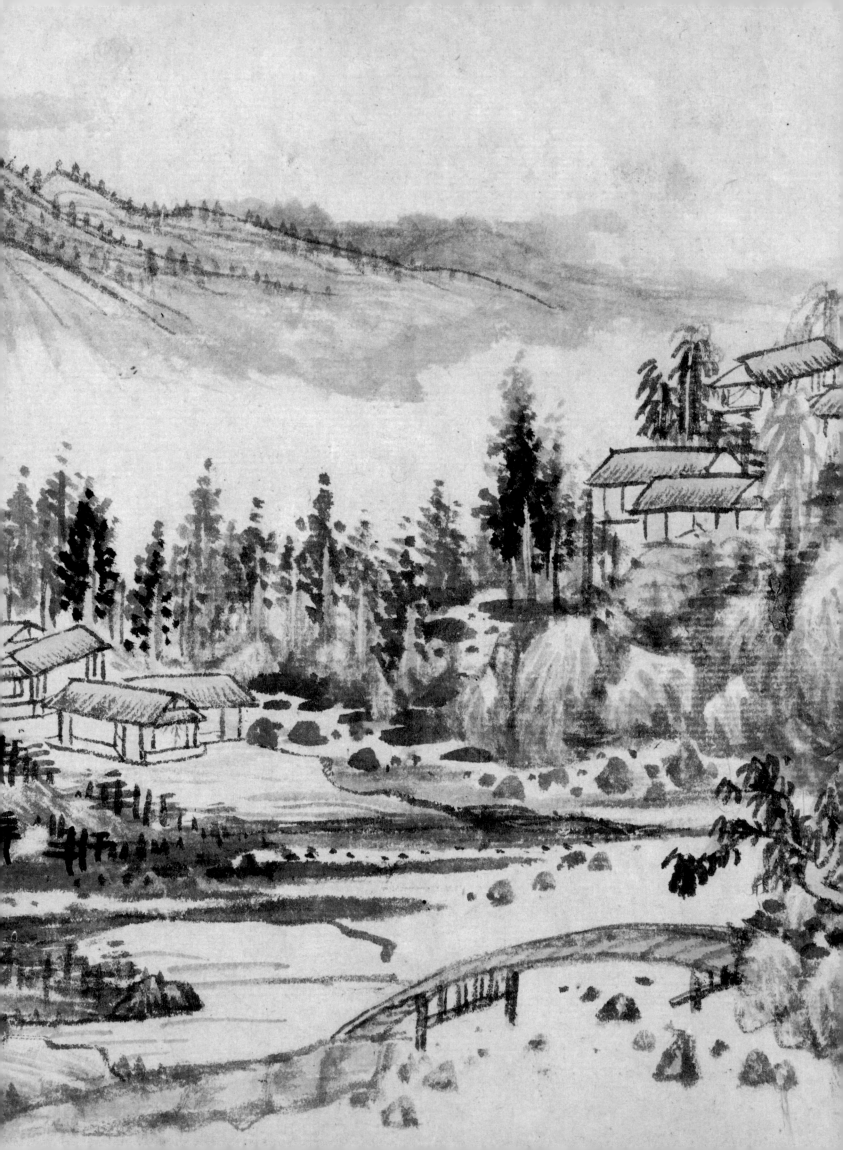

Wen's idealized image of a scholar's garden exemplifies the era's taste for understatement, restraint, and modesty. It hardly mattered that the hall had not yet been built. When one compares Wen's depiction of the Hall of Distant Fragrances (Yuanxiang Tang) of the Garden of the Clumsy Administrator in Suzhou (fig. 5) with an image of the actual structure as it appears today (fig. 6), it is evident that Wen felt free to radically simplify his image, making it appear rustic and quaint rather than attempting to describe accurately the imposing columns and massive tile roof of the original. In the same way, *Living Aloft* uses dry brushwork and a pale palette to evoke the ideal of a scholarly retreat rather than any architectural reality.

LIU YU

Liu Yu (active ca. 1660s – ca. 1690s), a native of Nanjing, Jiangsu Province, worked in that city during the early decades of the Qing dynasty, when it was a vital center for the arts. Under the Ming, Nanjing had been the empire's secondary capital with a large and prosperous population that sustained a diverse array of artistic expressions. Literati artistic values were promoted by the numerous high-ranking government officials stationed in the city, who were both practitioners and patrons of the arts. Professional painting flourished under court sponsorship and in an art market supported by a newly assertive class of wealthy merchants and entrepreneurs.[29] A center of Jesuit missionary activity since Matteo Ricci (1552–1610) first visited there in the late sixteenth century, Nanjing was also one of the first places where Chinese painters began to incorporate Western ideas of shading and perspective into their depictions of local scenery.[30]

After its fall to Manchu forces in 1645, the city lost its status as a secondary capital and its name was changed from Nanjing (Southern Capital) to Jiangning. Nevertheless, as the provincial capital of Jiangsu, the wealthiest region in the empire, the city continued to support a broad spectrum of artistic expressions.

During the early decades of Manchu rule the dominant figures in Nanjing's art scene were the Ming loyalists or "leftover subjects" (*yimin*), many of whom, notably Kuncan (1612–1673) and Zhang Feng (active ca. 1636–62), continued to nurture hopes of dynastic restoration. The most innovative and influential loyalist painter working in Nanjing, however, was Gong Xian (1619–1689). Gong developed a densely textured,

PLATE 3 Detail

monumental landscape style in which he was able to suggest volume and mass by vary-
ing the density and darkness of his ink dots. This modeling technique is highly schematic;
there is no single light source as in Western painting, although Gong's interest in the
effects of light and shade probably owes something to the influence of European
engravings and paintings brought to Nanjing by the Jesuits. Gong was far more deeply
influenced by the theories and stylistic innovations of the late-Ming critic and artist Dong
Qichang (1555–1636), who served as an official in Nanjing from 1622 to 1624.[31] Unlike
Dong's closest followers, however, who modeled their paintings after a specific canon of
old masters, Gong evolved a highly individualistic painting style that evinced few direct
links to earlier stylistic traditions. Dong Qichang's theories found their most literal
expression in the art of a group of painters working in the town of Taicang (located just
north of modern Shanghai in present-day Jiangsu Province) under the leadership of
Dong's disciple Wang Shimin (1592–1680). By the 1660s Nanjing's leading connoisseur
and collector, Zhou Lianggong (1612–1672), was corresponding with and collecting
the works of Wang Shimin and his celebrated student Wang Hui (1632–1717).[32]

Liu Yu lived and worked in this pluralistic artistic milieu, establishing himself as a
prominent figure in the Nanjing art world. Although he is usually not included among
the "Eight Masters of Jinling [Nanjing]," he belonged to the same circle of leading
collectors and artists active in the city during the late seventeenth century.[33]

Biographical information about Liu Yu is scant, but dated works suggest that his
period of activity extended from the late 1660s into the 1690s.[34] He is mentioned in the
supplemental list of Zhou Lianggong's *Record of Reading Paintings* (*Duhua lu*; postface
dated 1673), but is not given a biography, an indication that his career was not far
advanced at the time when Zhou was composing his text. Nor does Liu appear among
the artists or colophon writers in the extant works collected by Zhou, which were
assembled in the 1640s to 1660s.[35] Liu features more importantly in the writings of the
prominent official and powerful patron Song Luo (1634–1713), who served as governor-
general of Jiangxi (1688–92) and Jiangsu (1692–1705). In a colophon composed for a
painting that Liu Yu executed for him, Song Luo describes Liu's painting as exhibiting
"the careless elegance of a Yuan-dynasty painter, but it is even more vast and expansive
so that it approaches the styles of Dong Yuan [active 930s–960s] and Juran [active ca.
960–95]."[36] Song also recorded several poems he had composed following Liu Yu's

rhyme schemes.[37] In 1689 Liu Yu visited Song in Jiangxi and painted an album for him, *Twelve Landscapes after Tang Poems*, now in the Arthur M. Sackler Gallery, Washington, D.C.[38] From these records it is evident that Liu was an able poet, a calligrapher influenced by the Tang master Li Yong (675–747), and a painter possessed of a scholarly disposition.[39] In the brief biographical entry on Liu Yu in *Sequel to Precious Mirror of Painting* (*Tuhui baojian xuzuan*), Liu's landscapes are described as possessing a "scholarly spirit" (*shiqi*)—the chief desideratum of painters of the seventeenth century.[40]

Liu was on familiar terms with a number of the leading artists of the day, as he makes clear in his lengthy autobiographical postscript to the 1689 album painted for Song Luo (fig. 7):

> In the beginning, I loved to stroll about and play with my brush, sketching bamboo, trees, and landscapes however I pleased to relieve the anxiety of my studies and express my feelings on climbing up to take a view. And just like that, after awhile I became immersed [in painting].
>
> Master Gong Banqian [Gong Xian] said to me: "One cannot become famous in any art form without striving at it for several decades. If one doesn't make it, something must have distracted him and caused

FIGURE 7 Liu Yu (active ca. 1660s–ca. 1690s). *Artist's Postscript to Twelve Landscapes after Tang Poems*, dated 1689. Double album leaf, ink on paper, 9 3/8 × 8 1/8 in. (23.7 × 20.5 cm). Arthur M. Sackler Gallery, Smithsonian Institution, Washington, D.C.; Gift of Arthur M. Sackler, S1987.227

*him to fail. So it is certain that if you do not concentrate fully, how can
you [expect to succeed]?" I knew he was right, so I abandoned my
efforts to take the exams and put all my energy into painting.*

*Mister Cheng Qingqi [Cheng Zhengkui, 1604–1676] saw this and
was glad, saying, "When an artist starts to paint, he puts the highest
value on force and power... but what he really needs to do is master
fine detail... for then, no matter how loose and relaxed [his brushwork]
is, those who understand will know that it derives from [a mastery of]
detail... You should keep this in mind."*

*When Shiqi [Kuncan], the eminent monk from Chu, was living in
Baixia [near Nanjing], he saw several of my works, and asked one of
my friends: "Master Liu is from a wealthy family, is he not?" [My friend]
said: "He is an impoverished scholar." "Well then, he certainly is
becoming more and more uncouth by the day." When I first heard this,
I wondered greatly at it, but after awhile I realized that the master was
simply expressing his concern that I was following the fads of the time
and had lost the [real] reason [for painting]. So I strongly resolved that
I would not allow myself to be uncouth or paint something just because
other people like it.*

*Master Wang Shigu [Wang Hui] from Yushan is an old pal of mine.
For years, he has joked with me: "Your paintings are really very
beautiful. But you yourself don't understand their beauty, only I really
understand it." I have pondered the reason for this, and he probably was
saying that I lack confidence in myself because I have not seen many
works by the old masters. He really has such a profound take on me.*

*Now these gentlemen are thought of as established masters by the
experts in the land, and all of them are acquaintances of mine. One
urged me to concentrate, another taught me to master detail, one
warned me against uncouthness, and another imbued me with confi-
dence. I guess the reason I have been unable to profit [from their
advice] is that this art form really is so very hard [to master].*[41]

Liu must have already been familiar with Wang Hui's art by the early 1670s when he
added a colophon to a hanging scroll by Wang painted in 1673 (fig. 8) and to which

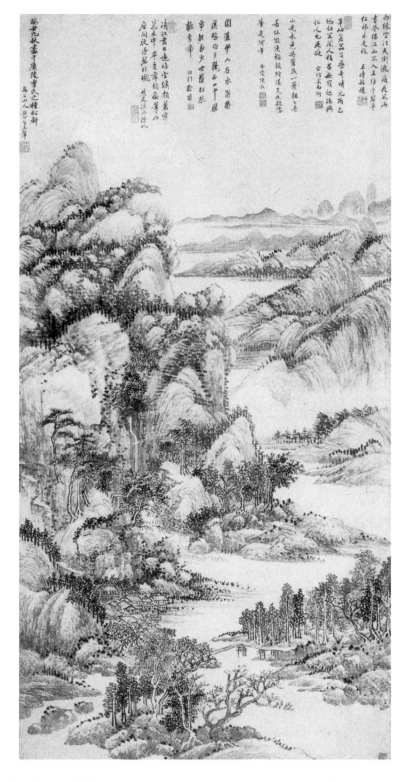

FIGURE 8 Wang Hui (1632–1717). *Verdant Peaks and Hundred Ranges*, dated 1673. Hanging scroll, ink on paper, 47 ¼ × 23 ⅞ in. (120 × 60.6 cm). Shanghai Museum. Inscriptions by (right to left) Wang Shimin (1592–1680), Zhou Eryan, Chen Fan, Liu Yu, Chen Cheng (all active late 17th century), and Wang Hui

fig. 9b fig. 9a

several other prominent figures, including Wang Shimin, Zhou Eryan, Chen Fan, and Chen Cheng (all active late 17th century), added inscriptions.[42] An undated letter from Liu Yu to Wang Hui, recorded in an anthology of letters written to Wang, confirms Liu's privileged relationship with both Wang and Gong Xian:

> *I once saw Master Shigu's [Wang Hui's] painting in ink on* Cheng
> [*-xintang paper*], *but that work now has an owner … This year you*
> [*i.e., Wang Hui*] *came here by boat. Disdaining to meet most people,*
> *you only favored Banqian [Gong Xian] and me. Outsiders were not*
> *permitted in our meetings, in which we talked half the night.*[43]

A letter from Gong Xian to Wang Hui that immediately precedes Liu Yu's letter in the same anthology not only underscores Liu's acquaintance with both men but reveals the admiration both Liu and Gong felt for Wang Hui's art:

> *Gonghan [Liu Yu] has told me of your marvelous paintings, which*
> *are not only preeminent in the Suzhou region, but are considered*
> *preeminent everywhere. Today I was thinking of taking a boat to visit*
> *you when, unexpectedly, I heard that you had arrived here. You can*
> *imagine how happy I was. Because my humble abode is so far away*
> *I could not go to wait upon you daily. Now I have heard that you are*
> *preparing to leave, which has made me so upset that I don't know what*
> *to do. Zilao has come bearing your precious [painting], which fulfills*

FIGURE 9 Colophons by Gong Xian (1619–1689), undated (fig. 9a), and Zeng Xi (1861–1930), dated 1928 (fig. 9b), to *Landscape* by Liu Yu (see fig. 14). Palace Museum, Beijing

my wishes, but how could I dare to send you one of my clumsy works,
which is only worth a laugh before being thrown out. My awkward
poem and those of other colleagues are also attached. Banyin [Lü Qian,
jinshi 1643; a student of Gong Xian's] will carry them along with a
small album leaf on which I have written out a poem that I composed
earlier. Tomorrow if someone comes from the south of the city I will
do another.[44]

A further indication of Gong Xian's link to Liu Yu is the long inscription (fig. 9a) he appended to an undated handscroll by Liu—a work Liu modestly neither signed nor sealed—that recalls Liu's 1689 colophon to his album for Song Luo, where he cites Gong's admonition that if one is to succeed, it is necessary "to strive for several decades":

In painting, one should prefer the fresh over the stale, the eccentric and
provocative over the conventional. Without working fifty years with an
inkstone you cannot achieve this. When [painting] becomes second
nature, then there is no hesitation. If you haven't achieved this, you will
be a thousand miles from your goal. Master Liu [Yu's paintings] are
beautiful and effortless. They're like the works of the Jin dynasty courtier
[Wang Xizhi] or the Tang academician [Yan Liben, died 673], or Mi Fu
[1052–1107] of the Song with his dotting method. [Liu Yu] has drunk
the heavenly dew, chewed the snowy lotus, resided atop bare stones,
and dressed in an icy coat. If you haven't gone through this, then you
can't achieve this kind of elegance. All this can be seen in his ink
and brush. Someday, when Gonghan [Liu Yu] returns from Yuedong
[Guangdong and Guangxi provinces] and hears what I have said, he
will certainly compose a poem to thank me.[45]

In his inscription, Gong refers to Liu in terms that suggest that Liu was a younger friend, possibly even a former student—a status supported by a colophon (fig. 9b) to the same handscroll written in 1928 by the Shanghai calligrapher Zeng Xi (1861–1930), which identifies Liu Yu as Gong Xian's disciple. Gong's inscription may be dated to 1688–89 on the basis of his remark that Liu Yu was then in Yuedong, probably a reference to Liu's travels to Jiangxi Province. (As noted above, Liu visited Song Luo there about

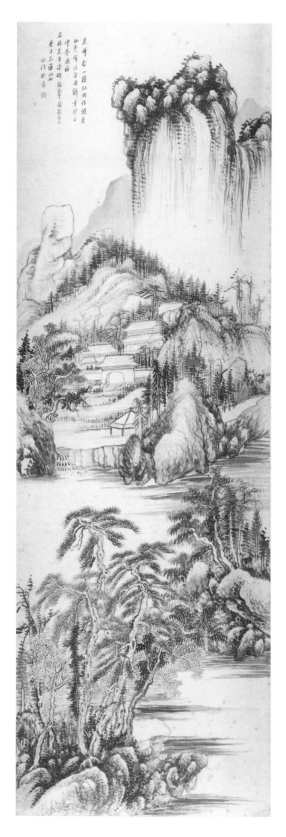

a year after Song had taken up the post of governor of Jiangxi in 1688). Before departing Nanjing, Liu evidently left his handscroll for Gong to examine. Gong added his colophon sometime prior to the eighth lunar month of 1689, when he died suddenly of illness. When Liu wrote his postscript to the album that he presented to Song Luo in the tenth lunar month of 1689 (see fig. 7), he probably did not yet know of Gong Xian's death.

Liu Yu's place at the center of the Nanjing art scene is further underscored by his inclusion in an album dedicated to a certain Banweng in the spring of 1679, which includes contributions from six of the so-called Eight Masters of Nanjing — Gong Xian, Fan Qi (1616 – after 1694), Gao Cen (active 1643 – 89), Wu Hong (active ca. 1653 – 79), Zou Zhe (active ca. 1647 – 79), and Xie Sun (active late 17th century) — as well as Wang Gai (1645 – ca. 1710) and Gao Cen's nephew Gao Yu (active late 17th century).[46] Shitao (1642 – 1707) also mentioned Liu Yu as an acquaintance in an inscription to one of his own albums, datable to about 1683,[47] when Shitao was living in Nanjing.

In his earliest landscapes, Liu practiced a rather coarse and heavy-handed style based loosely on the tradition of Dong Yuan and Juran as reinterpreted by his near contemporaries. Liu's inscription on a hanging scroll painted in 1673 (fig. 10), for example, states

FIGURE 10 Liu Yu (active ca. 1660s – ca. 1690s). *Landscape after Yun Xiang,* dated 1673. Hanging scroll, ink on paper, 77 ¼ × 25 ⅜ in. (196.1 × 64.5 cm). Palace Museum, Beijing

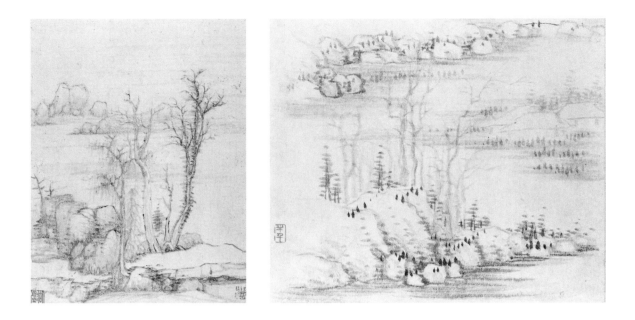

that he was inspired by a work by Yun Xiang (1586–1655),[48] a Suzhou artist from the previous generation whose style had an important influence on the work of Gong Xian:[49]

> *I have seen Yun Xiangshan's [Yun Xiang's] copy of a work by Shuming*
> *[Wang Meng] in which the texturing and washes were fine and elegant,*
> *especially the "unraveled rope" [texturing] used for the mountains.*
> *In the mid-winter of the guichou year [1673] while visiting Master*
> *Shilin, the ink was frozen and my imitation a failure; it may retain a*
> *trace of [Yun Xiang's] conception, but I really don't know whose work*
> *it resembles![50]*

This painting, as well as a long handscroll dated 1672, both in the Palace Museum, Beijing, show Liu Yu still searching for his own stylistic identity.[51] The hanging scroll, executed in coarse brushwork with long, hemp-fiber texture strokes (*pima cun*) set off by stubby foliage dots, imparts a great deal of visual energy but lacks the refinement and delicacy of Liu's later, smaller-scale works.

An album datable to early 1675 (fig. 11), in the Palace Museum, Beijing, displays a more advanced stage in the artist's career and demonstrates Liu's command over a broad range of brush techniques and compositional types inspired by such Yuan masters as Wu Zhen (1280–1354), Wang Meng, and Ni Zan.[52] Liu's evocations of antique styles,

FIGURE 11 (left) Liu Yu (active ca. 1660s–ca. 1690s). *Landscapes,* datable to early 1675. Album of ten paintings, ink and color on paper, 8 ⅞ × 6 ¾ in. (22.5 × 17 cm). Palace Museum, Beijing. Detail. Leaf H **FIGURE 12** (right) Gong Xian (1619–1689). *Landscapes and Trees,* ca. 1679. Album of twelve paintings, ink on paper, 6 ¼ × 7 ⁹⁄₁₆ in. (15.9 × 19.1 cm). The Metropolitan Museum of Art. From the P. Y. and Kinmay W. Tang Family Collection, Gift of Wen and Constance Fong in honor of Mr. and Mrs. Douglas Dillon, 1979 (1979.499). Detail. Leaf A

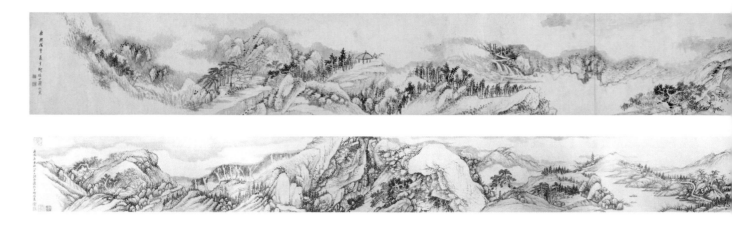

PLATE 3 (above; overall view) Liu Yu (active ca. 1660s–ca. 1690s). *Remote Valleys and Deep Forests*, dated 1678. Handscroll, ink and color on paper, 10 ⅝ × 144 ⅛ in. (27 × 366 cm). The Metropolitan Museum of Art. Promised Gift of Marie-Hélène and Guy Weill

however, do not reflect a deep knowledge of early painting; instead, his interpretations are derived from more recent sources, including early-Qing Orthodox school masters as well as such Nanjing artists as Kuncan, Zha Shibiao (1615–1698), Fan Qi, and, particularly, Gong Xian (fig. 12).

Remote Valleys and Deep Forests (pl. 3), in the Weill collection, is typical of Liu's mature style. Dated 1678, this handscroll, measuring twelve feet in length, compares closely to two other long handscroll compositions by the artist: one, dated 1680, from the collection of John M. Crawford Jr., now in the Metropolitan Museum (fig. 13), and the other, the undated work in the Palace Museum, Beijing (fig. 14) that bears Gong Xian's colophon (see fig. 9a). A frontispiece to the Weill scroll, by the noted Nanjing calligrapher Zheng Fu (1622–1694), dated 1679, is an additional enhancement to the painting and suggests that it was done for a local collector (see Catalogue, pl. 3c, page 169).

Compared to the Crawford scroll, *Remote Valleys and Deep Forests* is simpler and more intimate in feeling. Its visual appeal is enhanced by a restrained use of reds and pale blues on the houses and the trunks of the trees, a palette Liu also used in the Beijing handscroll. Nevertheless, the underlying brush idiom of the three scrolls is consistent, and they share many of the same motifs and compositional devices.

Remote Valleys and Deep Forests takes the viewer on a journey through a succession of "space cells," where familiar scenes of human habitation alternate with dramatic depictions of natural scenery. The painting opens with an echelon of landforms that

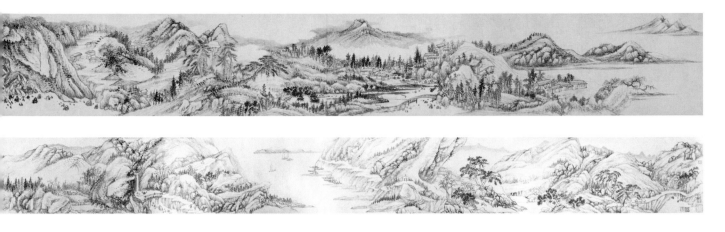

FIGURE 13 (below; overall view) Liu Yu (active ca. 1660s – ca. 1690s). *Landscape*, dated 1680. Handscroll, ink on paper, 10 ⅜ × 200 ¼ in. (26.2 × 508.7 cm). The Metropolitan Museum of Art. Bequest of John M. Crawford Jr., 1988 (1989.363.134)

draws the viewer's eye leftward from the far distance into the foreground, where a cluster of dwellings with thatch roofs occupies a level area at the foot of a low mountain. The mountain divides this settlement from a neighboring valley, where more houses stand on either side of a stream. A foreground bridge leads the eye across the stream, but the horizontal momentum of the scroll is interrupted by the receding waterway, which directs the viewer's attention past the middle-ground settlements to a broad mountain that spreads outward from its narrow peak in radiating lines that resemble the spokes of an inverted folding fan. Similar mountains appear in both the Crawford and Beijing scrolls.

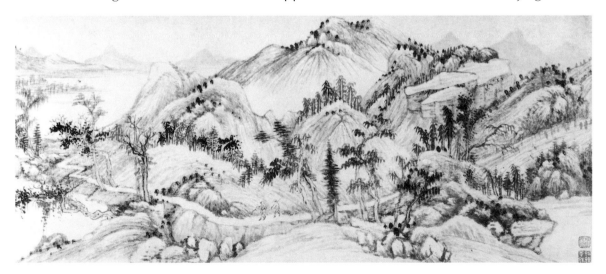

FIGURE 14 Liu Yu (active ca. 1660s – ca. 1690s). *Landscape*. Handscroll, ink and color on paper, 10 ½ × 176 ⅜ in. (26.6 × 448 cm). Palace Museum, Beijing. Detail. Opening section

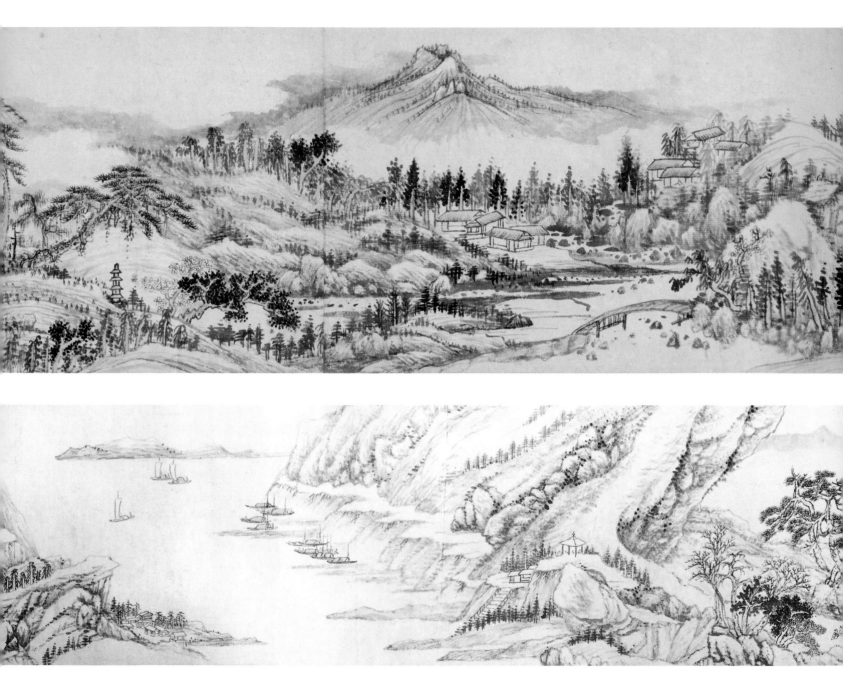

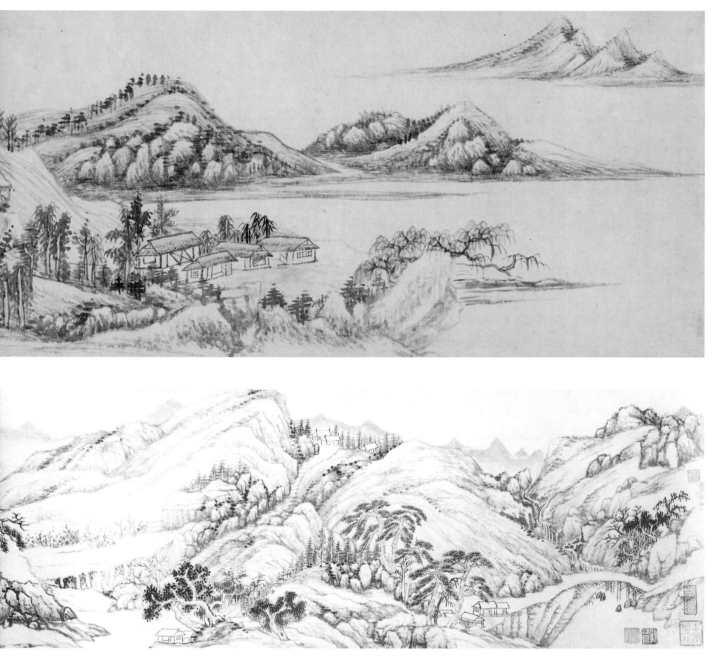

PLATE 3-1 (above) Liu Yu (active ca. 1660s–ca. 1690s). *Remote Valleys and Deep Forests*, dated 1678. Handscroll, ink and color on paper, 10 ⅝ × 144 ⅛ in. (27 × 366 cm). The Metropolitan Museum of Art. Promised Gift of Marie-Hélène and Guy Weill **FIGURE 13-1** (below) Liu Yu (active ca. 1660s–ca. 1690s). *Landscape*, dated 1680. Handscroll, ink on paper, 10 ⅜ × 200 ¼ in. (26.2 × 508.7 cm). The Metropolitan Museum of Art. Bequest of John M. Crawford Jr., 1988 (1989.363.134)

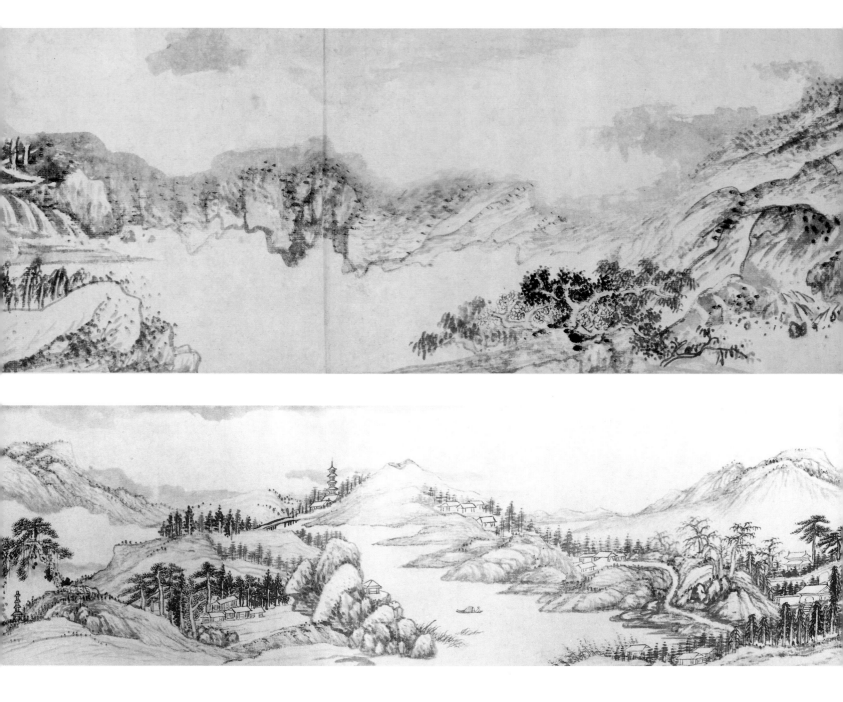

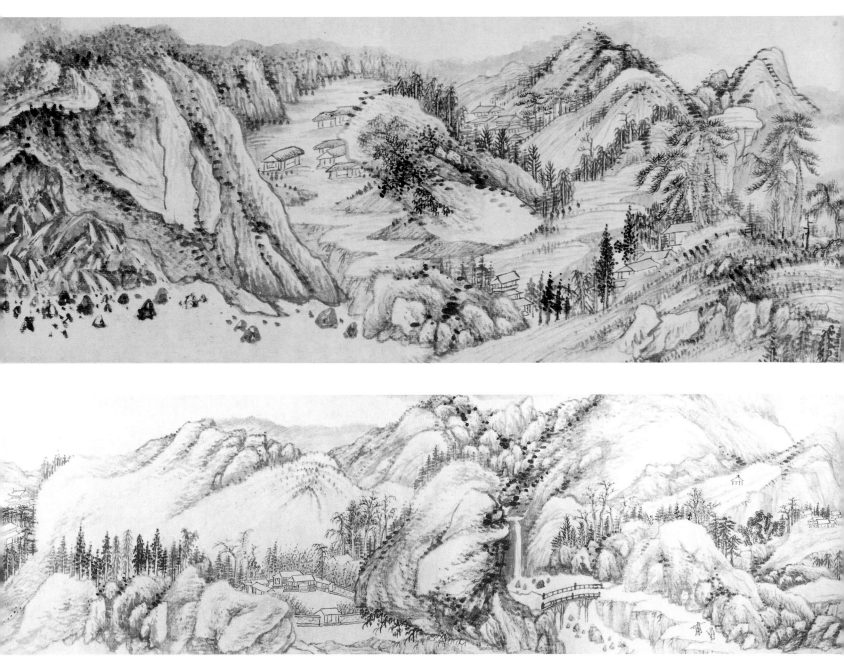

PLATE 3-2 (above) Liu Yu. *Remote Valleys and Deep Forests*, dated 1678 **FIGURE 13-2** (below) Liu Yu. *Landscape*, dated 1680

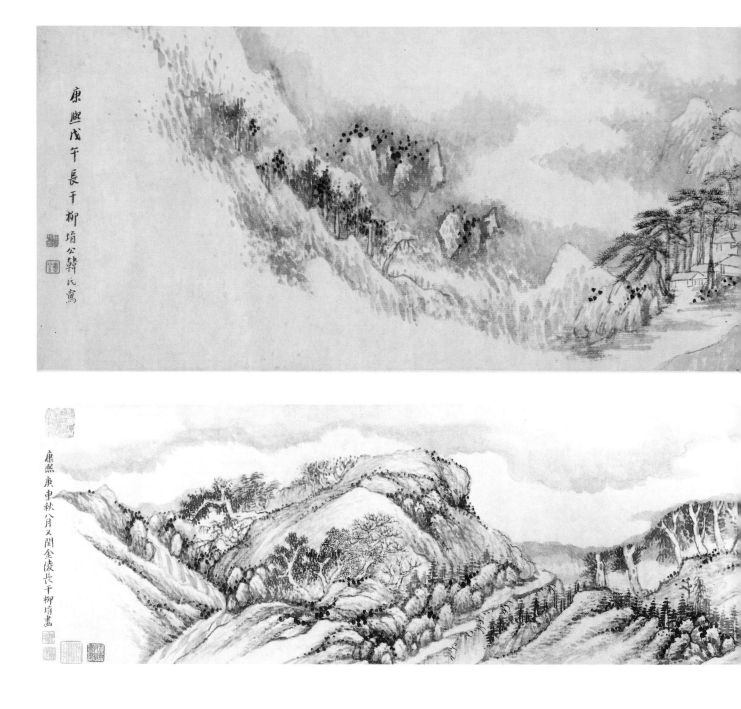

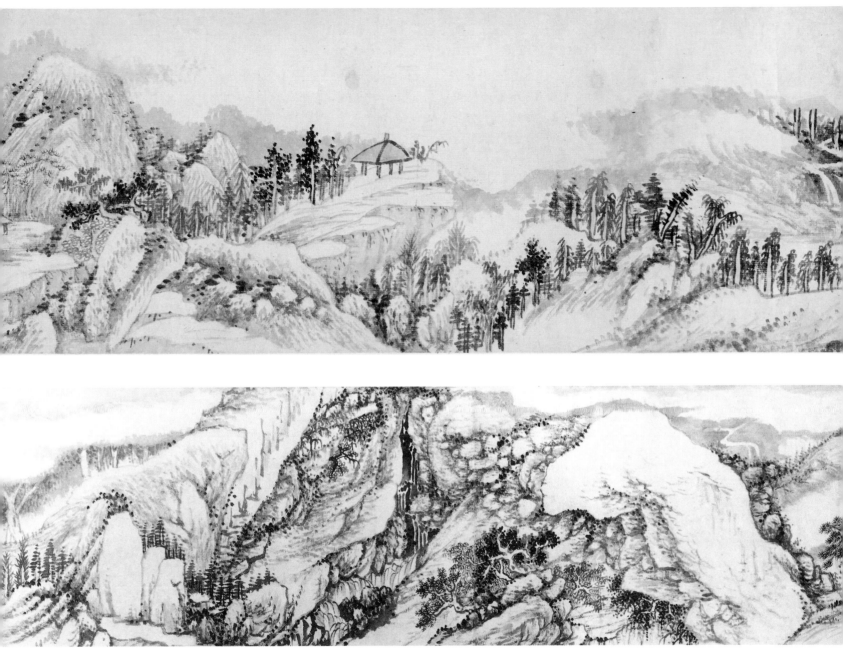

PLATE 3-3 (above) Liu Yu. *Remote Valleys and Deep Forests*, dated 1678 **FIGURE 13-3** (below) Liu Yu. *Landscape*, dated 1680

A grove of tall pines growing from a foreground hill dominates the next segment of the scroll. The largest pine shelters a small pagoda-shaped pillar of the type that might have been used to commemorate a Buddhist holy man. A similar pine and pillar appear in the Crawford painting (see fig. 13). Liu juxtaposes the pines with a cluster of small buildings partially obscured by the hill. This sudden shift in scale is a device Liu employs repeatedly for dramatic effect, both here and in the Crawford scroll. A similar distortion of space and scale occurs in Liu's treatment of the mountain behind this cluster of structures, where a ring of peaks forms a circular "space cell" enclosing two high valleys. At the base of the space cell is a dwelling with a two-story tower. This prominent structure marks the point from which the two valleys diverge. The right valley ends with an imposing temple complex; the left valley opens into a broad space dotted with a half dozen thatched houses. But the scale of these distant houses is larger than that of the foreground tower. This studied amateurism seems intended to convey Liu's "scholarly spirit," which led him to disregard concerns of descriptive realism in favor of calligraphic self-expression.

The succeeding passage presents another shift in scale as a seemingly tall mountain suddenly becomes one side of a large foreground grotto from which a stream emerges in numerous rivulets. Liu's rather stiff treatment of the cascading water corroborates the critic and collector Qin Zuyong's (1825–1884) assessment of Liu's work:

> Liu Yu's brush manner is relaxed and elegant, and readily avoids vulgarity. I once owned a long handscroll of mountains and valleys [which possessed] endless transformations and whose forests, trees, mountains, and rocks were all without mannerisms. Only the streams and waterfalls were unnatural and had a forced appearance. Regarding the art [of painting], even Huang Gongwang, let alone an ordinary painter, would consider it difficult.[53]

The large trees to the left of the grotto confirm its proximity to the viewer. The grotto, with its upwelling spring and suggestion of hidden Daoist paradises, creates a dramatic crescendo at the center of the composition.

The remainder of the scroll presents quieter, more intimate scenes in which distant terrain features are largely obscured by banks of clouds. Immediately to the left of the

grotto is a quiet pool, its distant shore seemingly suspended between the blank surface of the water and the similarly blank clouds above. The ambiguity of this outcrop is only relieved when the eye travels leftward to where a mountain stream cascades into view, making it clear that the lower expanse of empty paper is to be read as water—not sky. A tree-lined spit of land, which embraces the pool from the left, draws the eye toward a promontory topped by a simple pavilion—a motif made famous by the fourteenth-century recluse-painter Ni Zan. The pavilion is the harbinger of another dwelling place, this one set on a level clearing surrounded by a grove of pines. Above this elegant residence the clouds part briefly to reveal higher mountains before again closing off the distant view. The scroll ends with a final upward sweep of mountain, where rocky out-crops, trees, and stippled slopes are sketchily revealed before disappearing one final time into the mist. There Liu Yu has added his terse inscription: "Painted in the *wuwu* year of the Kangxi reign era [1678] by Liu Yu, Gonghan, of Changgan [Nanjing]."

The style of *Remote Valleys and Deep Forests* draws significantly on the painting manners of both Gong Xian and Wang Hui. Liu's reliance on dry linear brushwork set off by dark texture dots recalls Gong Xian's style of the 1660s and 1670s, before Gong's paintings became darker and more densely textured (see fig. 12). But Liu's works are more firmly rooted in traditional idioms and compositional types than Gong's. Liu draws heavily upon the landscape motifs and brush idioms associated with Dong Yuan and Juran, the tenth-century masters whom Dong Qichang placed at the apex of his Orthodox lineage, and Dong Qichang's most revered Yuan-dynasty inheritor of this tradition, Huang Gongwang. These artists were also the preeminent models for Wang Hui's painting style of the 1670s (see fig. 8), when Wang painted numerous large-scale compositions, inclu-ding long handscrolls inspired by Huang Gongwang's *Dwelling in the Fuchun Mountains* and other monumental landscape compositions.[54] In Liu's scroll, the salient motifs all derive from Orthodox school interpretations of Huang's style in which conical peaks, set off by clusters of round boulders and interspersed with flat plateaux, are defined with long, parallel hemp-fiber texture strokes accented with foliage dots. Liu's trees are of the same conventionalized form as those in the works of Wang Hui and Dong Qichang, in which distant groves and foreground shrubs appear identical.

Yet Liu's integration of Orthodox and individualist stylistic sources is also tempered by his playful shifts in scale and abundant use of houses, temples, and other narrative

details. Like other Nanjing masters of this time, Liu's commitment to calligraphic abstraction was balanced by the desire to make his pictures visually appealing. In the Weill painting he has succeeded in creating a landscape that engages viewers and transports them to another world.

DAI BENXIAO

Dai Benxiao (1621–1693) was born in Hezhou (present-day He Xian), Anhui Province, a town located on the north shore of the Yangzi River about thirty miles west of Nanjing, where his ancestors had been members of the local gentry since the founding of the Ming dynasty.[55] Perhaps anticipating the peasant unrest that accompanied the disintegration of the Ming dynasty, Dai's father, Dai Zhong (1602–1646), moved the family to Nanjing in about 1632, remaining there for five years. In Nanjing he became a political activist, joining the reform-minded Fushe (Revival Society). After 1637 the family relocated several times within the region, but Dai Zhong remained politically active, accepting a post from the Nanjing court of the Ming Prince of Fu after Beijing fell to the Manchus in 1644. When Nanjing surrendered to Manchu forces in mid-1645 Dai Zhong and his family were in the Wuxing area, where Dai helped to lead a local resistance effort during which he was wounded. Returning to Hezhou with Dai Benxiao's help, Dai Zhong became a monk, but fearing that he would be accused of ignobly saving his own life, he starved himself to death.

Nothing is known of Dai Benxiao's life for more than a decade following the Manchu conquest of China, but by 1660 he had begun to support himself through painting, which led him to meet other artists and visit some of China's scenic mountains. In 1662 he visited Mount Huang, in Anhui Province, and attended a gathering in nearby She Xian that included the leading local painter Hongren (1610–1664), whose depictions of Mount Huang had made its scenic attractions famous. In 1666 Dai traveled to Beijing, visiting Mount Tai, the eastern sacred mountain, in Shandong Province, on his way north. During his stay in Beijing, he became acquainted with the poet Wang Shizhen (1634–1711).[56] In 1668 he left the capital to climb Mount Hua, the sacred mountain of the west, in Shaanxi Province, stopping en route in Taiyuan to visit the famous Ming loyalist painter and calligrapher Fu Shan (1605–1690). After returning to his native region, Dai was a frequent visitor to Nanjing, where he became acquainted with the painter Gong Xian and

PLATE 4a Detail, pl. 4

Gong's patron, the playwright Kong Shangren (1648–1715), as well as the monk-painter Shitao, who lived at a Buddhist temple near Nanjing from 1680 to 1687.

Not surprisingly, Dai Benxiao's art reflects a strong shared aesthetic and spiritual bond with the leading loyalist artists active in Anhui and Nanjing, particularly Hongren, Gong Xian, and Shitao. Like these masters, Dai's painting style is characterized by a reliance on dry, linear brushwork with little or no color or wash. Similarly, Dai distanced himself from the Orthodox school practice of deriving inspiration from the close study of antique models; instead, he based his painting style on his spiritual encounters with actual landscape scenery and his own creative powers:

> When I start to apply the brush in painting, I never have any pre-existing, completed vision [of what I will paint]—I let [my hand] go free, to start or stop on its own.[57]

The Strange Pines of Mount Tiantai (pl. 4), dated 1687, a large-scale composition of great complexity, is typical of Dai's mature style. It presents an imaginary depiction of Mount Tiantai (Heavenly Terrace Mountain) in Zhejiang Province, a place of refuge for Buddhist and Daoist holy men since at least the fourth century and the legendary dwelling place of the Five Hundred Luohans, representatives of the Buddha who chose to remain in the world to safeguard the Buddhist Law.[58] The mountain's natural stone bridge, featured prominently in Dai's image, is a fabled point of connection between this world and the paradise of the immortals. Legend has it that anyone who succeeds in crossing this bridge immediately attains enlightenment, but this task is made difficult by the narrowness of the arch, its slippery surface, dampened by the mists rising from the waterfall below, and the presence of a large rock at one side of the arch, which creates an additional barrier.[59] Dai's image is not a realistic depiction of the site, which he may not have visited; rather, it is a fanciful re-creation based on earlier depictions and his own imagination. The bridge, pathway, and stone-cut stairs leading to a grotto at the left all draw the viewer into the scene. Above the grotto two figures stand beside what may be a boulder or perhaps another opening at the base of the stone bridge (pl. 4a). This ambiguity between solid and void is not only a conscious effect found elsewhere in Dai's work but has special significance in relation to this site: an earlier visitor, the fourth-century monk Tanyou, found that when he attempted to cross the bridge a large hole

PLATE 4 Dai Benxiao (1621–1693). *The Strange Pines of Mount Tiantai*, dated 1687. Hanging scroll, ink on paper, 67 ¼ × 30 in. (170.8 × 76.2 cm). The Metropolitan Museum of Art. Gift of Marie-Hélène and Guy Weill, in honor of Douglas Dillon, 1991 (1991.256)

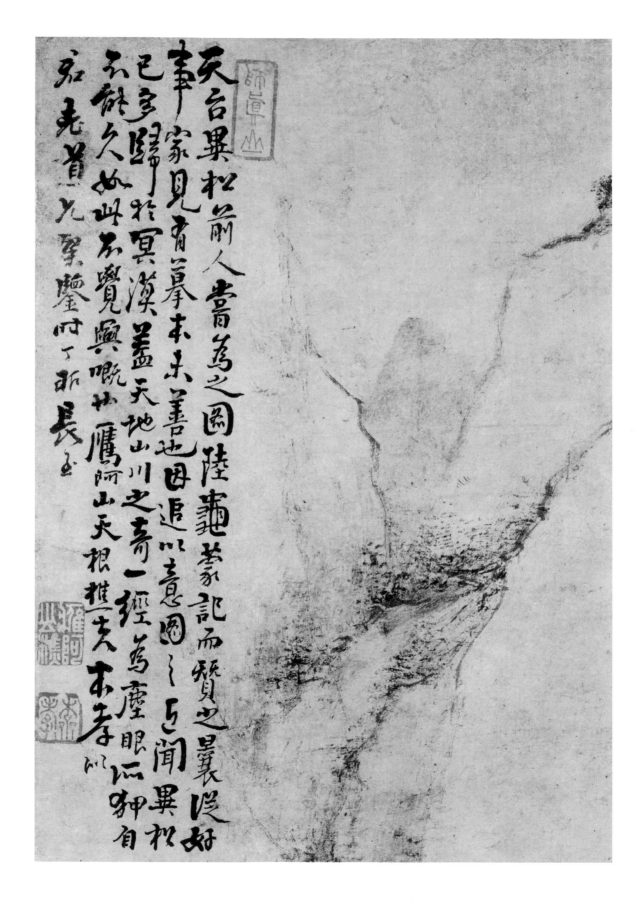

天台異松前人嘗為之圖陸龜蒙蓋家記而預賀之曼脩姓好
事家見青華末未善此也因追以意圖之亦聞異松
已多歸於冥漠蓋天地山川之青一經萬塵眼而無自
不餘久如此亦覺興願也鴈阿山天根抴其本李以
宏光首先寫鑒於丁卯長至

suddenly opened to reveal a Buddhist paradise; when he recrossed the bridge and looked back, he saw only the solid rock face.[60] A second stairway, higher up, leads to a structure —presumably one of the mountain's Buddhist temples. Nearby, a thatched pavilion perched atop a tall escarpment offers a high vantage point for viewing the arch. Another empty pavilion stands atop a pinnacle that rises along the right side of the painting.

The traces of man's presence have been pushed to the borders of Dai's composition; the real focus of the painting is the contorted pines that cling to the cliffs around the stone arch.[61] Symbolic of survival in times of adversity, the mountain's suddenly threatened pines reflect the artist's uncertainty at being able to find a spiritual sanctuary in a world from which he feels alienated, as he makes clear in his inscription (pl. 4b):

> The strangely shaped pine trees of Mount Tiantai have been depicted
> by artists of previous periods. Lu Guimeng [of the Tang dynasty] has
> recorded and written a eulogy for one of these paintings. I have seen a
> copy of this painting at the home of a collector and was not impressed
> by it. Therefore I have decided to portray this theme drawing upon
> my own imagination. I have heard recently that most of these strange
> pines have met the sad fate of extinction. It seems that once the natural
> wonders of the sky, earth, mountains, and rivers are exposed to the
> intimate scrutiny of the dusty world, they do not last long. This is indeed
> cause for lamentation. [Dai] Benxiao, Heavenly Root Gatherer of Mount
> Ying'a, did this for the amusement of old Jun, my elder brother in the
> Way. On the summer solstice of the dingmao year [June 21, 1687].[62]

As with Hongren, who immortalized the craggy pines of Mount Huang (fig. 15), Dai Benxiao's pines (pl. 4c) seem to represent the tortured survivors of the Manchu conquest, the courageous few who had clung to China's soil in a vain effort to resist the encroachments of the Manchus. In Dai's treatment, the impossibly twisted and contorted trees cling precariously to the stony walls of the mountain, their survival as unlikely as the quest to achieve immortality by crossing the bridge. Like Dai's father and other Ming loyalists, the pines are trapped in a world that is beyond their control, with no hope of restoring the old order or attaining the paradise promised beyond the arch.

PLATE 4b Detail, pl. 4. Dai Benxiao (1621–1693) inscription, dated 1687

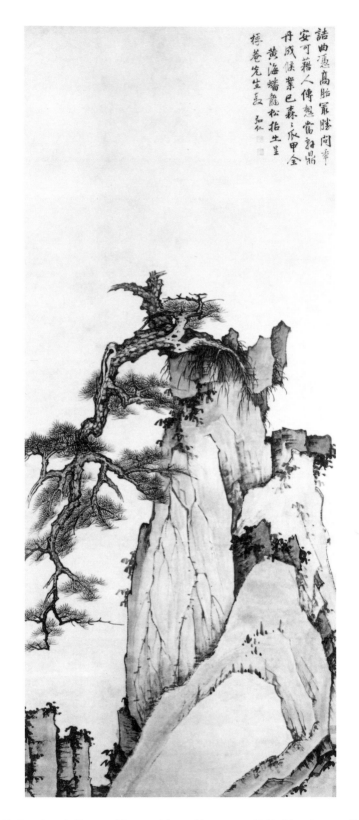

FIGURE 15 Hongren (1610–1664). *Dragon Pine on Mount Huang,* ca. 1660. Hanging scroll, ink and pale color on paper, 75 ⅞ × 31 ¼ in. (192.7 × 97.4 cm). The Metropolitan Museum of Art. Gift of Douglas Dillon, 1976 (1976.1.2)
PLATE 4c Detail, pl. 4

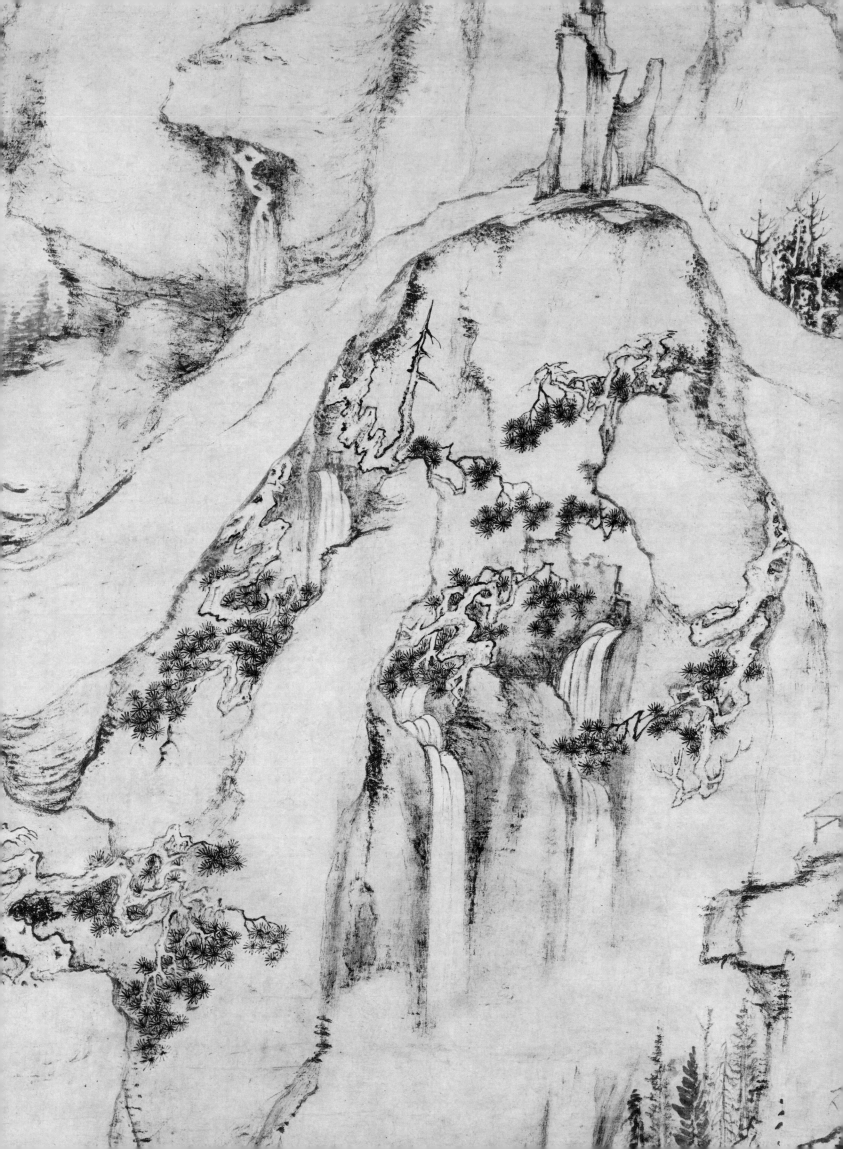

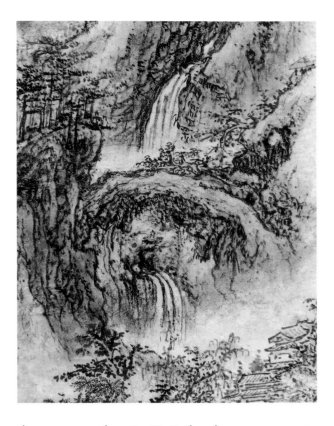

The landscape, an extension of the interior world of the artist, is embedded with other attributes of an escapist vision that were current at the time. Stone arches appear in the works of other loyalists that Dai would have known, including those of Kuncan (fig. 16) and Zhang Feng (fig. 17). Dai has also endowed his landscape with a grotto hung with stalactites, a reference to Daoist "cave-heavens" (see pl. 4a); a pavilion and temple that offer shelter; and waters that gush forth from the mountain's depths, as they do from the cavern in Liu Yu's landscape (see pl. 3-2), offering the promise of renewal. But the two travelers in Dai's landscape are not a comforting presence; one stares directly out of the painting, confronting the viewer with a cryptic expression that imparts a note of uncertainty to the image.

The style of Dai's painting is similarly disorienting. He has created a convoluted and ambiguous space through the piling up of twisting and overlapping forms, defined principally by contours with a minimum of texture strokes or interior shading. Despite the visual complexity of the composition, the forms, drawn in outlines of nearly transparent dry ink, evoke almost no sense of mass. As James Cahill has observed, Dai's style dematerializes landscape forms and may be read as a "visual metaphor for the same theme of disengagement from present reality that underlies [his imagery]."[63]

Dai's unique style is a fusion of disparate influences. While he employs the dry, linear brushwork characteristic of the Anhui masters with whom he is often linked—a style Fu Shen has identified as a common attribute of many Ming loyalist artists and one that may be traced back to the Yuan painter Ni Zan—Dai has not adopted the spare, angular forms associated with Hongren and other painters inspired by Mount Huang.[64] Instead, he has combined an austere use of ink with a preference for dense, visually complex composi-

FIGURE 16 Kuncan (1612–1673). *Wooded Mountains at Dusk,* dated 1666. Hanging scroll, ink and color on paper, 49¾ × 23⅞ in. (126.2 × 60.6 cm). The Metropolitan Museum of Art. Bequest of John M. Crawford Jr., 1988 (1989.363.129). Detail

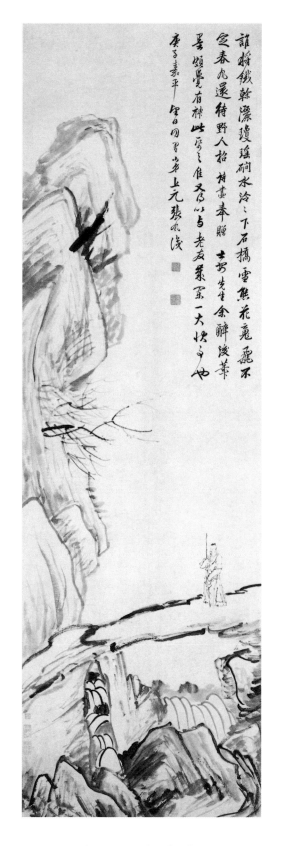

FIGURE 17 Zhang Feng (active ca. 1636–62). *The Stone Bridge,* dated 1661. Hanging scroll, ink on paper, 60 × 18 ¼ in. (153 × 46.4 cm). The Metropolitan Museum of Art. Ex. Coll.: C.C. Wang Family, Purchase, Friends of Asian Art Gifts, The Dillon Fund Gift and Anonymous Gift, 1993 (1993.202)

tions that recall the convoluted landscapes of Gong Xian as well as those of the late-Yuan master Wang Meng.[65] Dai's preference for kinesthetic forms and abstract compositional movement is inspired by Dong Qichang, but his interlocking assemblage of unstable picture elements, each animated by its own leaning, folding, or twisting form, goes beyond anything ever attempted by Dong.[66] More distinctively, Dai's raspy brushwork and pale ink temper the harshness of his dynamic forms while his references to actual topography, inclusion of figures and dwelling places, and evocation of atmosphere make his landscapes both more otherworldly and more inviting than Dong's. In the end Dai reveals himself to be a visionary artist whose dreamlike images, delicate drawing, and subtle handling of ink entice and hold the attention of the viewer.

MEI QING

Mei Qing (1624–1697), a leading artist from Xuancheng, Anhui, derived artistic inspiration from three distinct sources: the dramatic topography of Mount Huang, which he visited in 1671 and 1690; the innovative painting style of the monk-artist Shitao (1642–1707), who resided in Xuancheng from 1666 to 1680; and the study of ancient masters, as exemplified by the album in the Weill Collection (pl. 5).[67]

Mei Qing was born into an extended family of prominent local gentry living in the city of Xuancheng, situated south of the Yangzi River about seventy-five miles south of Nanjing.[68] The Mei clan established itself in Xuancheng in the late-Tang period and thereafter produced a succession of high-level government officials and renowned scholars, including the Song poet Mei Yaochen (1002–1060) and the Ming dramatist and bibliophile Mei Dingzuo (1549–1618).[69] The clan's ancestral home was located about twenty-five miles south of the city, at Bojian Shankou, a scenic area between Mount Bojian and Mount Huayang. Mei Qing's grandfather, Mei Shouji (*juren* degree, 1576) moved the family residence to the eastern part of the city proper, and it was there that Mei Qing was born, the fourth of five sons.[70] Because his father died when he was still very young, Mei Qing, along with his brothers, was raised and educated at Huangchi, another family residence about thirty miles northwest of the city.

Mei followed the family tradition of scholarship. By the age of sixteen he had returned to Xuancheng, where he was a prefectural level "government student" (*zhusheng*), and

PLATE 5d Detail

in 1642 he published his first collection of poems, *Collection from a Farmer's Garden* (*Jiayuan ji*).[71] This publication appeared shortly after his family had moved to Jiayuan (Farmer's Garden), a rural village one mile east of town—a move that enabled them to avoid the turmoil that accompanied the disintegration of the Ming dynasty and subsequent occupation of Xuancheng by Manchu troops in 1645.

During the first decade of the Qing dynasty Mei Qing lived in retirement. In 1649 he moved his residence to Xintian (New Fields) near the clan's ancestral home, where he devoted himself to poetry and painting. In describing Mei's surroundings, his friend Qian Guangxiu wrote: "This year I passed by his retreat at New Fields. The distant peak had the seat of honor and swift streams were at the gate. Shadows from the trees and the songs of the birds confused what was up and what was down. There was no place he did not paint and no time he did not compose poetry."[72] Mei's earliest extant paintings date to the year of his move to Xintian (fig. 18).[73]

This idyllic period of seclusion came to end when Mei Qing decided to pursue an official career, a resolution that was probably strengthened by the success of his close friend and fellow townsman Shi Runzhang (1619–1683), who earned his "presented scholar" (*jinshi*) degree in 1649.[74] In 1654 Mei moved to another family property closer to the city, Green Tranquility Pavilion (Pinglü Ge) at Wandong (East of Wan [Wan is an old name for Xuancheng]), which he later renamed Heavenly Longevity Pavilion (Tianyan Ge).[75] Setting aside whatever misgivings he may have had about serving the Manchus, in 1654 Mei passed the provincial level (*juren*) civil service examination and traveled to Beijing in order to take the *jinshi* examinations held in the capital the following spring. During the next thirteen years Mei traveled to Beijing four times to attempt this examination. After his fourth failure, in 1667, he abandoned hope for official advancement and returned to Xuancheng, where he lived until his death in 1697.

After returning home, Mei remained involved in local scholarly pursuits; he was an active member in a local poetry and painting society and published two volumes of poetry, *Selected Poems from the Heavenly Longevity Pavilion* (*Tianyan Ge shanhou shi*), of 1671, a collection of his own poems, with a preface by Shi Runzhang, and *Mei's Poetry Selections* (*Meishi shilue*), of 1691, an anthology of one hundred eight poets of the Tang through the Ming, with a preface by the renowned poet Wang Shizhen. Mei also participated in the compilation of several local histories: *Gazetteer of Xuancheng*

(*Wanling zhi*), published in 1673; *Sequel to the Gazetteer of Xuancheng* (*Wanling xuzhi*); *Complete Gazetteer of Jiangnan* (*Jiangnan tongzhi*); and *Prefectural Gazetteer of Xuancheng* (*Xuancheng xianzhi*), published in 1686.[76] Mei also traveled widely, visiting scenic mountains and cultural centers. In 1670 he visited Mount Tai; the following year he climbed Mount Huang for the first time. In subsequent years Mei visited some of the urban centers in the region, including Nanjing, Suzhou, Hangzhou, and Yangzhou, and in 1691 made a last trip to Beijing.

Mei Qing's early interest in painting may be seen as a natural outgrowth of his passion for poetry and his lifelong exposure to natural scenery. His earliest extant work, *Strolling in a Misty Valley* (fig. 18), was done in the autumn of 1649, shortly after he moved to his new residence in the scenic area around Mount Bojian. The painting shows him working in the dry, linear style typical of many late-Ming painters, with angular rock formations and craggy pines loosely organized along a serpentine stream. The style vaguely recalls the work of the Yuan master Huang Gongwang, but owes much more to the local Anhui manner, particularly that found in images of Mount Huang, which Mei was not to visit for another twenty-two years.[77] A ten-leaf album of local scenery (fig. 19), dated 1657, possibly painted for his clansman Mei Chong (active late 17th century), shows Mei Qing experimenting with a more varied range of brush styles and employing landscape forms exaggerated for dramatic effect, but his basic repertoire of motifs and brush techniques has changed little except for the occasional application of light ink washes to soften the linear quality of the drawing.[78]

The expressive quality of Mei Qing's art was dramatically enhanced after he became acquainted with Shitao, who moved to Xuancheng in 1666. Shitao resided at the Guangjiao Temple, three miles north of the city at Mount Jingting, where the Mei family also had property. In 1667, the year he returned from Beijing after his final unsuccessful attempt at the *jinshi* examination, Mei inscribed Shitao's early masterpiece, *The Sixteen Luohans* (fig. 20).[79] Although Shitao was eighteen years his junior, Mei indicates in his colophon that Shitao's painting had an immense impact on him and that he had already become an ardent admirer of the young monk's art:

> *Among the inspired practitioners of monochrome drawing* (baimiao),
> *the very best is Longmian* [*Li Gonglin, ca. 1041–1106*]. *Most* [*works*

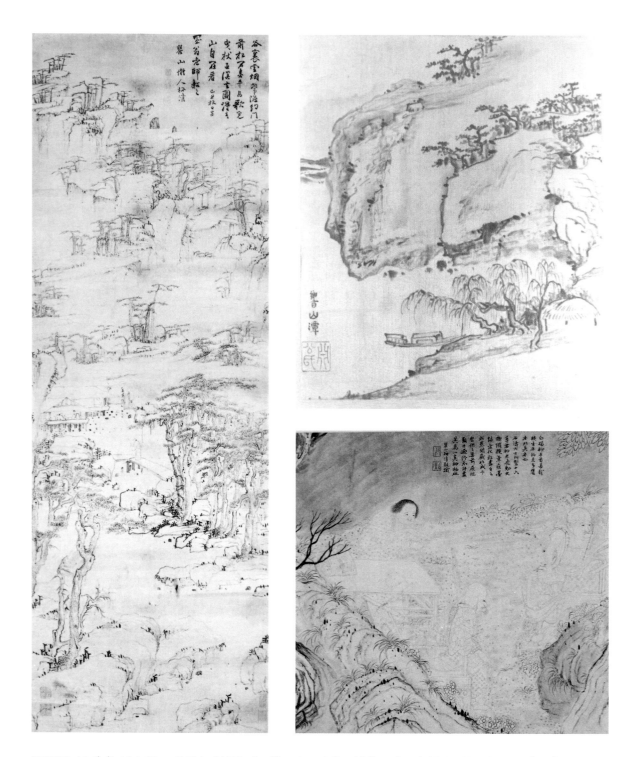

FIGURE 18 (left) Mei Qing (1624–1697). *Strolling in a Misty Valley*, dated 1649. Hanging scroll, ink on satin, 61 ¾ × 20 ½ in. (156.8 × 52.1 cm). The Metropolitan Museum of Art. Purchase, Soong Family Gift, in memory of Dr. T. V. Soong, 1994 (1994.284) FIGURE 19 (top right) Mei Qing (1624–1697). *Ten Views of Wanling*, dated 1657. Album of ten paintings and a one-leaf artist's postscript, ink and color on satin, 10 ⅛ × 8 ⁷/₁₆ in. (25.7 × 21.5 cm). Tang Family Trust Collection. Detail. Leaf E, "Echo Hill" FIGURE 20 (bottom right) Shitao (1642–1707). *The Sixteen Luohans*, dated 1667. Handscroll, ink on paper, 18 ¼ × 235 ⁵/₁₆ in. (46.4 × 597.8 cm). The Metropolitan Museum of Art. Gift of Douglas Dillon, 1985 (1985.227.1) Detail with Mei Qing (1624–1697) inscription

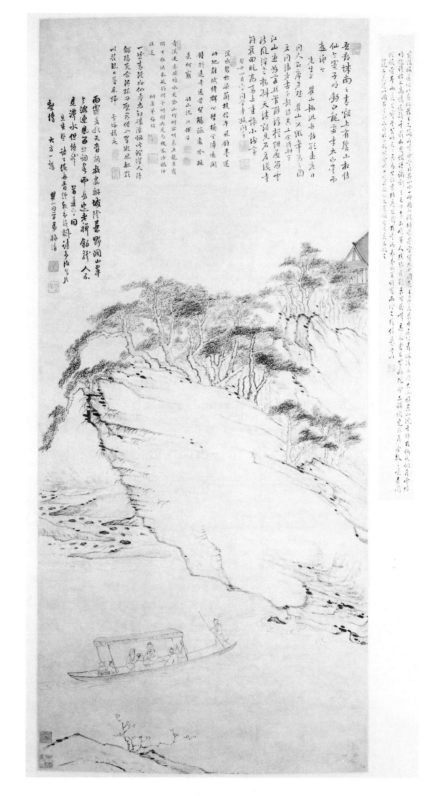

FIGURE 21 Mei Qing (1624–1697). *Boating Beneath Echo Hill*, datable to 1673. Hanging scroll, ink on paper, 53 × 23 ¼ in. (134.6 × 59 cm). Inscribed by the artist and by Shi Runzhang (1619–1683; dated May 21, 1673), Shen Bi, Mei Jun, and Mei Geng (1640–after 1716). The Metropolitan Museum of Art. Gift of Sandy A. Mactaggart, 2002 (2002.208.1)

attributed to him] that I have seen are imitations, not authentic. Master
Shitao's Sixteen Luohans *[possesses] exquisite detail, bravura [brush]*
movements, a divinely interesting composition, and brushwork and ink
washes that almost exhaust [the possibilities of] creative metamorphosis.
He said that this handscroll took one year from start to finish. I have set
it out on my table and admired it tens of times, but I have never been
able to exhaust one ten-thousandth [of its richness].

Shitao remained in Xuancheng until 1680, and during the years he lived there Mei Qing
often visited him.[80] Shitao's enthusiasm for the scenery of Mount Huang, which he visited
in 1668 and again in 1670, undoubtedly inspired Mei Qing to visit the mountain for the
first time in 1671. Mei was directly inspired by Shitao's images of the mountain, as he
makes clear in several inscriptions accompanying paintings that, he notes, copy images
made by Shitao.[81]

The impact of Shitao's style is immediately apparent in Mei's *Boating Beneath Echo
Hill* (fig. 21), which bears a colophon by Shi Runzhang dated May 21, 1673. Mei had
painted the same site—located on the Wan River just south of the city of Xuancheng—
in his album of 1657 (see fig. 19), but the 1673 painting shows him employing a more
daring compositional organization in which a few bold forms are used to create a series
of opposed diagonals. A similar visual tension is created through the juxtaposition of
densely brushed details with areas of blank paper. Finally, Mei uses a dramatic range of
ink tonalities, from the sooty black foliage dots to the transparent rock textures done in
raspy dry ink. All of these effects serve to destabilize the image and animate it with a
sense of kinetic energy.[82]

By 1675 Mei's reputation as an artist had spread beyond his home region. In the third
lunar month of that year, the collector and connoisseur Xu Qianxue (1631–1694) invited
Mei and his grandnephew Mei Geng (1640–after 1716) to Kunshan, in Jiangsu Province,
as his guests. He then asked Mei for a depiction of his newly completed Tranquil Garden
(Dan Yuan).[83] Two months later, Mei painted a landscape for the Suzhou artist Gao Jian
(1634–ca. 1708).[84] In the course of his travels Mei also made the acquaintance of other
prominent artists, including Cheng Sui (1605–1691), Gong Xian, and Wang Hui.

In spite of the early recognition of his artistry, Mei's most prolific period, judging from
his extant dated works, was from 1690 to 1695, in the last decade of his life. In 1690

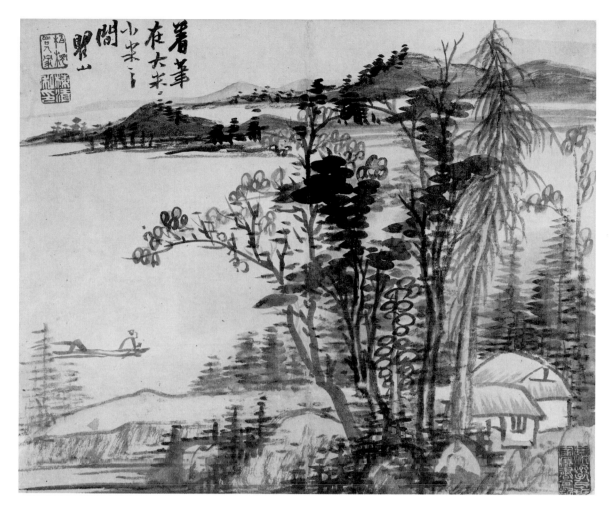

PLATE 5a Mei Qing (1624–1697). *Landscape in the Manner of Mi Fu [1052–1107] and Mi Youren [1074–1151]*. Ink and color on paper. Leaf A from *Landscapes after Ancient Masters for Zeweng*, dated 1693. Album of twelve paintings and a one-leaf artist's postscript, 9 ¾ × 11 ¾ in. (24.8 × 29.8 cm). The Metropolitan Museum of Art. Promised Gift of Marie-Hélène and Guy Weill

Mei made a second trip to Mount Huang, and his paintings following this visit, including some large-scale hanging scrolls and multipanel sets of scrolls that form a continuous composition, often take the scenery of Mount Huang as their subject. Yet Mei worked best in the intimate format of the album, returning again and again to a familiar set of compositional types, which he varied slightly in each execution.

In addition to drawing on the scenery of Mount Huang for inspiration, a number of Mei Qing's paintings from this period present his highly personal interpretations of the old masters. The Weill album (pl. 5), executed in the tenth lunar month (October 29– November 26) of 1693, when Mei was sixty-nine (seventy *sui*) and at the height of his

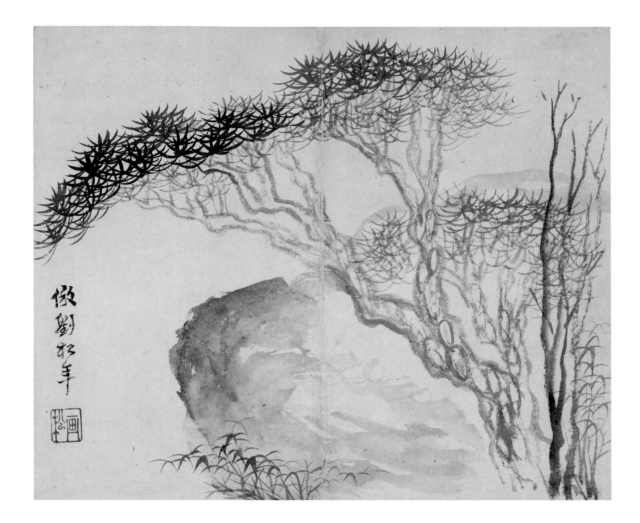

artistic powers, demonstrates that, whatever his knowledge of earlier styles may have been, at this stage in his career he preferred to treat his models creatively—as points of departure for his own original compositions.

Each of the twelve leaves of painting bears a brief inscription in which Mei Qing identifies the particular master who inspired him. Mei followed this same formula in a number of albums painted in the early 1690s, which suggests that such demonstrations of an artist's command of antique styles was much in demand at the time. In some instances Mei reuses the same compositions with only minor variations. A careful comparison of leaves in the Weill album with similar images from other works of the period reveals how Mei creatively modifies his basic repertoire of styles just as a calligrapher might vary the way in which he writes the same character. In the Weill album, Mei further

PLATE 5b Mei Qing (1624–1697). *Landscape after Liu Songnian* [*active ca. 1175–after 1207*]. Ink on paper. Leaf B from *Landscapes after Ancient Masters for Zeweng*, dated 1693. Album of twelve paintings and a one-leaf artist's postscript, 9 ¾ × 11 ¾ in. (24.8 × 29.8 cm). The Metropolitan Museum of Art. Promised Gift of Marie-Hélène and Guy Weill

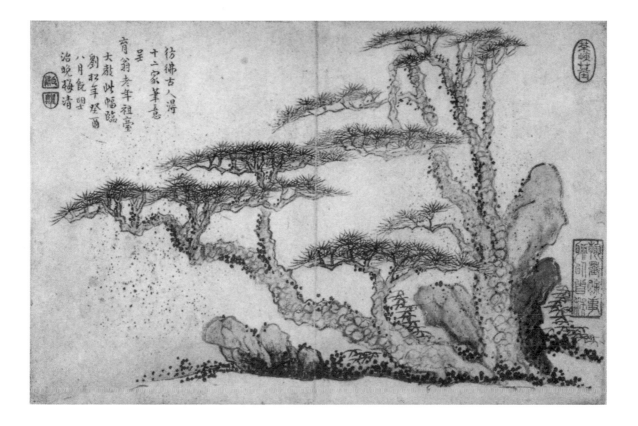

enhances the variety of images by alternating grand panoramas with intimate close-ups and using a different seal on all but one leaf.

In the album's present sequence, the first painting (pl. 5a) derives inspiration from the landscape style of the Song painters Mi Fu and his son Mi Youren (1074–1151), as confirmed by Mei's inscription: "These brushstrokes are between 'Elder Mi' and 'Younger Mi.'" Except for the bold texture dotting defining the foliage and the juxtaposition of tall foreground trees with distant triangular mountains, however, there is little that links the composition to the Mi tradition.

The second painting (pl. 5b) is inspired by the Southern Song academic painter Liu Songnian (active ca. 1175–after 1207). Recalling Liu's meticulous depictions of garden scenery, Mei's painting features a prominent foreground pine tree set off by low clusters of bamboo and a massive boulder. This is a simpler version of a composition that Mei used in a larger-scale album (fig. 22) painted two months earlier, in the eighth lunar month (August 31–September 29). The poet Wang Shizhen particularly appreciated Mei

FIGURE 22 Mei Qing (1624–1697). *Landscape after Liu Songnian* [*active ca. 1175–after 1207*], from an album dated 1693. Album leaf, ink and color on paper, 12 × 17 ⅞ in. (30.5 × 45.4 cm). Shanghai Museum

Qing's depictions of pines. In describing Mei's achievements, Wang wrote: "his poetry was famous in Jiangsu; his landscape paintings attained the marvelous class, and his pines entered the divine class." Wang also wrote that "Mei [Qing's] paintings of pines were the most outstanding under heaven."[85] This pine fully justifies Wang's extravagant praise: the undulating contours of its trunk and branches are vigorous; the swift, swirling movements of its scaly bark are buoyant; and the orchestration of foliage is masterful, with each of the elegantly shaped needles held within a web of graceful arcs that range from jet-black blades to lines as pale and delicate as cobwebs. Mei juxtaposes this suite of linear patterns with the softly washed surfaces of the boulder. Two clusters of bamboo and the stark lines of a bare tree offer a final counterpoint to the exuberant pine. The seal accompanying Mei's inscription, "Painter of pines" (*Hua song*), shows that he was not unconscious of his reputation in this genre.

PLATE 5c Mei Qing (1624–1697). *Landscape after Ma Yuan [active ca. 1190–1225], Jing Hao [active ca. 870–ca. 930], and Guan Tong [active ca. 907–23].* Ink and color on paper. Leaf C from *Landscapes after Ancient Masters for Zeweng,* dated 1693. Album of twelve paintings and a one-leaf artist's postscript, 9¾ × 11¾ in. (24.8 × 29.8 cm). The Metropolitan Museum of Art. Promised Gift of Marie-Hélène and Guy Weill

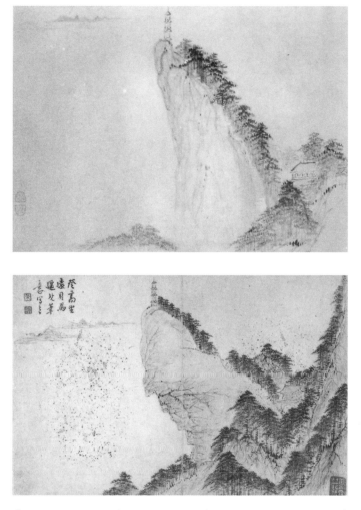

The third painting (pl. 5c), which Mei claims was painted "after Ma Yaofu [Ma Yuan, active ca. 1190–1225] and also imitating Jing [Hao, active ca. 870–ca. 930] and Guan [Tong, active ca. 907–23]," presents a dramatic composition in which a spindly peak crowned by a pagoda is juxtaposed with a broad river. This pinnacle and a second mountain that rises along the left-hand margin of the painting frame a V-shaped valley lined with pine trees and cradling a temple complex. In keeping with the distinctive "one-corner" compositions of Ma Yuan, most of the landscape elements are massed behind the diagonal defined by the river's near shore. Except for Mei's inscription along the right-hand margin and a thin strip of land at the upper edge, the remainder of the composition is given over to the empty expanse of the river, its starkness softened with a pale blue wash, employed perhaps to highlight the white sails of the two boats that hug the near shore. Only the pagoda-topped pinnacle breaks out of this organizational structure, extending upward to intersect with the distant shoreline. Mei, evidently satisfied with the dramatic qualities of this image, had employed a simpler, mirror-image version of the composition in an album dated to the fourth lunar month (May 16–June 14) of 1692 (fig. 23) and a more complex version in the album painted two months prior to this one (fig. 24). In the latter image, Mei also states that he used the brush ideas of Ma Yuan. The most significant difference between that painting and the Weill composition appears to be the texturing patterns. In the earlier leaf, the mountains are described with texture lines that recall the

FIGURE 23 (top) Mei Qing (1624–1697). *Landscape after Ma Yuan [active ca. 1190–1225],* from an album dated 1692. Album leaf, ink and color on paper, 11 3/4 × 16 in. (29.8 × 40.6 cm). Shanghai Museum FIGURE 24 (bottom) Mei Qing (1624–1697). *Landscape after Ma Yuan [active ca. 1190–1225],* from an album dated 1693. Album leaf, ink and color on paper, 12 × 17 7/8 in. (30.5 × 45.4 cm). Shanghai Museum

angular branches of Ma Yuan's plum trees; in the Weill leaf, however, these lines are paler, drier, denser, and less angular—attributes that Mei presumably linked with Jing Hao and Guan Tong. Mei's implausible combination of styles, fusing elements inspired by a leading artist of the Southern Song Academy with traits supposedly derived from two tenth-century patriarchs of the monumental landscape tradition, emphasize his iconoclastic attitude toward any narrowly defined canon of orthodox modes.

The fourth painting (pl. 5d) depicts an intimate scene of quiet contemplation. A gentleman is seated in a small boat floating between two low embankments with willow trees. The figure gazes into the middle distance, where a mountain stream cascades gently into the still waters of the inlet. The contemplative mood is heightened by the pale washes used to describe the landscape elements, effectively suggesting a dense, mist-laden atmosphere that would have muffled distant sounds; only the murmur of the brook

PLATE 5d Mei Qing (1624–1697). *Landscape after Li Cheng [919–967]*. Ink on paper. Leaf D from *Landscapes after Ancient Masters for Zeweng*, dated 1693. Album of twelve paintings and a one-leaf artist's postscript, 9¾ × 11¾ in. (24.8 × 29.8 cm). The Metropolitan Museum of Art. Promised Gift of Marie-Hélène and Guy Weill

FIGURE 25 (top) Mei Qing (1624–1697). *Wilderness Anchorage in the Shade of Willows after Guo Xi [ca. 1000–ca. 1090]*, from an album dated 1693. Album leaf, ink and color on paper, 12 × 17 ⅞ in. (30.5 × 45.4 cm). Shanghai Museum
FIGURE 26 (bottom) Mei Qing (1624–1697). *Landscape*, from an album dated 1695. Album leaf, ink and color on paper, 10 ½ × 13 ⅛ in. (26.7 × 33.3 cm). Shanghai Museum

punctuates the silence. There is little in this landscape scene of southern China to suggest the style of the northern Chinese master Li Cheng (919–967), whom Mei states he is imitating, but the invocation of Li's name immediately calls to mind bleak wintry scenes and brings to Mei's image the chill of early spring, when the willow whips are still naked and moisture rising off the water immediately congeals into an icy fog. A closely related image from the album painted two months earlier (fig. 25) is identified by Mei as "wilderness anchorage in the shade of willows." In that painting he states that he was inspired by the Northern Song master Guo Xi (ca. 1000–ca. 1090). While it shares a number of motifs with the Weill leaf, the painting conveys an entirely different mood: the willow leaves have sprouted, and there is neither a distant stream nor the veiling mist that gives the Weill leaf its contemplative mood and icy chill. Mei Qing produced yet an-

PLATE 5e Mei Qing (1624–1697). *Landscape after Fan Kuan [active ca. 990–1030].* Ink on paper. Leaf E from *Landscapes after Ancient Masters for Zeweng,* dated 1693. Album of twelve paintings and a one-leaf artist's postscript, 9 ¾ × 11 ¾ in. (24.8 × 29.8 cm). The Metropolitan Museum of Art. Promised Gift of Marie-Hélène and Guy Weill

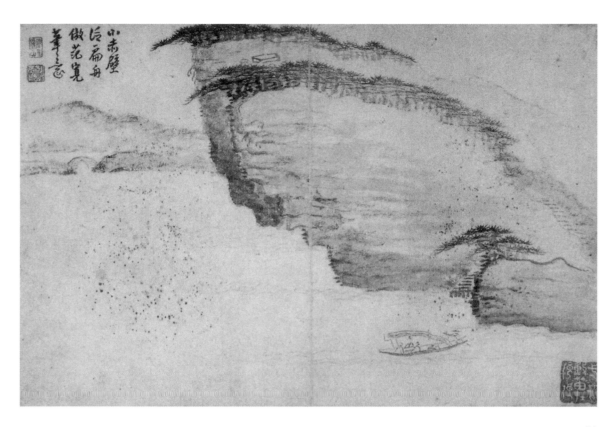

other related image in the first lunar month (February 13 – March 14) of 1695 (fig. 26).[86]
On that painting he also added a poem:

> A lone boat anchors and does not leave,
> In the green shade west of the tall willows.
> The single sound of a long whistle,
> As wintry mist spreads over evening waves.[87]

The fifth painting (pl. 5e) is inspired by another northern master of monumental land-
scape, Fan Kuan (active ca. 990 – 1030). The standard image of Fan Kuan for seventeenth-
century painters was a landscape of massive granitic peaks topped with densely foliated
scrubby trees. Mei Qing employed these motifs in an evocation of Fan's style in the album
painted two months earlier, conflating Fan's stylistic traits with his familiar image of Echo
Hill (fig. 27; see also figs. 19 and 21). Here, Mei is more original. He thrusts the viewer
into the midst of a barren mountainscape composed of outcrops, cliffs, and distant peaks.
A small pavilion crowns the massive central escarpment, but there are no trails leading

FIGURE 27 Mei Qing (1624 – 1697). *Landscape after Fan Kuan [active ca. 990 – 1030]*, from an album dated 1693.
Album leaf, ink and color on paper, 12 × 17⅞ in. (30.5 × 45.4 cm). Shanghai Museum

to that structure nor anywhere else in this craggy, inhospitable scene. Only the cluster of trees that has grown up among the boulders softens the harshness of Mei's image. The trees and the pavilion also serve to bring a more human scale to the scenery, tempering the monumentality of Fan's landscape style. The rugged textures of the rock surfaces are effectively modeled by layers of light and dark contour lines, dots, and ink washes that in some places appear to function almost like chiaroscuro shading. The strongly calligraphic brushwork and powerful forms of the densely textured rocks and individualized trees — with their distinctive foliage patterns or wispy bare branches — are reminiscent of Gong Xian's works (see fig. 12), which Mei Qing would undoubtedly have encountered on his visits to Nanjing in the 1670s.

The sixth painting (pl. 5f), in which Mei Qing invokes the manner of the Yuan scholar-recluse Wu Zhen, presents a striking contrast to the dense linear brushwork and monu-

PLATE 5f Mei Qing (1624–1697). *Landscape after Wu Zhen [1280–1354]*. Ink on paper. Leaf F from *Landscapes after Ancient Masters for Zeweng*, dated 1693. Album of twelve paintings and a one-leaf artist's postscript, 9 ¾ × 11 ¾ in. (24.8 × 29.8 cm). The Metropolitan Museum of Art. Promised Gift of Marie-Hélène and Guy Weill

CULTIVATED LANDSCAPES

mental imagery of the preceding leaf. Two figures, a *qin* player and his companion, are seated on a promontory, silhouetted against a watery expanse that fills the majority of the composition. Their isolation is reinforced by an array of foreground trees — bamboo, pine, and, perhaps, plum — that screens off access to the promontory. Wu Zhen's influence is most apparent in the bold contrast of dark foliage dots with paler ink washes and dragged hemp-fiber texture strokes, but the poetic mood evoked by Mei's distilled imagery also recalls the deeply personal symbolism of Wu's painting.[88]

Mei Qing's inscription on the seventh painting (pl. 5g) identifies his source as "old man Stony Field," the sobriquet of the early-Ming literati painter Shen Zhou. A gentleman scholar — identifiable as such by his distinctive headdress — sits in a small boat, a paddle cradled in his arm, gazing away from the viewer toward a stand of pine trees lining the far shoreline. The economically rendered boat, the figure, and the landscape

PLATE 5g Mei Qing (1624–1697). *Landscape after Shen Zhou [1427–1509]*. Ink and color on paper. Leaf G from *Landscapes after Ancient Masters for Zeweng*, dated 1693. Album of twelve paintings and a one-leaf artist's postscript, 9 ¾ × 11 ¾ in. (24.8 × 29.8 cm). The Metropolitan Museum of Art. Promised Gift of Marie-Hélène and Guy Weill

elements—notably the distinctive elongated moss dots set between the trees—are all motifs that recall Shen Zhou's style. Shen Zhou was also deeply influenced by the imagery of reclusion created by Wu Zhen, and Mei's painting captures the same mood of quiet contentment Shen Zhou brought to his interpretation of that theme.

Mei returns to the theme of reclusion in his eighth painting (pl. 5h), where he again credits Wu Zhen as his source of inspiration. A pavilion, ideally sited according to the principles of geomancy (*fengshui*), stands beside a stream at the foot of a mountain where beneficial energy, or *qi*, is concentrated. Nestled between two massive boulders, the structure is further sheltered by a grove of trees and a thicket of bamboo. A gentleman sits inside the open door gazing out as if awaiting a friend—confirming that for the Chinese recluse visits from sympathetic companions were always welcome. The foliage

PLATE 5h Mei Qing (1624–1697). *Landscape after Wu Zhen [1280–1354]*. Ink on paper. Leaf H from *Landscapes after Ancient Masters for Zeweng*, dated 1693. Album of twelve paintings and a one-leaf artist's postscript, 9 ¾ × 11 ¾ in. (24.8 × 29.8 cm). The Metropolitan Museum of Art. Promised Gift of Marie-Hélène and Guy Weill

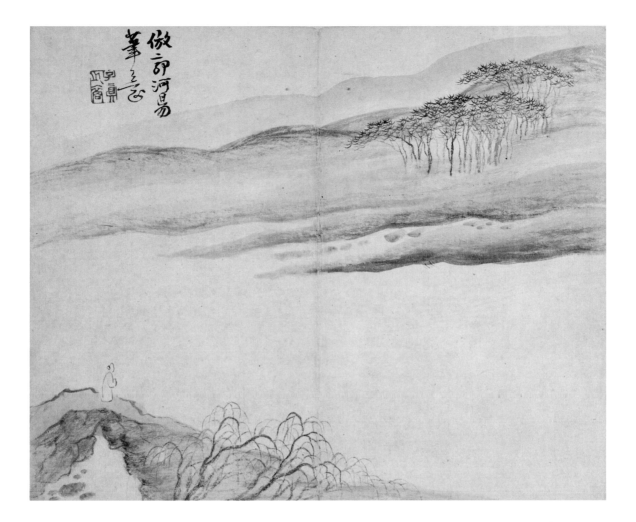

patterns and outlines of the trees and rocks are drawn in round, centered-tip brushstrokes that echo the calligraphic painting style of Wu Zhen, but the dense array of motifs pressed close to the picture surface as well as the dramatic juxtaposition of brush patterns and varied ink tonalities are characteristic features of Mei Qing's own style. The same range of ink tones is apparent in Mei's inscription, written with a single inking of the brush; the characters progress from wet and dark to dry and pale so that the final ideograph almost fades into the curving slope of the distant mountains.

The ninth painting (pl. 5i) presents a "level distance" (*pingyuan*) panorama in the manner of the Northern Song master Guo Xi. At the bottom of the composition are an earthen dike and bridge buttressed by bare willows. There, a solitary figure gazes into the distance across a broad river to a low-lying middle-ground shore, where ranks of pine

PLATE 5i Mei Qing (1624–1697). *Landscape after Guo Xi [ca. 1000–ca. 1090]*. Ink and color on paper. Leaf I from *Landscapes after Ancient Masters for Zeweng*, dated 1693. Album of twelve paintings and a one-leaf artist's postscript, 9 ¾ × 11 ¾ in. (24.8 × 29.8 cm). The Metropolitan Museum of Art. Promised Gift of Marie-Hélène and Guy Weill

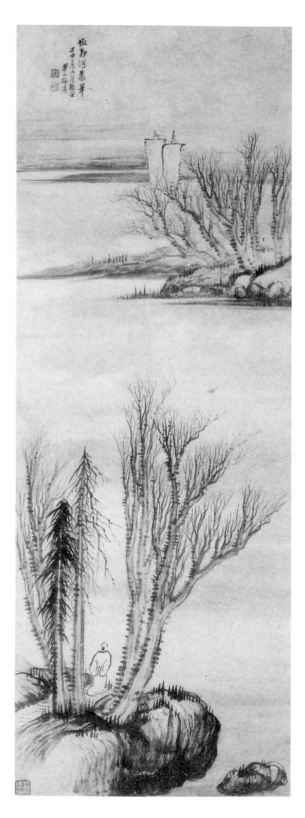

trees step back toward a horizon defined by the blue silhouette of distant mountains. This is a recomposed and simplified version of the hanging scroll composition after Guo Xi that Mei painted in 1692 (fig. 28).

In the next painting (pl. 5j) Mei Qing employs a "deep distance" (*shenyuan*) compositional schema, in which the viewer's gaze is directed past tall foreground cliffs into the far distance, to evoke the imagery of the tenth-century master Li Cheng. The painting is a more elaborate version of a design Mei used two years earlier in a smaller-scale album (fig. 29). In

FIGURE 28 (left) Mei Qing (1624–1697). *Landscape after Guo Xi [ca. 1000–ca. 1090]*, dated 1692. Hanging scroll, ink and color on paper, 71 × 25 ¾ in. (180.3 × 65.4 cm). Shanghai Museum **FIGURE 29** (right) Mei Qing (1624–1697). *Landscape after Li Cheng [919–967]*, from an album dated 1691. Album leaf, ink and color on paper, 6 ¾ × 4 ¾ in. (17.1 × 12.1 cm). Shanghai Museum

the Weill leaf, Mei effectively suggests a measured progression into space through a receding echelon of overlapping cliff faces and logical shifts in scale, from the figure walking along the wooden trestle at the foot of the nearest cliff, to the temple visible above the trees in the middle ground, to the tiny boats in the far distance. Mei's unconcern with logic is apparent, however, in the tiny size of the houses and trees atop the rightmost promontory, which should be closer to the viewer (and therefore larger) than the strolling figure. In addition to evoking Li's landscape style through this antique compositional formula, Mei Qing uses a dense buildup of fine contour lines, texture dots, and washes to suggest the earlier master's brush idiom. The seventeenth-century date of Mei's interpretation is underscored by the abstract qualities of the drawing. The brushwork is uniformly dark with no sense of the veiling effects of atmosphere. And while there is no indication

PLATE 5j Mei Qing (1624–1697). *Landscape after Li Cheng [919–967]*. Ink on paper. Leaf J from *Landscapes after Ancient Masters for Zeweng*, dated 1693. Album of twelve paintings and a one-leaf artist's postscript, 9¾ × 11¾ in. (24.8 × 29.8 cm). The Metropolitan Museum of Art. Promised Gift of Marie-Hélène and Guy Weill

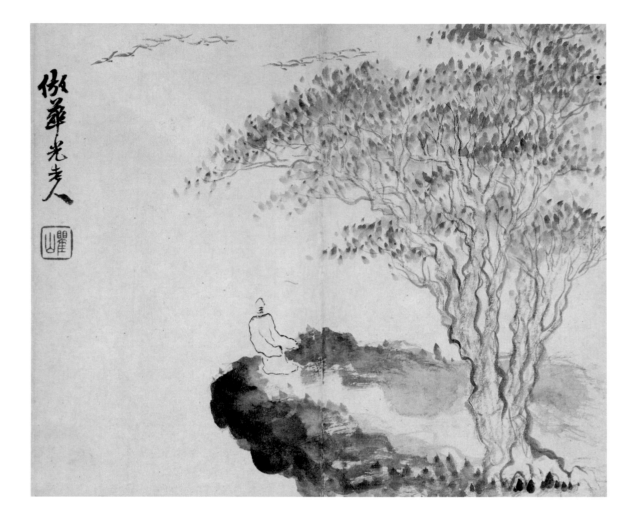

of Western influence, such as the use of light and shadow to model forms naturalistically, the uninked areas on two of the promontories create the optical illusion of highlighting, making those areas appear as if they are projecting forward while the darker, more densely textured surfaces appear to recede.

Mei's inscription on the eleventh painting (pl. 5k) states that he is imitating the style of the Buddhist monk-painter Zhongren (died 1123), who lived at Huaguang Temple, in Hengzhou, Hunan Province. A friend of the great poet and calligrapher Huang Tingjian, Zhongren was known for his monochrome depictions of plum blossoms, but there is no evidence that he ever painted landscapes. Thus, Mei Qing's invocation of Zhongren's name suggests that he viewed the earlier master as a source of spiritual influence rather than a stylistic model. The painting shows a lone figure standing at the end of a spit of land, gazing away from the viewer toward formations of geese. The geese, the strong

PLATE 5k Mei Qing (1624–1697). *Landscape after Zhongren [died 1123]*. Ink and color on paper. Leaf K from *Landscapes after Ancient Masters for Zeweng*, dated 1693. Album of twelve paintings and a one-leaf artist's postscript, 9 ¾ × 11 ¾ in. (24.8 × 29.8 cm). The Metropolitan Museum of Art. Promised Gift of Marie-Hélène and Guy Weill

wind that pulls the figure's trailing sleeves, and the red (perhaps plum) blossoms on the tall tree behind him all suggest a change of season. A nearly identical composition appears in an album dated to the fourth lunar month of the preceding year (fig. 30).

In the Weill album's final painting (pl. 5l), Mei Qing takes us into the high mountains. There, among the peaks, two figures are seated at the mouth of a cave — one playing the *qin*, the other intently listening. The interior of the cave is not dark, but offers a glimpse of sky and pale blue mountains. Either the opening is actually a stone arch that frames a view of distant peaks, such as those to the left, or it is an entrance to a cave-heaven and we are peering into a Daoist paradise.[89] In a somewhat fuller treatment of this same composition in the album done two months earlier (fig. 31), Mei identifies this subject as Cloudy Gate Cave and Valley — a theme he alludes to in his postscript to the Weill album. Mei Qing does not title the Weill image, but in addition to his dedication he has added a terse inscription along the right margin identifying the leaf as painted in the style of the late-Yuan scholar-artist Wang Meng (see fig. 39). The hallmark of Mei's interpreta-

FIGURE 30 Mei Qing (1624–1697). *Landscape after Zhongren [died 1123],* from an album dated 1692. Album leaf, ink and color on paper, 11 ¾ × 16 in. (29.8 × 40.6 cm). Shanghai Museum

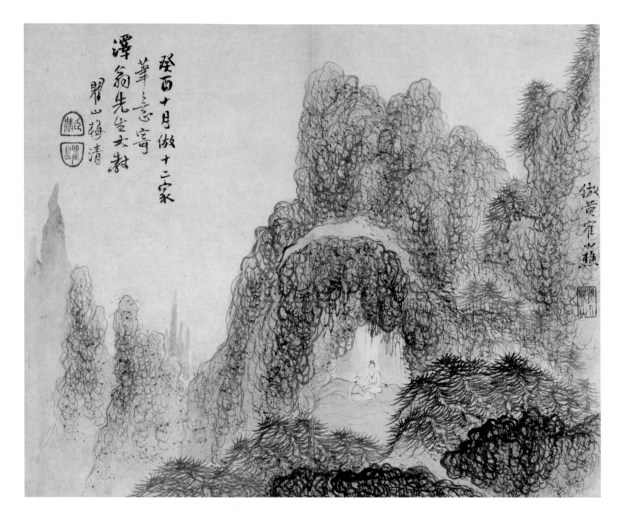

PLATE 5l Mei Qing (1624–1697). *Landscape after Wang Meng [ca. 1308–1385]*. Ink and color on paper. Leaf L from *Landscapes after Ancient Masters for Zeweng*, dated 1693. Album of twelve paintings and a one-leaf artist's postscript, 9 ¾ × 11 ¾ in. (24.8 × 29.8 cm). The Metropolitan Museum of Art. Promised Gift of Marie-Hélène and Guy Weill

tion of this style—as seen in a number of works identified by him as in the manner of Wang Meng—is piled-up mountains defined by a dense skein of looping texture strokes and topped by thickly massed pine trees.[90]

Here, and in the painting done two months earlier, our attention is captured not only by the enigmatic cave but by the two figures at its entrance. The *qin* player and his attentive listener recall the legend of Boya and Zhong Ziqi.[91] Boya was a master of the zither and Ziqi the consummate connoisseur, who perfectly understood what was in Boya's mind when he heard him play. This gave rise to the expression "the person who appreciates one's music" (*zhiyinzhe*) to describe the ideal companion—one who under-

（書法圖版）

PLATE 5m Mei Qing (1624–1697). *Artist's Postscript.* Ink on paper. Leaf M from *Landscapes after Ancient Masters for Zeweng,* dated 1693. Album of twelve paintings and a one-leaf artist's postscript, 9 ¾ × 11 ¾ in. (24.8 × 29.8 cm). The Metropolitan Museum of Art. Promised Gift of Marie-Hélène and Guy Weill

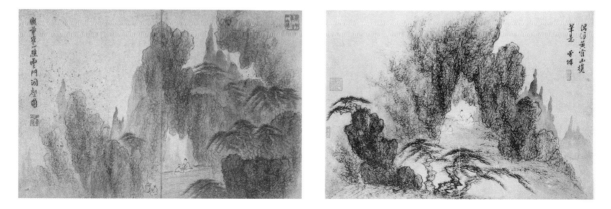

FIGURE 31 (left) Mei Qing (1624–1697). *Cloudy Gate Cave and Valley after Wang Meng [ca. 1308–1385],* from an album dated 1693. Album leaf, ink and color on paper, 12 × 17 ⅞ in. (30.5 × 45.4 cm). Shanghai Museum **FIGURE 32** (right) Mei Geng (1640–after 1716). *Landscape after Wang Meng [ca. 1308–1385],* from an album dated 1693. Album leaf, ink and color on paper, 11 ⅛ × 16 in. (28.2 × 40.5 cm). Shanghai Museum

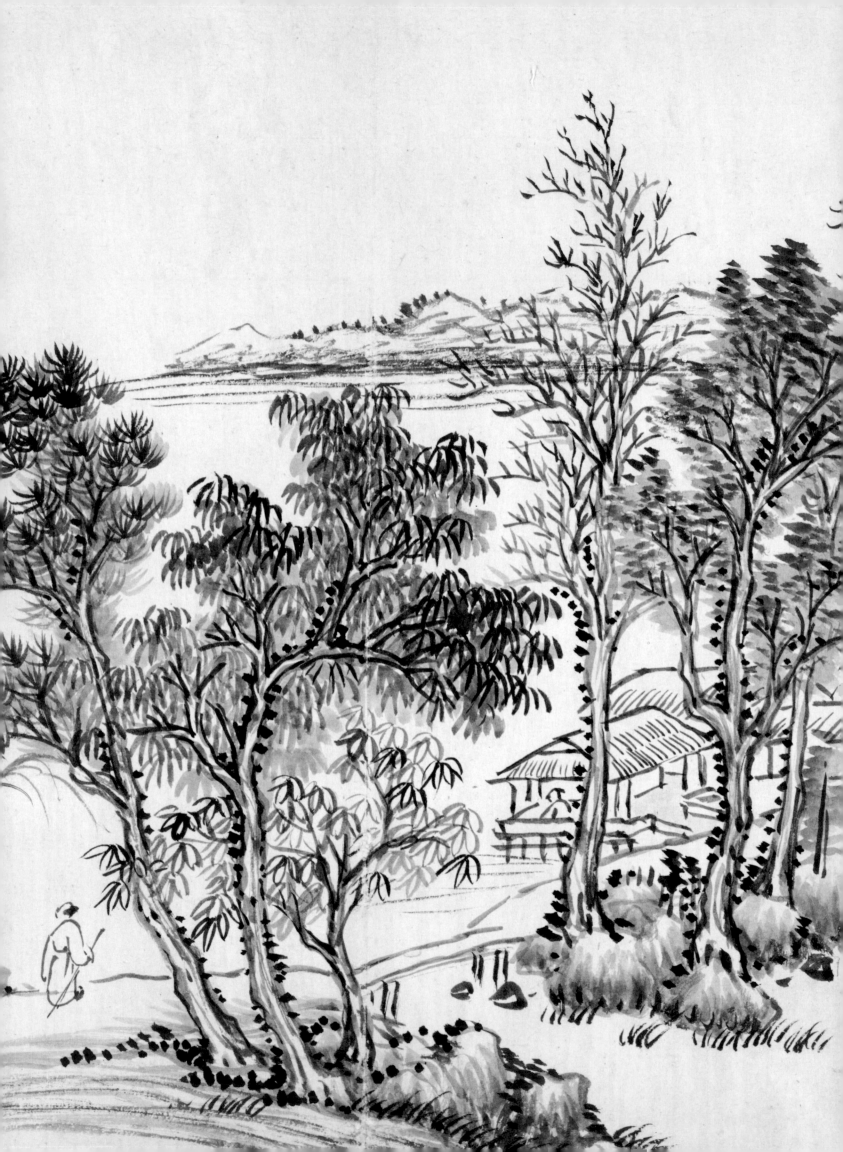

stands without the need for words. In Mei Qing's image, the value and rarity of such a friendship is commensurate with living at the gates of paradise. Following his suite of paintings Mei Qing has added a postscript (pl. 5m) inscribed in a bold running script with a poem and a dedication to Master Zeweng, who was evidently a high-ranking official (see Catalogue, page 172, for the translation of the inscription).

Mei Qing was not the only member of his family who made a name as an artist. His grandnephew Mei Geng was also active in Xuancheng and often added his inscriptions to the works of his older relative (see fig. 21).[92] Judging from his extant works, notably an album in the Shanghai Museum dated the sixth lunar month (July 3–August 1) of 1693 (fig. 32), Mei Geng seems to have practiced a style based closely on that of Mei Qing.[93] A close comparison of Mei Geng's paintings in the Shanghai album with paintings by Mei Qing—including several in the Weill album, which was actually executed four months later—suggests that Mei Geng based his work directly on prototypes by Mei Qing and that both artists repeatedly returned to the same repertoire of images. Indeed, there seems to be something of a family industry in painting. At least two other family members, Mei Chong and Mei Wei (both active late 17th century), also produced paintings in the manner of Mei Qing, who was clearly the innovative master and the inspiration behind his relatives' work.[94]

WANG HUI AND HIS DISCIPLES

In 1691 Wang Hui (1632–1717), the preeminent artist of his day, was summoned to Beijing to oversee the execution of an imperial commission documenting the Kangxi emperor's (r. 1662–1722) 1689 tour of southeastern China. *The Kangxi Emperor's Southern Inspection Tour* (fig. 33), consisting of twelve monumental handscrolls, is one of the largest pictorial works of the Qing dynasty.[95] Since the finished scrolls bear no artists' signatures, seals, or other identifying information, it is necessary to examine circumstantial evidence to determine who assisted Wang Hui in this project. A concentration of collaborative works by Wang Hui and a number of other southern painters dated to the years 1691–96 makes it clear that Wang recruited students and younger professionals from his home region to accompany him to Beijing. The Weill album, *Landscapes after Ancient Masters* (pl. 6), dated 1692, the largest and most important known example of

PLATE 6f Detail

FIGURE 33 Wang Hui (1632–1717) and assistants. *The Kangxi Emperor's Southern Inspection Tour, Scroll Three: Ji'nan to Mount Tai*, datable to 1691–98. Handscroll, ink and color on silk, 26 ¹¹/₁₆ × 548 ½ in. (67.8 × 1393.8 cm). The Metropolitan Museum of Art. Purchase, The Dillon Fund Gift, 1979 (1979.5)

such a collaboration, provides invaluable evidence about how Wang Hui shaped the styles of his assistants to conform with the Orthodox manner that epitomized scholarly taste of the time. It was this style, crystallized in *The Kangxi Emperor's Southern Inspection Tour*, that set the standard for later court commissions.

The album brings together the works of Wang Hui and four other artists: Yang Jin (1644–1728), Gu Fang (active ca. 1690–1720), Wang Yun (1652–after 1735), and Xu Mei (active ca. 1690–1722). Yang Jin, Wang Hui's most prominent disciple and a fellow native of Changshu, Jiangsu Province, contributed six leaves to the album. His style comes closest to that of the master, and, like Wang Hui, he takes an array of old masters as his models. Perhaps not surprisingly, however, his boldest images—a depiction of cloudy mountains and an image of a mountain waterfall—do not refer to any specific stylistic source. Gu Fang, from Huating, Jiangsu, appears in the album as a favored younger protégé of the master, contributing four leaves in the styles of various old masters. Two of Gu's paintings also bear inscriptions by Wang Hui, a mark of special approbation. Wang Yun, a professional painter from Yangzhou who specialized in figures and architectural drawings, contributed two leaves to the album. Although visually appealing, they

show little of the technical complexity or references to ancient idioms that characterize the works of Wang Hui's protégés. Wang Yun's calligraphy is similarly rudimentary; his inscriptions are brief and written in a modest, precisely executed standard script. Wang Yun's later career was strongly influenced by the polished style of the *Southern Inspection Tour* scrolls, and he is best known for similarly detailed, colorful paintings on silk.[96] Xu Mei, a Suzhou painter of flowers and figures who went on to collaborate in the creation of the handscroll *The Kangxi Emperor's Sixtieth Birthday Celebration* of 1715, no longer extant, is the least well known of the artists represented in the album; his junior status is suggested by the fact that he contributed only a single leaf. That painting, restrained in its brushwork, shows little awareness of the calligraphic conventions common to Orthodox school painters. Instead, Xu favors a descriptive approach that recalls the topographic images of his late-Ming townsman Zhang Hong (1577 – ca. 1652).[97] Nonetheless, Xu was able to invoke an antique source of inspiration: the delicate, mist-filled works of Zhao Lingrang (active ca. 1070 – after 1100).

In overseeing the creation of the *Southern Inspection Tour*, it was the responsibility of Wang Hui, the master artist, to weld this disparate group of painters together to create a work with a single cohesive style and artistic program. In the Weill album, too, Wang clearly oversaw the selection of subject matter and styles. The result is very different from the usual group albums made up of individual works contributed to commemorate a specific occasion, such as a birthday, or assembled by a collector, such as Zhou Lianggong.[98] All the paintings take inspiration from a specific earlier master's style or at least show stylistic or thematic affinities with other leaves in the album. Except for Xu Mei's reference to Zhao Lingrang, all the models selected are southern artists, which suggests that Wang and his students wished to capitalize on their status as southerners and their command of the great southern idioms of the Song, Yuan, and early Ming dynasties. The album is particularly rich in references to the styles of Yuan scholar-artists and their immediate followers in the early Ming. There are no Northern Song monumental landscape styles evoked. Instead, the low, watery landscapes of the south are ubiquitous.

Wang Hui contributed three leaves to the Weill album, each a monochrome evocation of a Yuan-era model. Wang's paintings begin and end the album, framing the works of his students. In his inscription on a painting by Gu Fang, Wang sheds some light on how his assistants were expected to use their free time to study the ancient paintings

PLATE 6a Wang Hui (1632–1717). *Fishing Village after Guan Daosheng [1262–1319]*. Ink on paper. Leaf A from *Landscapes after Ancient Masters*, dated 1692. Album of sixteen paintings, 11 × 12 ⅛ in. (28 × 30.7 cm). The Metropolitan Museum of Art. Gift of Marie-Hélène and Guy Weill, 2000 (2000.665.2a)

available to them in Beijing collections:

> *In his studio in Chang'an [i.e., the capital, Beijing], from morning till*
> *night Ruozhou [Gu Fang] and I daily discuss calligraphy and famous*
> *paintings until the second drum [9–11 p.m.] when we retire. Watching*
> *him paint, [his works] truly rival those of the Yuan masters.*

By requiring that they study and copy a specific corpus of models, Wang Hui both molded his disciples' artistic development and defined a uniform stylistic standard for the *Southern Inspection Tour,* insuring that it would exhibit a cohesive pictorial style. Nonetheless, the Weill album reveals the varied training and temperament of Wang's assistants.

The first leaf (pl. 6a), contributed by Wang Hui, presents an interpretation of a composition attributed to Guan Daosheng (1262–1319), the wife of Zhao Mengfu. Wang Hui has even transcribed the texts of the two poems inscribed by Guan and Zhao on the original work (see Catalogue, page 174, for the translation of the poems). In subject matter and brush style, Wang Hui's painting resembles Zhao Mengfu's *Water Village* of 1302 (fig. 34). But Wang has compressed the long horizontal composition into the narrow confines of the album leaf while still managing to retain the illusion of recession along diverging diagonals typical of fourteenth-century compositions. Wang Hui's choice of model here may have a deeper layer of significance. Zhao Mengfu's poem on fishing is replete with images of the simple pleasures of the fisherman-recluse. The accompanying poem by Zhao's wife laments the fact that while Zhao lives close to the emperor in the capital, he misses his homeland. For Wang Hui, the text may thus be a veiled complaint about his loss of independence in working at the capital and separation from his home.

The following painting (pl. 6b), by Xu Mei, is a delicate reinterpretation of the same subject matter. Entitled "Water Village after Zhao Danian [Lingrang]," Xu's painting is less

FIGURE 34 Zhao Mengfu (1254–1322). *Water Village,* dated 1302. Handscroll, ink on paper, 9 ¾ × 47 ⅜ in. (24.9 × 120.5 cm). Palace Museum, Beijing

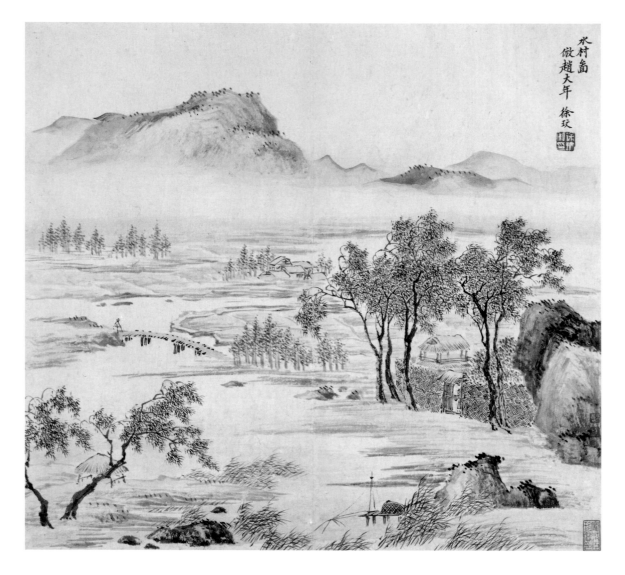

calligraphic and more descriptive in its treatment of the theme than Wang Hui's. It is filled with keenly observed details: a fishing hut on stilts with its net in the water, a rustic thatched pavilion, a two-story hall enclosed within a woven bamboo fence, and a figure standing at the gate, awaiting the arrival of the man with a staff who is about to cross the nearby bridge—perhaps a neighbor from the dwelling further up stream. In contrast to Wang Hui's upturned ground plane, Xu Mei's composition effectively suggests a continuous recession along the winding stream; the bank of mist and paler distant forms evoke the blurring effects of atmospheric distortion. While his subject matter bears a striking resemblence to that of Zhao Lingrang (fig. 35), Xu's recomposition of Zhao's

PLATE 6b Xu Mei (active ca. 1690–1722). *Water Village after Zhao Lingrang* [*active ca. 1070–after 1100*]. Ink and color on paper. Leaf B from *Landscapes after Ancient Masters*, dated 1692. Album of sixteen paintings, 11 × 12 ⅛ in. (28 × 30.7 cm). The Metropolitan Museum of Art. Gift of Marie-Hélène and Guy Weill, 2000 (2000.665.2b)

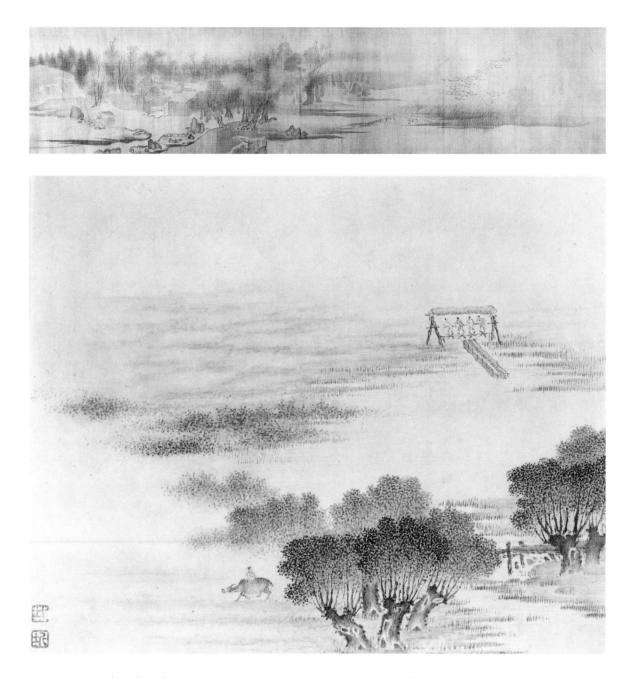

FIGURE 35 Attributed to Zhao Lingrang (active ca. 1070–after 1100). *River Village in Autumn Dawn.* Handscroll, ink and color on silk, 9 5/16 × 41 in. (23.6 × 104.2 cm). The Metropolitan Museum of Art. Ex coll.: C. C. Wang Family, Purchase, Gift of J. Pierpont Morgan, by exchange, 1973 (1973.121.2) **FIGURE 36** Fan Qi (1616–after 1694). *Landscapes Painted for Yuweng,* dated 1673. Album of eight leaves, ink and color on paper, 6 × 7 3/8 in. (15.2 × 18.8 cm). The Metropolitan Museum of Art. Bequest of John M. Crawford Jr., 1988 (1989.363.131). Detail. Leaf C

picture elements and his interest in conveying a vivid sense of recession and atmosphere suggest that he was more influenced by Zhang Hong, the Suzhou specialist in topographic paintings, or by such Western-influenced Nanjing artists as Ye Xin (active ca. 1640–73) and Fan Qi (fig. 36).

The album's third leaf (pl. 6c), by Wang Yun, takes Zhao Mengfu's "level distance" compositional formula (see fig. 34) and stretches it to the limit. Wang Yun juxtaposes a foreground image of cloud-ringed mountains with a series of distant ranges that appear almost like banks of clouds. Only the indistinct forms of four sailboats make it clear that the intervening space is water and not a "cloud sea." Wang Yun's dramatic compositional

PLATE 6c Wang Yun (1652–after 1735). *River and Sky: Level Distance.* Ink on paper. Leaf C from *Landscapes after Ancient Masters*, dated 1692. Album of sixteen paintings, 11 × 12 ⅛ in. (28 × 30.7 cm). The Metropolitan Museum of Art. Gift of Marie-Hélène and Guy Weill, 2000 (2000.665.2c)

manipulation recalls that of Mei Qing (see pl. 5e), but his low ground plane and attention to atmospheric distortion reveal a much deeper interest in representational goals that find their ultimate roots in the works of the Southern Song Academy, when artists also explored vast expanses of space in an intimate format (fig. 37). Only Wang Yun's animated texture strokes reveal an effort to bring his art into conformity with Orthodox school models.

The following leaf (pl. 6d), also by Wang Yun, retains the level ground plane of the preceding leaf but makes the theme of a fishing village more concrete. Wang also emphasizes the vigorous texture and foliage patterns that are hallmarks of the Orthodox manner. Reflecting his knowledge of the tenth-century sources of Guan Daosheng and Zhao Mengfu, Wang titles his painting "Shadowy Summer Grove" and notes that he is studying the brush ideas of Juran.[99]

Yang Jin, Wang Hui's fellow townsman and senior disciple, adheres far more closely to the Orthodox canons of subject matter and style than either Xu Mei or Wang Yun. In his first contribution to the Weill album (pl. 6e), he has chosen to complement Wang Hui's first leaf with a parallel work that, according to Yang's inscription, is based on a painting by Zhao Mengfu, *Fishing Cottage Under a Clear Autumn Sky*, a subject in keeping with the autumn day on which Yang executed the painting: "the sixteenth day of the seventh lunar month of the *renshen* year [August 27, 1692]." Yang eschews the low ground plane and abundant use of ink wash preferred by Wang Yun and Xu Mei in favor of a more abstract compositional arrangement and a similarly schematic rendering of forms with calligraphic brushstrokes. The picture elements are arranged in a powerful Z-shaped pattern that zigzags across the page. Each leg of the Z represents a different

FIGURE 37 Xia Gui (active ca. 1200–1240). *Streams and Mountains, Pure and Remote.* Handscroll, ink on paper, 18 ¼ × 350 in. (46.5 × 889.1 cm). National Palace Museum, Taipei. Detail

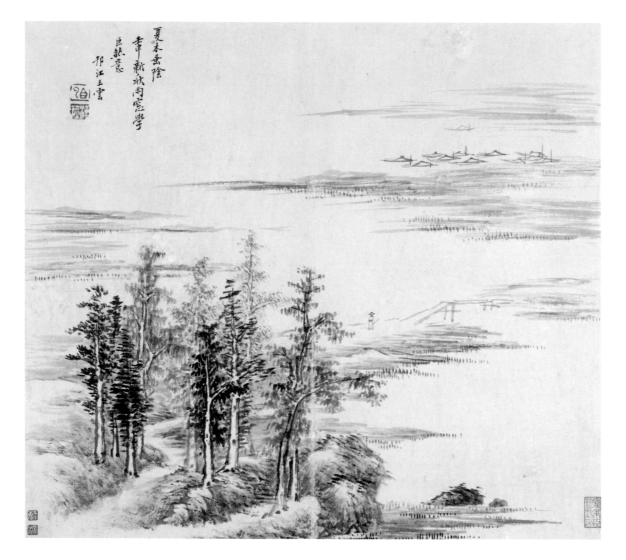

PLATE 6d Wang Yun (1652–after 1735). *Shadowy Summer Grove after Juran [active ca. 960–95].* Ink on paper. Leaf D from *Landscapes after Ancient Masters,* dated 1692. Album of sixteen paintings, 11 × 12 ⅛ in. (28 × 30.7 cm). The Metropolitan Museum of Art. Gift of Marie-Hélène and Guy Weill, 2000 (2000.665.2d)

PLATE 6e Yang Jin (1644–1728). *Fishing Cottage Under a Clear Autumn Sky after Zhao Mengfu [1254–1322]*. Ink on paper. Leaf E from *Landscapes after Ancient Masters*, dated 1692. Album of sixteen paintings, 11 × 12 ⅛ in. (28 × 30.7 cm). The Metropolitan Museum of Art. Gift of Marie-Hélène and Guy Weill, 2000 (2000.665.2e)

PLATE 6h Yang Jin (1644–1728). *Bamboo and Rock after Guan Daosheng [1262–1319]*. Ink on paper. Leaf H from *Landscapes after Ancient Masters*, dated 1692. Album of sixteen paintings, 11 × 12 ⅛ in. (28 × 30.7 cm). The Metropolitan Museum of Art. Gift of Marie-Hélène and Guy Weill, 2000 (2000.665.2h)

Yang's next contribution (pl. 6h), inspired by the art of Guan Daosheng, introduces a new pictorial subject: "old tree, bamboo, and rock."[101] Zhao Mengfu was responsible for reviving this theme during the Yuan dynasty and used it as a vehicle for equating painting and calligraphy. On his short handscroll *Elegant Rocks and Sparse Trees* (fig. 38), Zhao appended an inscription that declares:

> *"Write" rocks with flying-white [cursive script], trees with seal script,*
> *and bamboo with clerical script. Only when a person is capable of*
> *understanding this will he know that painting and calligraphy are*
> *basically the same.*

Yang Jin's painting of a strangely eroded garden rock flanked by bamboo and a pair of leafless trees follows this prescription. The compositional elements are set in a shallow picture space with no background and scarcely any ground line to anchor them. While Yang's image is still evocative of a tranquil garden setting, the representational value of Yang's picture elements is subservient to their function as brush patterns. Yang asserts in his inscription that Guan Daosheng used the same calligraphic discipline to animate her subject:

> *The lady [Guan] sketches bamboo the way she writes characters,*
> *And doesn't sink into painters' shortcuts.*
> *Her inspiration comes from a mountain dwelling on a bright moonlit night;*
> *Suddenly the [painted] leaves rustle in the autumn wind.*

FIGURE 38 Zhao Mengfu (1254–1322). *Elegant Rocks and Sparse Trees.* Handscroll, ink on paper, 10¾ × 24¾ in. (27.3 × 63 cm). Palace Museum, Beijing

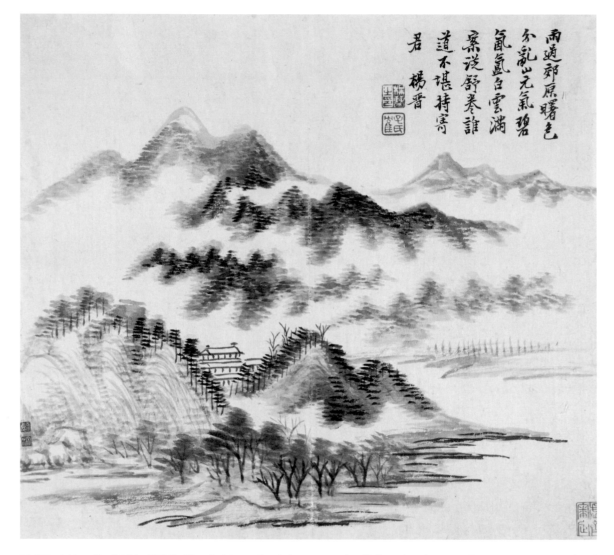

PLATE 6i Yang Jin (1644–1728). *Cloudy Mountains*. Ink on paper. Leaf I from *Landscapes after Ancient Masters*, dated 1692. Album of sixteen paintings, 11 × 12 ⅛ in. (28 × 30.7 cm). The Metropolitan Museum of Art. Gift of Marie-Hélène and Guy Weill, 2000 (2000.665.2i)

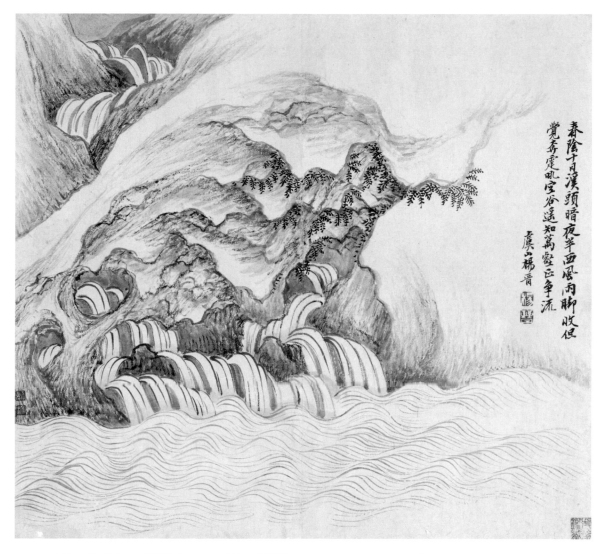

PLATE 6j Yang Jin (1644–1728). *Mountain Waterfall.* Ink on paper. Leaf J from *Landscapes after Ancient Masters*, dated 1692. Album of sixteen paintings, 11 × 12 ⅛ in. (28 × 30.7 cm). The Metropolitan Museum of Art. Gift of Marie-Hélène and Guy Weill, 2000 (2000.665.2j)

PLATE 6k Gu Fang (active ca. 1690–1720). *Landscape with Temple*. Ink on paper. Leaf K from *Landscapes after Ancient Masters*, dated 1692. Album of sixteen paintings, 11 × 12 ⅛ in. (28 × 30.7 cm). The Metropolitan Museum of Art. Gift of Marie-Hélène and Guy Weill, 2000 (2000.665.2k)

In his next painting (pl. 6i) Yang Jin takes as his point of inspiration the lament of the Daoist sage Tao Hongjing (451–536), who regretted that he could not send the emperor Liang Wudi (r. 502–49) the white clouds that often surrounded his residence.[102] Painting a scene of cloudlike mountains in the tradition of Mi Fu, Yang adds a poetic rebuttal to Tao's lament:

> Dawn's light emerges as the rain lifts from the wilderness expanses,
> Revealing the azure mists of the scattered mountains' primal breath.
> White clouds fill the table as I unroll the scroll,
> Who says they cannot be sent to a friend?

Yang's painting is a vibrant image of contrasting patterns: the contrapuntal frisson of vertical trees and horizontal foliage dots in the foreground gives way to the larger, undulating rhythms of bands of white cloud and dark mountain. In China depictions of cloud-ringed mountains have long been regarded as an auspicious omen connoting good government. The able ruler benefits his people the way a tall mountain, by attracting clouds, brings rain for the farmers' crops. Thus, Yang's image would have been appropriate for presentation to a high-level government official—perhaps the intended recipient of this album.

Yang Jin's final contribution to the album (pl. 6j) is an evocative image of a mountain waterfall that flows beneath a stone arch—an image reminiscent of Liu Yu's cascade-filled grotto (see pl. 3). The surging waters are the inevitable outcome of mountains surrounded by rain clouds, as Yang makes clear in his inscription:

> For ten days spring clouds have obscured the stream,
> In the middle of the night a west wind brings the rain to an end.
> Feeling only the roar of the rolling thunder in the empty valley,
> From a distance I know that the myriad gorges are vying in their flows.[103]

In his painting, Yang contrasts the geometric cascades and waves of the water with the irregular undulations of the rock, creating a daring juxtaposition of varied patterns.

Following Yang Jin's six leaves are four by Gu Fang, each in the style of a different earlier master. Gu's first leaf (pl. 6k) does not invoke the name of a specific artist, but recalls Shen Zhou in its poetic evocation of the artist's experience of a specific time and place:

In the evening I pass the temple south of the bridge,
Leaning on my staff I lightly trod the wilderness path.
Birds cry, the spring rain is plentiful,
Flowers fall, the midday breeze is fair.

Gu's inscription on his second painting (pl. 6l) tells us that he was inspired by *Reading in a Thatched Hall* by Wang Meng. Recomposing the earlier artist's typical vertical composition (fig. 39) to fit the album format, Gu duplicates Wang Meng's penchant for filling almost the entire picture space with densely textured landscape elements and framing a view of a rustic compound with tall foreground trees.[104] Like Wang Meng, Gu has also added touches of red, umber, blue, and green to further enliven his landscape.

PLATE 6l Gu Fang (active ca. 1690–1720). *Reading in a Thatched Studio after Wang Meng [ca. 1308–1385]*. Ink and color on paper. Leaf L from *Landscapes after Ancient Masters*, dated 1692. Album of sixteen paintings, 11 × 12 ⅛ in. (28 × 30.7 cm). The Metropolitan Museum of Art. Gift of Marie-Hélène and Guy Weill, 2000 (2000.665.2l)

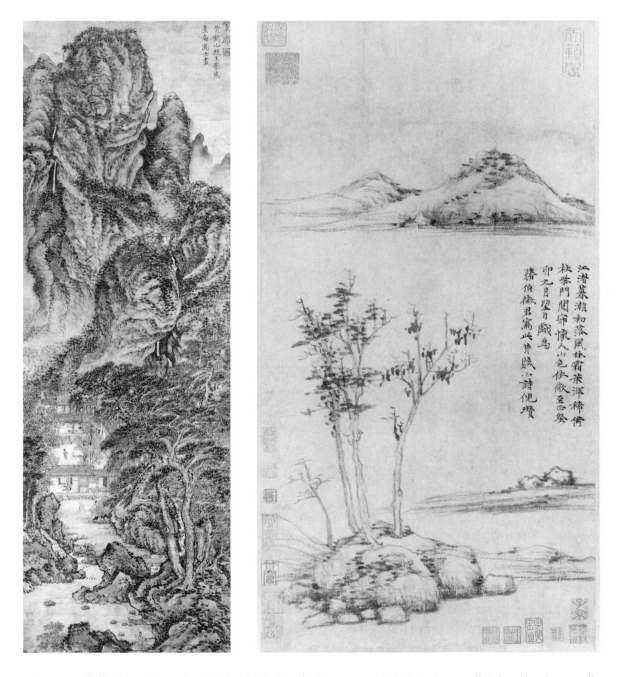

FIGURE 39 (left) Wang Meng (ca. 1308–1385). *Simple Retreat*, ca. 1370. Hanging scroll, ink and color on silk, 53 ½ × 17 ¾ in. (136 × 45 cm). The Metropolitan Museum of Art. Ex coll.: C.C. Wang Family, Promised Gift of the Oscar L. Tang Family **FIGURE 40** (right) Ni Zan (1306–1374). *Wind Among the Trees on the Riverbank*, dated 1363. Hanging scroll, ink on paper, 23 ½ × 12 ½ in. (59 × 31 cm). The Metropolitan Museum of Art. Bequest of John M. Crawford, Jr., 1988 (1989.363.39)

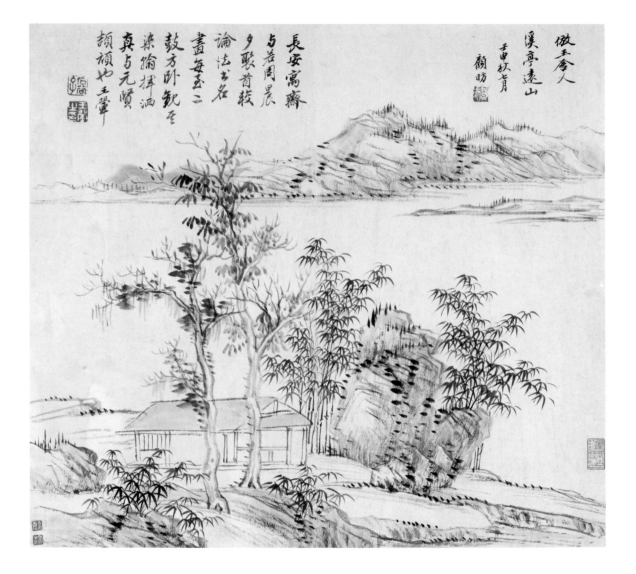

In the next leaf (pl. 6m), Gu resumes his monochrome palette in an evocation of Wang Fu's (1362–1416) *Pavilion by a Stream with Distant Mountains*. Wang Fu was himself inspired by the painting style of Ni Zan (fig. 40) and followed Ni's style closely, making him an ideal model for later Orthodox school painters to emulate.[105] Wang Hui's approval of Gu's method is evident in his inscription (discussed above), in which he lauds his pupil's dedication and talent.

Gu Fang's final contribution to the album (pl. 6n) is a landscape in the manner of the tenth-century southern master Juran. Here, Wang Hui has again shown his approval of Gu's work by adding a poetic inscription (see Catalogue, page 177, for the translation of the inscription).

PLATE 6m Gu Fang (active ca. 1690–1720). *Pavilion by a Stream with Distant Mountains after Wang Fu [1362–1416]*. Ink on paper. Leaf M from *Landscapes after Ancient Masters*, dated 1692. Album of sixteen paintings, 11 × 12 ⅛ in. (28 × 30.7 cm). The Metropolitan Museum of Art. Gift of Marie-Hélène and Guy Weill, 2000 (2000.665.2m)

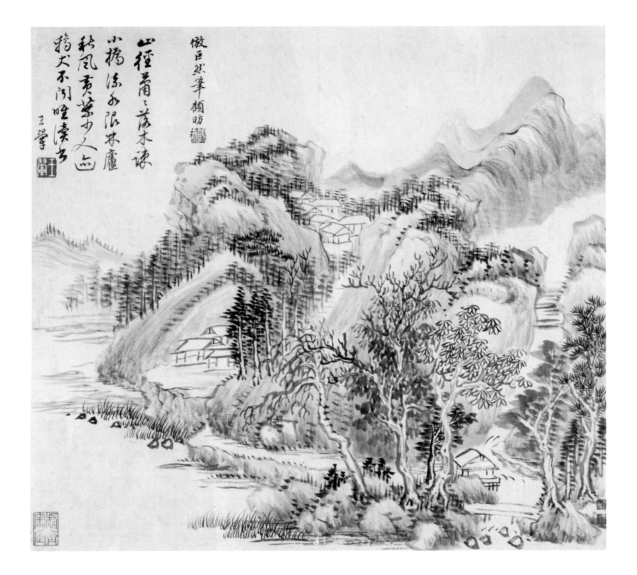

Wang Hui reserved the final two paintings in the album for himself. In the penultimate leaf (pl. 60), he creates an idyllic mood through the addition of a quatrain that belies his rigorous nature and disciplined approach to art:

> Dozing with the fragrance of tea, not a care in the world,
> In my hand a scroll of the Yellow Court [Sutra].
> Leaning on a pillow, the blinds rolled up, I look out on the
> myriad miles of river,
> The boatmen don't talk as the wind fills our sails.

Wang's painting juxtaposes a foreground promontory with a distant line of mountains in

PLATE 6n Gu Fang (active ca. 1690–1720). *Landscape after Juran [active ca. 960–95]*. Ink on paper. Leaf N from *Landscapes after Ancient Masters*, dated 1692. Album of sixteen paintings, 11 × 12 1/8 in. (28 × 30.7 cm). The Metropolitan Museum of Art. Gift of Marie-Hélène and Guy Weill, 2000 (2000.665.2n)

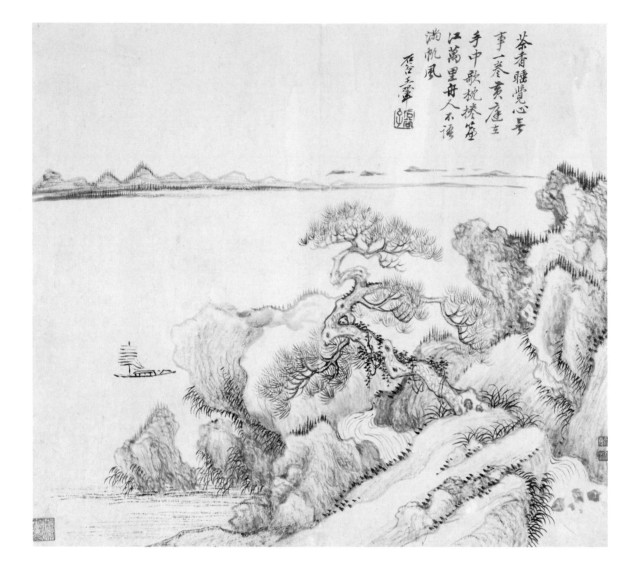

a composition that recalls those of the late-Yuan artist Sheng Mou (active ca. 1310–60). The painting may also be compared with that of Wang Yun discussed above (see pl. 6c). In Wang Yun's landscape the picture elements are small in scale and the brushwork is inconspicuous, emphasizing the vast expanse of space. In Wang Hui's image, the larger picture elements call attention to themselves through their undulating silhouettes, bold brushwork, and contrasting ink tonalities. The sailboat, a conventional narrative detail, serves primarily to magnify the scale of the foreground forms. Whereas Wang Yun's short inscription is pushed to the edge of his composition, Wang Hui's conspicuous poem fills the sky in the right half of his image, accentuating the primacy of calligraphic brushwork over representation.

PLATE 60 Wang Hui (1632–1717). *Landscape with Sailboat.* Ink on paper. Leaf O from *Landscapes after Ancient Masters,* dated 1692. Album of sixteen paintings, 11 × 12 ⅛ in. (28 × 30.7 cm). The Metropolitan Museum of Art. Gift of Marie-Hélène and Guy Weill, 2000 (2000.665.2o)

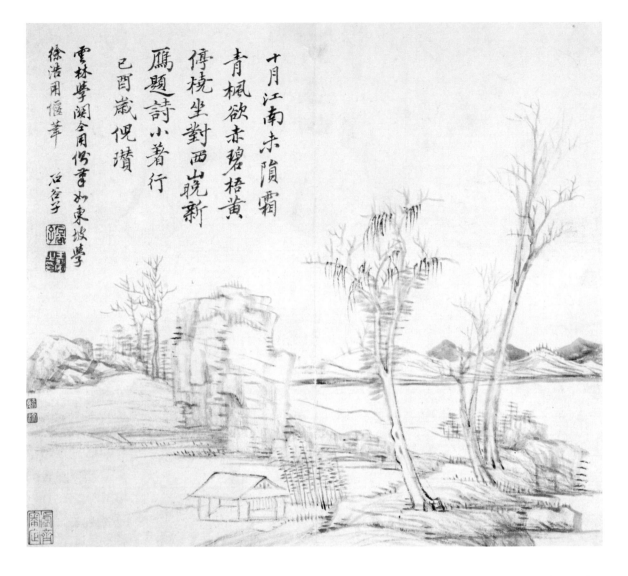

In the album's final leaf (pl. 6p), Wang Hui returns to his theme of learning from the old masters by creating a landscape based directly on a painting, now lost, by the Yuan artist Ni Zan; he even transcribes Ni's inscription. When his painting is compared to an actual Ni Zan (see fig. 40), however, we see that Wang Hui has reduced the earlier master's individual brush marks to a set of calligraphic conventions.

The Weill album, executed at a time when he would have been preoccupied with planning the *Southern Inspection Tour* scrolls, shows Wang Hui molding his assistants' disparate styles so that they might work in harmony on the grand task of illustrating the emperor's journey across the landscape of China. Since there is no recipient named in the album as it now survives, it seems likely that the dedication, perhaps in a colophon,

PLATE 6p Wang Hui (1632–1717). *Landscape after a Painting by Ni Zan [1306–1374]*. Ink on paper. Leaf P from *Landscapes after Ancient Masters*, dated 1692. Album of sixteen paintings, 11 × 12 ⅛ in. (28 × 30.7 cm). The Metropolitan Museum of Art. Gift of Marie-Hélène and Guy Weill, 2000 (2000.665.2p)

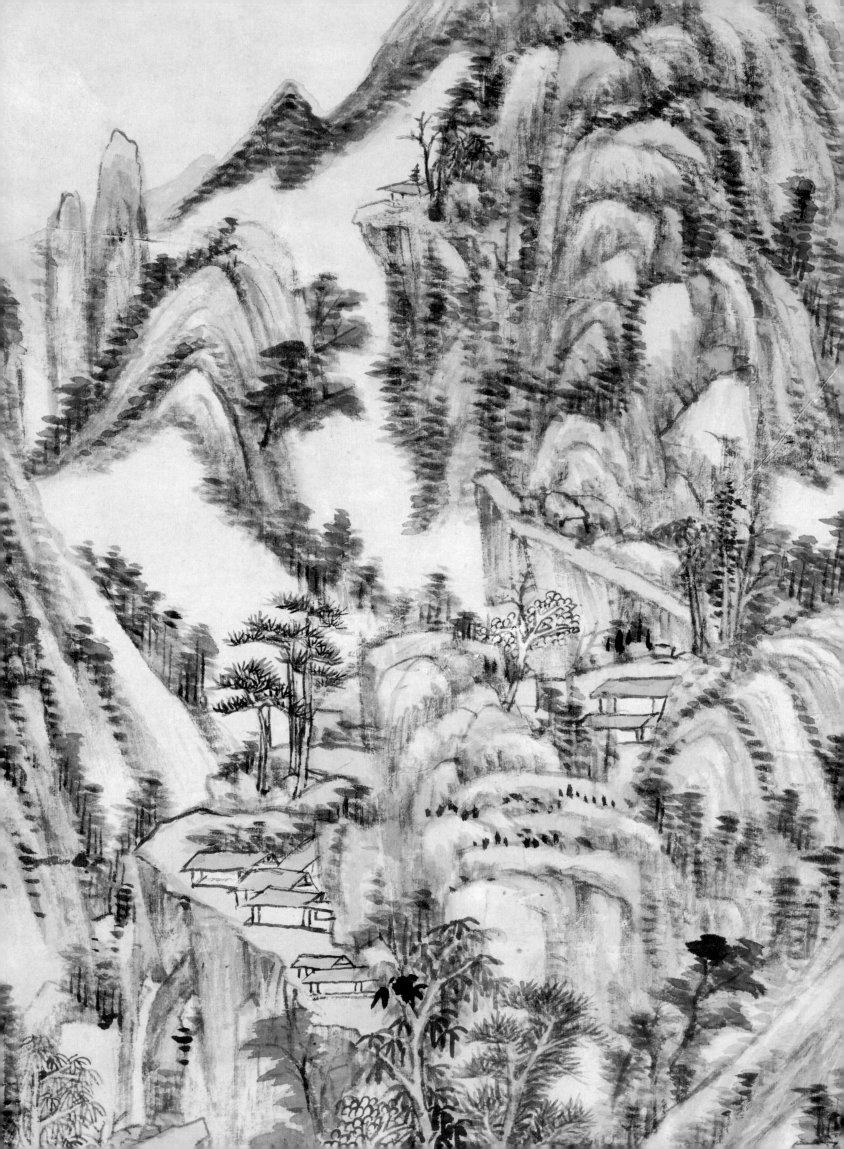

was purposefully removed to conceal the identity of the original owner, who must have been a powerful figure in the capital. Two hundred years later, the album was the cherished possession of two important late-nineteenth- and early-twentieth-century collectors: Sun Yuwen (died 1899), who also owned *Dwelling in the Floating Jade Mountains* by Qian Xuan (ca. 1235–before 1307),[106] and Pang Yuanji (1864–1949), the most important and knowledgeable connoisseur and collector in Shanghai during the early twentieth century, who included the album in his 1909 catalogue.[107]

The Weill album not only elucidates the identity of other artists who contributed to the *Southern Inspection Tour* project but expands our understanding of court and professional painting circles during this formative period in the establishment of a Qing courtly style. It is a rare example of how a master painter utilized the collaborative process to create a cohesive pictorial manner for a large-scale project that demanded many participants. The individual leaves stand on their own as handsome works of art, and also reveal a formative stage in the development of several important eighteenth-century talents, particularly Yang Jin and Wang Yun, whose mature styles were strikingly different from one another.

WANG YUANQI

A talented landscape painter and theorist, Wang Yuanqi (1642–1715) not only inherited the mantle of orthodoxy from his grandfather, the painter and collector Wang Shimin, but, as a senior government official, played an important role in establishing the Orthodox style as the standard for court painting under the Kangxi emperor.[108] As a member of the Hanlin Academy from 1700 until his death, Wang spent the last fifteen years of his life in Beijing, where he fulfilled a number of tasks connected to the arts. In recognition of his stature as an artist, in 1701 the emperor presented Wang with a seal, the legend of which reads: "His paintings will be passed down for people to view."[109] The chief connoisseur for the imperial collection, Wang was subsequently appointed editor-in-chief of the massive *Peiwenzhai* encyclopedia on calligraphy and painting, published in 1708. After the death of Song Junye (1652–1713), the government official who oversaw the production of *The Kangxi Emperor's Southern Inspection Tour* scrolls (see fig. 33), Wang was put in charge of a second grandiose commemorative project, a painting and

PLATE 7a Detail, pl. 7

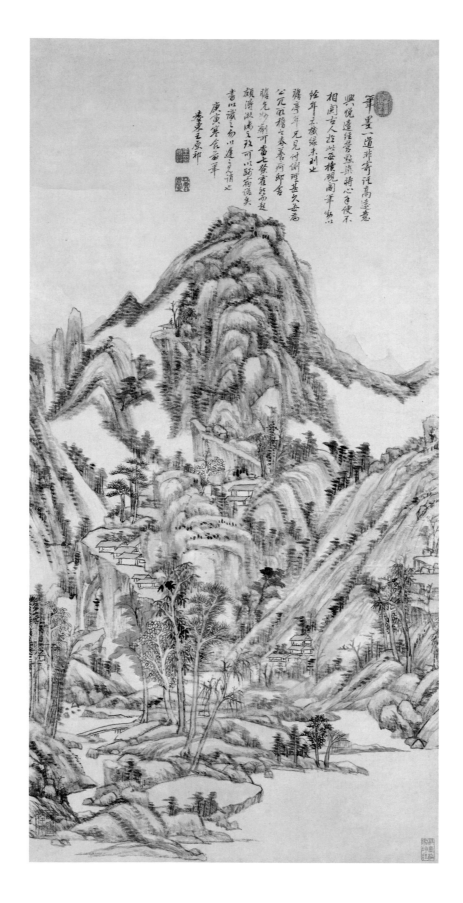

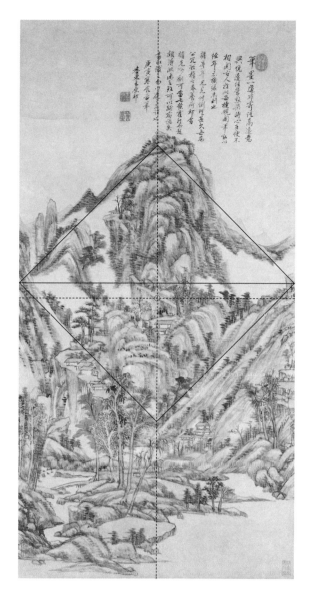

compendium of laudatory texts created for the emperor's sixtieth birthday celebration.[110]

In spite of his heavy official responsibilities, Wang was a prolific painter who extended the principles of calligraphic brushwork and dynamic compositional structures first expounded by the Ming theorist and painter Dong Qichang. Wang articulated his own ideas about painting in a short essay, "Desultory Jottings by a Rainy Window" (*Yuchuang manbi*).[111] There Wang stressed the need to integrate dynamic brushwork, the rising and falling (*qifu*) of landforms, and alternating passages of openness and density (*kaihe*) within larger compositional patterns that he identified as "dragon veins," a term appropriated from geomancy.[112] Wang's landscapes were not fundamentally influenced by the direct observation of nature, however; instead, he derived his pictorial language from the creative reinterpretation of a limited repertoire of compositions and styles associated with those Song and Yuan masters revered as embodying the highest ideals of scholar painting. This Orthodox canon of models was first set forth by Dong Qichang and transmitted to Wang Yuanqi through his grandfather, Wang Shimin, Dong's leading disciple. Yet unlike his grandfather's other famous follower, Wang Hui, Wang Yuanqi was less concerned with evoking earlier styles than with achieving a unique personal expression based on the compositional principles articulated in his writings.

PLATE 7 Wang Yuanqi (1642–1715). *Landscape for Zhanting,* dated 1710. Hanging scroll, ink and color on paper, 37½ × 18½ in. (95.2 × 47 cm). The Metropolitan Museum of Art. Promised Gift of Marie-Hélène and Guy Weill
FIGURE 41 Diagram of pl. 7

Landscape for Zhanting (pl. 7), dated 1710, exemplifies Wang's achievement of a landscape style that is distinctively his own. As in the landscape by Shen Zhou discussed above (see pl. 1), Wang's inspiration here is the pictorial idiom of the late-Yuan master Huang Gongwang (see fig. 2). But Wang distills the earlier artist's broad range of brush-strokes and landscape forms into a few salient motifs and abstracted brush conventions that he then uses additively to assemble his mountain. He further exploits the tension between abstract pattern and the illusion of three-dimensionality by causing forms to lean and the ground plane to tilt so that the entire composition is destabilized and set in motion. What distinguishes *Landscape for Zhanting* from most of Wang's paintings is that his kinesthetic brushwork and animated forms are held in dynamic equilibrium within a surprisingly stable compositional framework built around the painting's vertical axis. That framework is defined by the large, central mountain peak whose triangular form is buttressed by diagonal slopes that converge on the central axis, creating a diamond-shaped lozenge in the middle of the composition (fig. 41). Within this symmetrical, "frontal" presentation, the artist has created a rich environment that can be read on several levels.

On the narrative level, Wang presents an inviting world in which the viewer may wander from the majestic trees that populate the valley floor upward toward the lofty summit. Clouds have gathered in the higher valleys, providing a source of rain to replenish the streams and the pool below and to nourish the lush vegetation that dots the slopes. A bridge, paths, and dwellings permit the viewer to roam through or "inhabit" the landscape.

This vital ecosystem may also be read as a geomantic diagram. All the structures in the painting are carefully sited, not on mountain crests but on terraces or level areas, each of which is situated at the bottom of a slope—places where the vital energy (*qi*) that circulates through the cosmos was thought to collect, as evidenced by the tall trees that have grown up at each of these locations (pl. 7a).[113] Wang's awareness of this geomantic principle is confirmed by his cognomen (*hao*) "Lutai," which means "terrace at the foot of a mountain." The dwelling near the center of the painting, in particular, enjoys an auspicious location: at the base of the central peak, where it is embraced by converging ridgelines. We may assume that the recipient of the painting, a colleague who provided Wang with some efficacious medicine, was not only versed in the vital

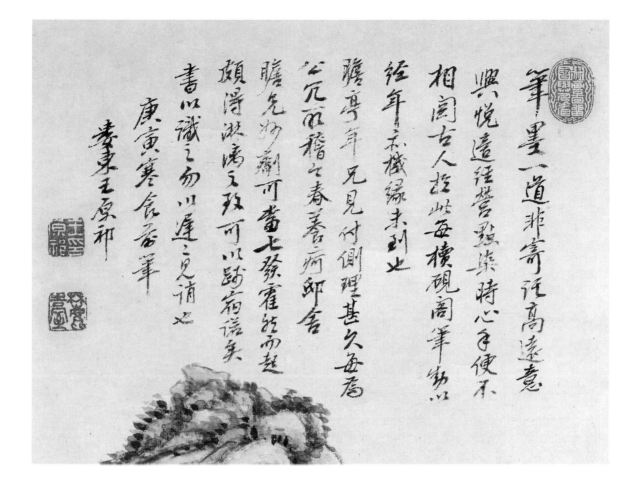

meridians and conduits of the human anatomy, but would recognize the geomantic significance of this frontal mountain and its well-sited habitations.

Finally, the painting may be read as an expressive embodiment of the artist. The dry ink lines and transparent color washes enable the viewer to follow and vicariously re-experience the act of painting. As Wang stresses in his essay, the conception of the painting must be clear before the artist picks up the brush. Once he had visualized his composition, Wang then drew its framework, outlining the contours of the rock outcrops until the basic compositional structure was established. He then went over this skeletal framework, adding texture strokes, foliage patterns, and architectural details. Next he added touches of color—umber and pale green for the landscape, blue for the foliage and distant mountains—and a few accents in darker ink to reinforce the silhouettes of rocks or emphasize a tree so that the overall effect was not too homogenous. Finally, he inscribed his dedication.

PLATE 7b Detail, pl 7. Wang Yuanqi (1642–1715) inscription, dated 1710

Wang's inscription (pl. 7b) suggests that he took particular pleasure in completing this painting:

> The way of brush and ink is such that if it is not the product of lofty and profound ideas and a happy and relaxed mood, when [the artist] adds dots and washes, his mind and hand will not respond to one another. In accord with this principle, the ancients would put away their inkstones and lay aside their brushes, often for years at a time, if the right occasion did not arise.
>
> My colleague Zhanting entrusted me with some celi paper a long time ago, but I was distracted by official business. This spring I was recuperating from illness at home. Mr. Zhanting's marvelous medicinal compound worked like the seven stimulants. I recovered immediately, feeling fully vitalized, and was able to fulfill my old promise. I note this in hopes that he will not admonish me for my tardiness.[114]

As a further embellishment, Wang impressed four seals on the work.[115] To the right of Wang's inscription is the seal presented to him by the Kangxi emperor in 1701. Following his inscription are a pair of seals giving his name, *Wang Yuanqi yin* ("seal of Wang Yuanqi"), and cognomin *Lutai*; the first is carved in intaglio, so the characters appear white against a red ground, and the second, in relief, with red characters on a white ground. A fourth seal, *Xilu houren* ("descendant of 'Western Thatched Hut' [Wang Shimin]"), which proudly proclaims his illustrious ancestry, has been unobtrusively stamped in the lower left corner within the forms of the landscape (a fifth seal in the lower right belongs to a later collector). Judging both from the painting and the inscription, it is evident that this work was "the product of lofty and profound ideas and a happy and relaxed mood."

LI FANGYING

The scholar-artist Li Fangying (1696–1755), traditionally identified as one of the "Eight Eccentrics of Yangzhou,"[116] was born into a family of government officials in Nantong-zhou (present-day Nantong), Jiangsu Province. Li's career path changed unexpectedly in

PLATE 8d Detail

1729, when he accompanied his father, Li Yuhong (1659–1739), the provincial surveillance commissioner (*anchashi*) of Fujian Province, to an audience with the Yongzheng emperor (r. 1723–35). The emperor, seeing the advanced age of Li's father, appointed the younger Li magistrate of Le'an (present-day Guangrao Xian) in Shandong Province, in spite of his father's protests that his son's temperament was ill-suited for an official career.[117]

Li's father's assessment was borne out during the next twenty years as Li Fangying's service was repeatedly interrupted due to clashes with his superiors. In Le'an, Li led relief efforts following a flood in 1730, and even devised a successful new system to contain the river, but because he had dispensed grain from the state granaries without authorization, he was impeached (the charges were later forgiven). In 1732 Li was named magistrate of Juzhou (now Ju Xian) district, where he donated his official stipend for the renovation of the district school. In 1734 he was transferred to nearby Lanshan district (now Linyi Xian), where he settled a dispute with a local strongman and took further actions to prevent flooding. Li's conscientious opposition to an impractical land-reclamation project advocated by the governor-general led to his brief imprisonment in 1735, until the governor was removed from office for falsifying reports of the project's success. Li stayed in Lanshan until 1739 when he returned home to mourn the death of his father and care for his mother until her death about three years later.

FIGURE 42 Wang Mian (1287–1359). *Fragrant Snow at Broken Bridge.* Hanging scroll, ink on silk, 44 ⅝ × 19 ⅝ in. (113.2 × 49.8 cm). The Metropolitan Museum of Art. Ex coll.: C. C. Wang Family, Purchase, Gift of J. Pierpont Morgan, by exchange, 1973 (1973.121.9)

From 1739 to 1745 Li remained in mourning and increasingly devoted himself to his art.[118] But in early 1746 he was ready to resume his official career. By the third lunar month, he had departed for the capital, sojourning in Yangzhou for several months en route and painting several hanging scrolls there before continuing to Beijing.[119] By 1747 Li had been reassigned as a magistrate in Anhui Province, serving in several posts before being transferred to Hefei in about 1749. In Hefei, Li again offended his superiors and was indicted and dismissed from office on false charges.[120] The case lasted several years, and Li was not finally exonerated until 1753, when he was able to move his residence to the Xiang family garden in Nanjing, which he referred to as the Borrowed Garden (Jie Yuan).[121] There Li devoted himself to painting, making frequent visits to Yangzhou as well as traveling to local scenic spots in the company of the renown poet Yuan Mei (1716–1797) and the seal carver Shen Feng (1685–1755). He also made the acquaintance of several of the Yangzhou "eccentrics," including Jin Nong (1687–1763), Zheng Xie (1693–1765), and Li Shan (1686–ca. 1756).[122] In the eighth lunar month of 1755 Li fell ill and returned to his family home in Nantong, where he died early in the following month.[123]

Although Li does not seem to have indulged in the kind of nonconformist lifestyle that would justify the label "eccentric," his independent spirit clearly exasperated his superiors. Li's art reflects the same temperament of uncompromising idealism and rigorous austerity that must have led to his repeated impeachment. Like other "eccentric" painters of the day, Li painted spare compositions executed in a bold calligraphic manner using ink on paper. This mode of painting was the very opposite of the conservative style of flower painting practiced at the court of the Yongzheng and Qianlong (r. 1736–95) emperors, where verisimilitude and the use of vibrant mineral colors on silk was favored. Also like the other eccentrics, Li specialized in a narrow range of subject matter: various flowers, pines, bamboo, and fish.[124] Among these subjects, his favorite was the blossoming plum. The plum, the first flower to bloom in the spring, had long been admired by scholar-gentlemen for its fortitude in the face of harsh conditions. Its delicate blossoms, springing forth from knarled trunks and twisted branches, symbolized renewal, while its fragrance carried connotations of moral purity and loyalty.

Li shared this special admiration for the plum with several other "eccentric" artists of the time, notably Wang Shishen (1686–1759) and Jin Nong. Maggie Bickford, in her

study of the ink-plum genre, has offered several reasons why these artists felt a special affinity for the flowering plum: its lofty symbolism and long association with scholar-painting, which made it attractive to artist and patron alike; its viability as a vehicle for abbreviated brushwork, abstraction, and spontaneity of execution; and its link to the tradition of the ink-plum master Wang Mian (1287–1359), whose failed career in government and subsequent peripatetic life as an impoverished painter of flowering plums made him a sympathetic model (fig. 42).[125]

As Bickford points out, the plum—like the orchid and the bamboo—could be reduced to a few graphic conventions that enabled these artists to emphasize calligraphic execution over descriptive representation. For artists dependent upon painting for a living, who might be called upon to produce a painting at a special occasion or on short notice, the ability to rely on readily reproducible brush formulae also had obvious advantages. Li's images are particularly spare, even stark, in a way that emphasizes the beauty of the individual brush mark. There is a distilled, poetic quality to his minimalism, making every line and intervening space carry meaning. Li's evocations of the flowering plum are also quite distinct from those of his contemporaries. Wang Shishen's elegant depictions tend to be more delicate, done with a light touch.[126] Jin Nong's images tend to be more boldly graphic, emphasizing compositional drama and variations in brushwork that, like his writing, are highly stylized (figs. 43 and 44). Li's manner of painting is more expressively intense; focusing on a few spare branches, he pursues a rigorous understatement that, as Bickford has observed, is purged of naturalistic description, conventional sweetness, or gratuitous virtuosity.[127]

The Weill album (pl. 8), painted in 1742 when Li Fangying was living in retirement at his Plum Blossom Tower (Meihua Lou) in Nantong, is an outstanding example of Li's ink-plum art.[128] Embellished with poetic inscriptions, it exemplifies the artist's integration of poetry, painting, and calligraphy while showing off his ability to produce distinctive variations on the theme. Li turns the album into a virtuoso demonstration of animated calligraphic brushwork and dynamic compositional design.[129] In successive images branches point up or down, are bent or straight, dense or sparse, dark or light, stubby or attenuated. The artist seems keenly aware of the central axis of each composition—a line that is still visible since each album leaf was originally folded in half. In the second, fifth, and seventh paintings (pls. 8b, 8e, and 8g), for example, inscription and branch are arrayed

FIGURE 43 (left) Jin Nong (1687–1763). *Plum Blossoms*, dated 1757. Album of twelve paintings, ink on paper, 10 × 11 ¾ in. (25.3 × 30 cm). The Metropolitan Museum of Art. Edward Elliott Family Collection, Gift of Douglas Dillon, 1986 (1986.495). Detail. Leaf C **FIGURE 44** (right) Jin Nong. *Plum Blossoms*, dated 1757. Detail. Leaf H

on one half of the composition with only a single twig crossing into the opposite half. In the third painting (pl. 8c), branch and poem are set in opposite corners with only two twigs reaching across the median line and one of these extending directly up the axis. With the notable exception of the eighth and final leaf (pl. 8h), branches and twigs are not defined by outlines, but are drawn in a series of centered-tip brushstrokes that impart the illusion of roundness. This illusion is enhanced by variations in ink tone within the lines, making it appear as if the branches were subtly shaded. The number and placement of the blossoms, as well as their varying stages of opening, have all been carefully calculated for dramatic effect. A similar penchant for variety is evident in Li's use of a different personal seal on each leaf. Some seals have legends carved in intaglio, others in relief; some are crisply rectilinear, others are irregular, as if carved from a pebble; some give one of the artist's names, others express a thought.

Li's opening image of rightward-leaning branches (pl. 8a) draws the viewer into the album and initiates the right-to-left direction that one follows in viewing Chinese books and handscrolls. The branches bisect the page diagonally—a geometric configuration from which only two twigs escape. Fifteen years later, Jin Nong used this same diagonal compositional organization in an even more assertive and self-conscious manner (fig. 45). The two erect twigs direct attention to Li's poem, which likens the plum to a lovely

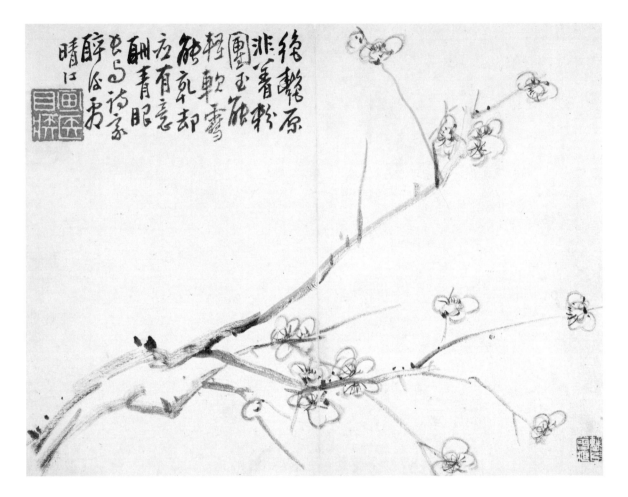

PLATE 8a Li Fangying (1696–1755). Leaf A from *Ink Plum*, dated 1742. Album of eight paintings, ink on paper, 9 ¾ × 12 ½ in. (24.7 × 31.7 cm). The Metropolitan Museum of Art. Promised Gift of Marie-Hélène and Guy Weill

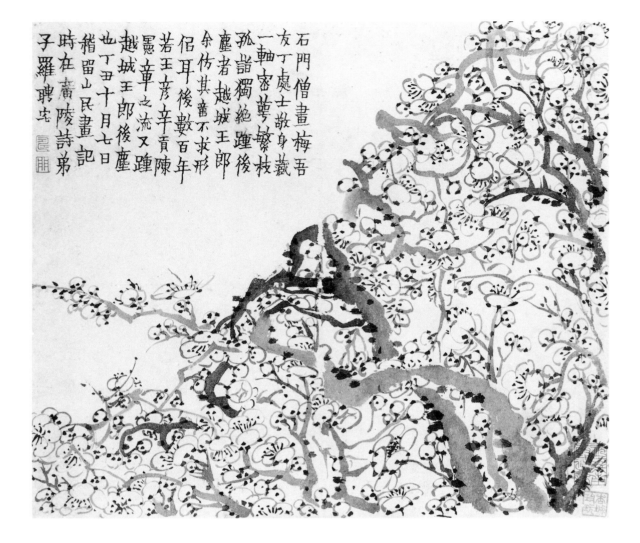

woman whose beauty does not require artificial adornment, only the appreciative notice
of the viewer:

> *Exquisite beauty does not rely on makeup,*
> *It's like jade, but soft and light; like snow, but powdery.*
> *Willing to reward the admiring poet,*
> *She lends herself to his intoxicated gaze.*[130]

Li's painting emulates the same qualities he enumerates in his poem. His dry brushstrokes
are as soft and light as snow; moss dots are sparingly applied, and nowhere does he use
pure black ink — everything is in muted tones of gray. The legend of Li's seal offers a final
enticement to the eye of the beholder: "Paintings cure the ailing eye."

FIGURE 45 Jin Nong (1687–1763). *Plum Blossoms*, dated 1757. Album of twelve paintings, ink on paper, 10 × 11 ¾ in.
(25.3 × 30 cm). The Metropolitan Museum of Art. Edward Elliott Family Collection, Gift of Douglas Dillon, 1986
(1986.495). Detail. Leaf B

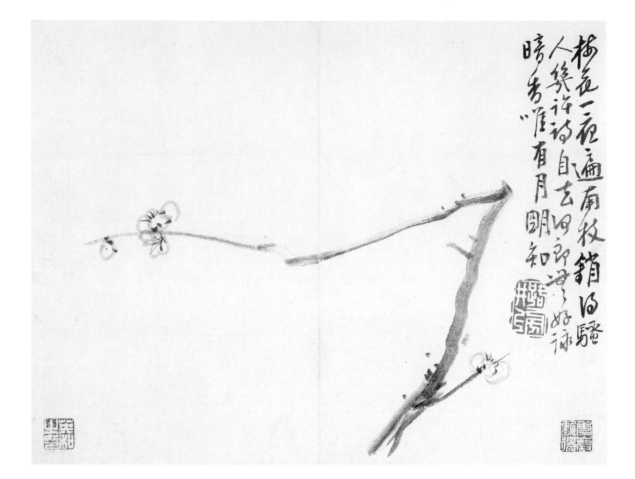

The second leaf (pl. 8b), which reverses the directional thrust of the image, is a study in minimalism: a single branch, bent at an acute angle, supports four blossoms in different stages of opening. The angled branch and a single twig once again provide a frame for Li's poem:

> *Overnight, plum blossoms have filled the southern branches,*
> *The enchanted poet composed numerous poems.*
> *No good lines have been written since court-attendant He,*
> *Only the bright moon appreciates their subtle fragrance.*

The poem laments the absence of sympathetic men to appreciate the plum since the time of He Xun (died ca. 527), who was noted for his poems on the blossoming plum.[131] This reference is actually an allusion to another poet, Gao Qi (1336–1374), who wrote: "No good lines have been written since court-attendant He/Alone in the spring wind, how

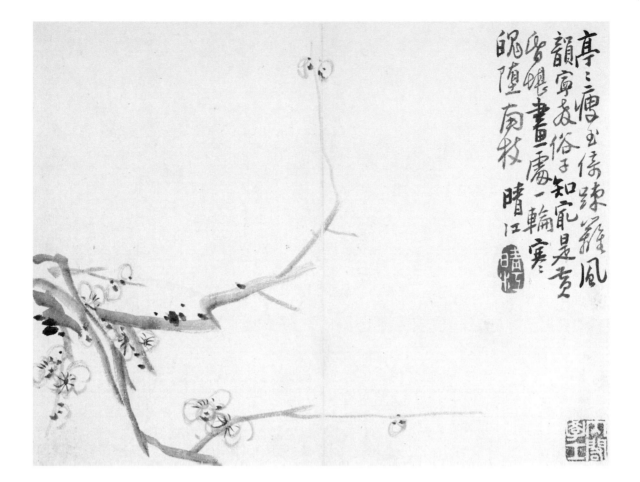

many more times will [the plum] bloom?" [132] Both Li and Gao stress the plum's isolation and vulnerability, features that are immediately conveyed by Li's spare composition. In Li's painting, there is no moon; only the round bud at the tip of the branch recalls its presence. The artist's roughly hewn seal, impressed after the inscription, bears a legend that emphasizes the random way in which one sometimes encounters beauty: "By the well or roadside."

Li's third leaf (pl. 8c) again reverses the orientation of the branches; they seem to reach back toward the poem, which has remained in the upper right corner:

> An elegant figure stands by the garden fence,
> How can a country bumpkin appreciate her grace?
> She is best portrayed at dusk,
> When a cool moon hangs over the southern branches.

PLATE 8c Li Fangying (1696–1755). Leaf C from *Ink Plum*, dated 1742. Album of eight paintings, ink on paper, 9 ¾ × 12 ½ in. (24.7 × 31.7 cm). The Metropolitan Museum of Art. Promised Gift of Marie-Hélène and Guy Weill

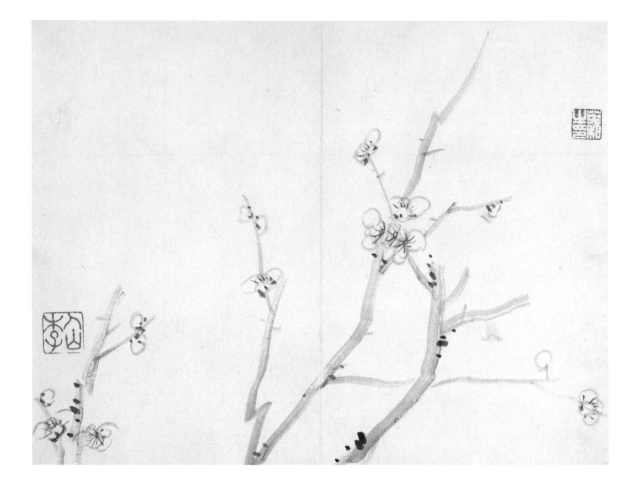

The poem's imagery again likens the plum to an elegant lady, the circular buds of the plum echoing the image of a moon hanging over the branches. The branches enter the composition from the left at the same level as the bottom of the poem. After crisscrossing and looping downward, the lower branch reasserts the horizontal axis, while the upper branch curves upward along the leaf's vertical axis as if the blossoms at their tips were co-ordinates within a graph. Li's irregularly shaped seal, which neatly fills out the rectangular silhouette of his inscription, repeats the name with which he signed: "Qingjiang [River Under Clear Skies]."

The fourth leaf (pl. 8d) presents a succession of upward-thrusting branches, with twigs and blossoms that crisscross or lean toward one another. The dry, raspy ink and blunt endings of the branches impart a sense of swift movement punctuated by abrupt stops. Twice, Li interrupts the smooth vertical direction of his branches with a zigzag motion

PLATE 8d Li Fangying (1696–1755). Leaf D from *Ink Plum*, dated 1742. Album of eight paintings, ink on paper, 9 ¾ × 12 ½ in. (24.7 × 31.7 cm). The Metropolitan Museum of Art. Promised Gift of Marie-Hélène and Guy Weill

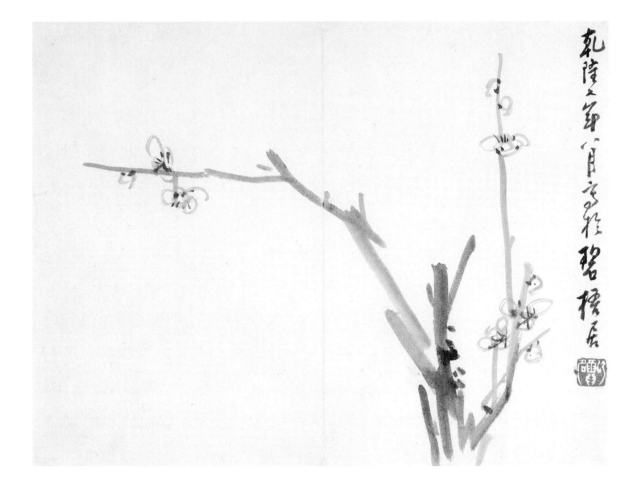

that vividly reminds us of the artist's hand—and whimsy. Li's equally whimsical seal, carved in bold relief lines, reads: "Li the immortal."

In contrast to the breezy, dry-brush linework of the preceding image, the branches of the fifth leaf (pl. 8e) are executed in a series of short, staccato movements with blunt, wet overlapping lines. As in the second leaf, a single branch extends into the left half of the composition. This elongated horizontal is counterbalanced by the stubby trunk and the parallel verticals of the rightmost twig and Li's one-line inscription, which gives the date and tells us that the leaf was painted in the Green Wutong Tree Dwelling (Biwu Ju). Li's compact seal offers a humorous exclamation point: "Known for drinking."

The sixth leaf (pl. 8f) is a variation of the first, with branches that now hang downward to bisect the composition diagonally while a single twig breaks free of this diagonal to point to the otherwise empty upper left corner. Li's prominent seal in the lower right

PLATE 8e Li Fangying (1696–1755). Leaf E from *Ink Plum*, dated 1742. Album of eight paintings, ink on paper, 9 ¾ × 12 ½ in. (24.7 × 31.7 cm). The Metropolitan Museum of Art. Promised Gift of Marie-Hélène and Guy Weill

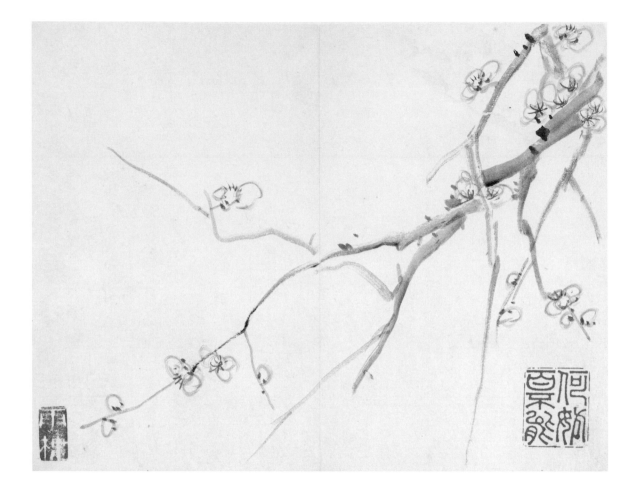

(the seal on the left belongs to a later collector) reinforces the *yin-yang* polarity of this secondary axis. The seal's legend, "So what if I can't do anything," defiantly proclaims Li's willingness to attempt anything. In this case, the downward-oriented branches may consciously recall the pendant-branch compositional type made famous by the fourteenth-century ink-plum master Wang Mian (see fig. 42).

The seventh leaf (pl. 8g) creates yet another variation on the diagonally divided composition. Two twigs angle outward from the lower left toward opposing corners. The tips of these twigs, together with the bent elbow of the main branch, create the now-familiar diagonal line that bisects the composition. Li's terse inscription, which states that he painted this leaf in his Plum Blossom Tower, and his seal, "Just showing the rough idea," help to fill in the space behind this diagonal.

PLATE 8f Li Fangying (1696–1755). Leaf F from *Ink Plum*, dated 1742. Album of eight paintings, ink on paper, 9 ¾ × 12 ½ in. (24.7 × 31.7 cm). The Metropolitan Museum of Art. Promised Gift of Marie-Hélène and Guy Weill

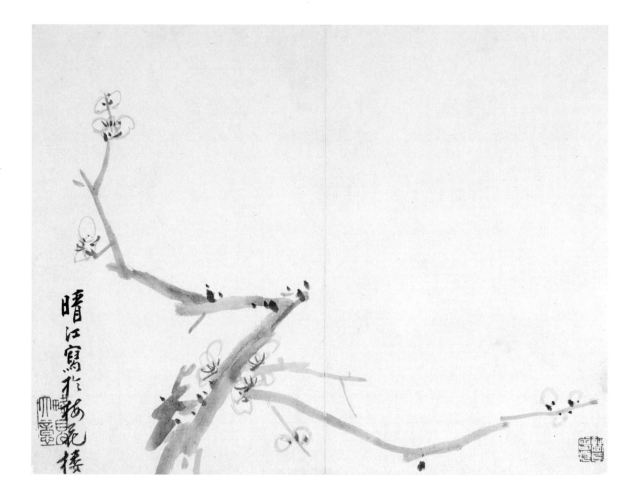

In the final leaf (pl. 8h) Li's poem returns to the theme of lonely isolation:

A reclusive beauty blooms alone in the deep woods,
Where snow falls and moss encroaches.
As messengers no longer come and the music has ceased to play,
With whom can I share my feelings during the wintry season?

In the last line of the poem, Li makes explicit the link between the plum and himself, lamenting their shared fate of having no one to appreciate their unique qualities. In the accompanying painting, a single thick branch and several truncated twigs stand bravely against the snow, sending forth three fragile blossoms. For the first time in the album, Li has used outline strokes to define the thick branch. He has then applied strokes of wash

PLATE 8g Li Fangying (1696–1755). Leaf G from *Ink Plum*, dated 1742. Album of eight paintings, ink on paper, 9 ¾ × 12 ½ in. (24.7 × 31.7 cm). The Metropolitan Museum of Art. Promised Gift of Marie-Hélène and Guy Weill

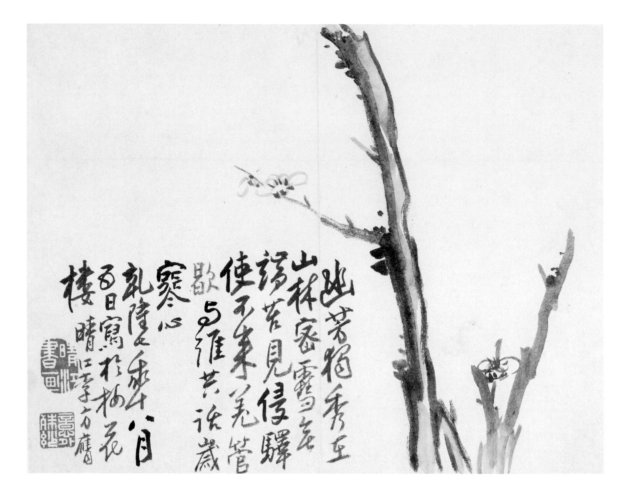

inside the outlines to further model its form. Intentionally uninked areas appear like high-lights, enhancing the appearance of shading and imparting a sense of three-dimensionality and roundness to the branch that is quite distinct from the "round" lines evoked through the use of a centered-tip brush. These areas might also be read as traces of snow that have begun to accumulate. The interplay between the bold stocky branches and the delicate blossoms is echoed in Li's calligraphy, which shows a similar variation in ink tonalities and blend of angular and curvilinear strokes as the painting. The tension between round and angular is reiterated in Li's two seals. The oval seal confirms the album's authorship: "The painting and calligraphy of Qingjiang." The square one declares Li's faith in his own artistry: "Marvelous beyond ideas."

Li's inscription tells us that he completed the album on the fifth day of the eighth lu-nar month of the seventh year of the Qianlong reign era, which corresponds to Septem-

PLATE 8h Li Fangying (1696–1755). Leaf H from *Ink Plum*, dated 1742. Album of eight paintings, ink on paper, 9 ¾ × 12 ½ in. (24.7 × 31.7 cm). The Metropolitan Museum of Art. Promised Gift of Marie-Hélène and Guy Weill

ber 3, 1742. Thus, Li's poem was not responding to an actual snowfall, but rather to his wintry state of mind. At midlife Li longed for a sympathetic patron or friend. In the end he found his greatest solace in the companionship of the plum. As Li's son later observed to the poet Yuan Mei: "I remember my father had two friends. You were one and plum blossoms were the other."[133]

MODEL CALLIGRAPHIES FROM THE HALL OF THREE RARITIES AND THE SHIQU BAOJI COLLECTION

Model Calligraphies from the Hall of Three Rarities and the Shiqu Baoji Collection (*Sanxi Tang Shiqu Baoji fatie*) is one of the monuments of cultural patronage sponsored by the Qing emperor Qianlong (r. 1736–95). The anthology reproduces in the form of rubbings a selection of calligraphic masterworks drawn from the imperial collection, known as *Shiqu Baoji*, or "Treasured Boxes Within the Stony Moat." The thirty-two-volume compilation, intended as an encyclopedic survey of transmitted masterworks, includes 340 works by 135 writers ranging in date from the Wei (220–265) and Jin (265–420) periods through the late-Ming dynasty (1368–1644). The act of collecting and creating reproductions was not merely a way for the Qing state to establish an imperial stylistic standard; it also had a profound ideological function. Emulating Tang and Song imperial initiatives to canonize an orthodox lineage of ancient masterworks, the *Hall of Three Rarities* anthology sought to identify the Manchu rulers with the highest traditions of state sponsorship and aesthetic taste. By collecting and reproducing the most revered cultural monuments of China's scholarly heritage, Qianlong presented himself as a Confucian sage-ruler whose legitimacy to govern the Han state equaled that of earlier dynastic founders.[134]

The anthology takes part of its name from an intimate chamber in the Palace for Cultivating the Mind (Yangxin Dian), located in the emperor's private residential quarters within the Forbidden City.[135] According to the Qianlong emperor's *Record of the Hall of Three Rarities* (*Sanxi Tang ji*), dated to the second lunar month of 1746, two of the most precious works in the palace collection were *Clearing Skies Before Snow* (*Kuaixue shi-qing tie*) attributed to Wang Xizhi (see pl. 9c) and *Mid-Autumn* (*Zhongqiu tie*) attributed to his son, Wang Xianzhi (344–388). In 1746, when Qianlong acquired *Letter to Boyuan*

Section title: "Calligraphy of Zhong You of the Wei [dynasty]"

Memorial Recommending Jizhi, attributed to Zhong You

Seal of Dong Gao (1740–1818)

Volume One title

書為游藝之一前代名蹟流傳今
人興懷珍慕是以好古者怕鉤摹
鐫刻以垂諸矣禩宋淳化閣帖
其家著矣顧後大觀淳熙皆有
續刻其他名家摹奉至不可觀
我朝祕府初不以廣購博收為
尚而法書真蹟積久頗富朕曾
命儒臣詳慎審定編為石渠寶
玆一書目曰文人學士浮佳蹟數
種乃鉤摹入石於為珍玩々取羣
玉之秘壽之貞珉足為墨寶矣
觀以公天下著梁詩正汪由敦蔣
溥霙加校勘擇其先者編次摹勒
以昭書學之淵源以示臨池之
模範特諭
乾隆十二年臘月御筆

Preface by the Qianlong emperor

PLATE 9a *Model Calligraphies from the Hall of Three Rarities and the Shiqu Baoji Collection*, second half of the 18th century. Set of rubbings mounted in 32 albums, ink on paper; each page, 11 ¼ × 7 in. (28.6 × 17.8 cm). The Metropolitan Museum of Art. Gift of Marie-Hélène and Guy Weill, 1984 (1984.496.1–32). Detail. *Volume One: Preface* by the Qianlong emperor (r. 1736–95), dated 1748; and *Memorial Recommending Jizhi*, attributed to Zhong You (151–230)

(*Boyuan tie*) by Wang Xizhi's nephew, Wang Xun (350–401), he renamed the space known as the "warm room" (*nuanshi*) in honor of these three rarities.[136] A year later the emperor ordered the compilation of an anthology of model calligraphies from the imperial collection, including the three works in the Hall of Three Rarities, to be engraved in stone and reproduced as rubbings. The emperor personally composed a preface for the anthology (pl. 9a):

> *Calligraphy is the premier art form for one's amusement. Famous writings that have been passed down from earlier periods are prized and admired, and engender joyful feelings. Therefore lovers of antiquity have always persevered in tracing, copying, and engraving [these writings] in order to hand them down to successive generations. The Song Model Calligraphies from the Chunhua Hall is the most famous [example of this practice]. Later, the Daguan and Chunxi [imperial compendia of 1109 and 1185] included additional engravings.[137] Other famous masters' copy books followed until one could no longer count them all. Our dynasty's imperial collection initially did not esteem buying widely or collecting broadly, and yet genuine traces of model calligraphies were amassed in abundance so that I was able to command learned officials to examine carefully and authenticate [the collection] to produce the Shiqu Baoji catalogue [of 1745].[138] I then remembered that when scholars acquired a group of excellent writings they esteemed them as treasures and so had engraved [copies] made [so that rubbings could be produced]. Now we have made a selection of the hidden treasures of the imperial archive and immortalized them in precious stone to serve as a compendium of ink treasures for the benefit of all under heaven. I hereby make known that Liang Shizheng [1697–1763], Wang Youdun [1692–1758], and Jiang Pu [1708–1761] [have been appointed] to again compare and collate the works [in the imperial collection] in order to select those that should be engraved so as to illuminate the origins of the study of calligraphy and to serve as models for those who practice writing.[139] By special edict, imperially brushed in the twelfth lunar month of the twelfth year of the Qianlong reign period [January 19–February 16, 1748].[140]*

As noted in Qianlong's preface, the compendium takes as its precedent the first such compilation of model writings, *Model Calligraphies from the Chunhua Hall* (*Chunhua Ge fatie*), which was commissioned by the Song emperor Taizong (r. 976–97) and completed in 992. Robert Harrist has characterized this compilation as "a landmark in the imperial codification of the Wang Xizhi tradition and in the history of state-sponsored standardization of culture in China."[141] For this anthology Taizong commanded that 419 calligraphies by more than 100 writers of earlier periods, including some 160 letters attributed to Wang Xizhi and 73 letters attributed to his son, Wang Xianzhi, be engraved on wood blocks.[142] Rubbings from these blocks were then compiled into ten-volume sets, which were distributed to members of the court as an imperial favor. The *Chunhua* compendium established a precedent for the reproduction and dissemination of exemplary writings, but Qianlong's preface also refers to other Song imperial compendia, including the *Daguan* anthology of rubbings compiled in 1109 for Emperor Huizong (r. 1101–25). The modern scholar Wang Lianqi has pointed out that the decision to publish the *Hall of Three Rarities* anthology in thirty-two volumes may have been inspired by the fact that the *Chunhua* anthology consisted of ten volumes and the *Daguan* compendium, twenty-two volumes.[143]

In much the same way that the late-Ming critic Dong Qichang enumerated an Orthodox lineage of scholar painters down through the middle Ming period, the *Hall of Three Rarities* anthology extended the canon of Wang Xizhi followers to encompass calligraphers of the Song, Yuan, and Ming dynasties. This accomplished more than simply expanding the corpus of calligraphic models deemed worthy of emulation. By identifying a succession of orthodox practitioners through the end of the Ming, it implicitly linked the Qing with this classical tradition and identified the Qing court as its protector and legitimate inheritor. Significantly, Qianlong's own writing style is based on that of Dong Qichang, the last calligrapher included in the anthology.

Like its Song precursors, the *Hall of Three Rarities* anthology consists entirely of writings in regular, running, and cursive scripts derived from the style of Wang Xizhi. It excludes all seal- and clerical-script writings as well as any writings preserved on bronze or stone monuments—the so-called epigraphic tradition of studying works preserved on stelae (*bei*) or on other artifacts of metal or stone (*jinshi*) as distinct from the tradition of ink manuscripts (*tie*). But the Qianlong anthology also presents a broader spectrum of

Beginning of colophon by the Qianlong emperor, dated 1748

於至正九年六月一日復得之怳然如隔世

事以得失嵗月考之歷五十六載嗟人生之

幾何遇合有如此者後之子孫宜保藏之

吳郡陸行直題于盍中時年七十有五

史載鍾太傅事魏殊有偉績此薦焦

季直表又見其為國不蔽賢之美其書

平生所見特石刻耳若真迹之存於世

者則僅止此啓南所藏法書甚多名

固知其不能出此上也

鍾太傅書淳傳者有戎輅力命諸帖而薦季直表

尤高古淳泊蓋鍾書全以隸法行之非魏之楷

畫也二王書法子古孫宓寒辨香於此泃蓊希

Colophon and seal of Wu Kuan (1436–1504)

Memorial Recommending Jizhi, signature of Zhong You —————

— Colophon and seals of Lu Xingzhi (1275–after 1349) ⌐ ⌐————— Collectors' seals —————

Encomium of the Qianlong emperor: "Clouds of cranes roaming
across the heavens; flocks of wild geese playing across the seas"

PLATE 9b *Model Calligraphies from the Hall of Three Rarities and the Shiqu Baoji Collection,* second half of the 18th
century. Detail. *Volume One*: Colophons to *Memorial Recommending Jizhi,* attributed to Zhong You (151–230)

Beginning of colophon by the Qianlong emperor

東晉至今近千年書跡傳流至今者絕不

龍跳天門

可得快雪時晴帖晉王羲之書應代寶藏
者也刻本有之今乃得見真跡臣不勝欣
幸之至延祐五年四月二十一日
翰林學士承旨榮祿大夫知制誥兼脩
國史臣趙孟頫奉
勅恭跋

天下法書第一吾家法書第一

麻城劉承禧永存珍秘

— Colophon by Zhao Mengfu (1254–1322), dated 1318 —

Encomium of the Qianlong emperor: "Leaping dragons from the Heavenly Gate; reclining tigers in the Phoenix Pavilion"

Seal and one-character inscription,
"divine," of the Qianlong emperor

End of colophon to *Memorial Recommending Jizhi* by the Qianlong emperor, dated 1748

Section title: "Wang Xizhi of the Jin [dynasty]"

Shaoxing double seal of
Emperor Gaozong (r. 1127–62)

Clearing Skies Before Snow,
attributed to Wang Xizhi

Title strip

PLATE 9c *Model Calligraphies from the Hall of Three Rarities and the Shiqu Baoji Collection,* second half of the 18th century. Detail. *Volume One: Clearing Skies Before Snow,* attributed to Wang Xizhi (303–361), and colophons

works than that enshrined in the early-Song imperially sponsored compendia, including the works of such Tang and Song scholar-officials as Yan Zhenqing (709–785), Huang Tingjian, and Su Shi, whose writings were more individualistic than those of the early-Tang interpreters of Wang Xizhi, but who became important exemplars for later calligraphers. In this regard, the Qing anthology was significantly influenced by later private compendia of rubbings. One such compilation that may have served as a model is the ten-volume *Model Calligraphies of the Hall for Viewing Antiquity* (*Yuegu Tang tie*) of Grand Councilor Han Tuozhou (died 1207). This compendium includes works by Tang writers who had been omitted from the *Chunhua* imperial compendium as well as writers who were known as much for their merit as officials or cultural figures as for their calligraphy.[144] Significantly, upon the completion of the *Hall of Three Rarities* anthology, the engraved stones were housed in a structure named Tower for Viewing Antiquity (Yuegu Lou).

The *Hall of Three Rarities* anthology opens with *Memorial Recommending Jizhi* (pls. 9a and 9b), a work attributed to Wang Xizhi's purported model, Zhong You (151–230).[145] The remainder of the first volume and most of the second are given over to eleven examples attributed to Wang Xizhi (pl. 9c) plus one each by his son Wang Xianzhi and his nephew Wang Xun. Volumes three, four, and five contain works ranging in date from the Liang dynasty (502–557) to the Five Dynasties period (907–960), but are dominated by calligraphers of the Tang dynasty, including Ouyang Xun, Chu Suiliang, Yan Zhenqing, Huaisu (ca. 736–ca. 799), and Liu Gongquan (778–865) as well as the entire *Essay on Calligraphy* (*Shupu*) by Sun Guoting (648?–703?) and various anonymous Tang copies of works attributed to Wang Xizhi. The next ten volumes treat Song writers, with two volumes devoted to Su Shi and his relatives, one volume to Huang Tingjian, and two volumes to Mi Fu. Works by the Song emperors Taizong, Gaozong (r. 1127–62), and Xiaozong (r. 1163–89) comprise another two volumes. They are placed ahead of other Song writers but are not set apart at the beginning of the anthology in a separate section reserved for royalty, as in the earlier *Chunhua* compendium. Yuan writers occupy nine volumes. Five of those are devoted to the works of Zhao Mengfu, the brilliant early-Yuan interpreter of the Wang Xizhi tradition—more space than is given to any other calligrapher in the anthology. The final six volumes contain the works of Ming calligraphers. Four of these present the writings of Dong Qichang, including one large-character work, *Eulogy for Ni Kuan* (active late 2nd century BCE; pl. 9d), that fills two entire volumes.[146] Dong's style

derived from that of Zhao Mengfu, and he occupied a similarly commanding position in defining the calligraphic taste of the generations that immediately followed him.

The selection of writings in the anthology reveals the Qianlong emperor's bias toward plump, moist, and elegantly fluid styles, particularly those of Su Shi, Mi Fu, Zhao Mengfu, and Dong Qichang. Curiously, the emperor did not seem to favor late-Yuan and Ming interpreters of these styles. For example, among Zhao Mengfu's immediate followers, Song Ke (1327–1387) is not represented, while Yu He (1307–1382), Shen Du (1357–1434), and Shen Can (1379–1453) are represented by only one work each. Ming followers of Su Shi and Huang Tingjian, notably Shen Zhou, Wu Kuan, and Wen Zheng-ming, are similarly represented by only one or two works each. More eccentric calligra-phers, including Yang Weizhen (1296–1370), Chen Xianzhang (1428–1500), Wang Chong (1494–1533), and Xu Wei (1521–1593), are not included. Ideological consid-erations undoubtedly also influenced Qianlong's preferences. Emperor Gaozong is fea-

PLATE 9d *Model Calligraphies from the Hall of Three Rarities and the Shiqu Baoji Collection,* second half of the 18th century. Detail. *Volume Thirty-one: Eulogy for Ni Kuan* [active late 2nd century B C E] by Dong Qichang (1555–1636), ca. 1612–16

tured among Song rulers, but works by emperors Huizong and Lizong (r. 1225–64), both noted calligraphers, are excluded—probably because these rulers were judged to be politically weak. Furthermore, practitioners of the archaic lean and angular writing style first associated with Zhong You and later favored by such noted Song and Yuan scholars as Li Gonglin, Qian Xuan, and Ni Zan—all of whom could be considered political outsiders or recluses—are generally overlooked.

The selection of works benefited from the scholarship invested in the *Shiqu Baoji* catalogue of paintings and calligraphy in the imperial collection, which was presented to the throne in the tenth lunar month of 1745.[147] Nevertheless, the anthology still contains errors of connoisseurship. *Epitaph for My Wet-Nurse* (*Baomuzhi tie*), a work traditionally attributed to Wang Xianzhi, had already been identified as a forgery in Song times. *Clearing Rain Over Luoyang* (*Luoyang yuji shi*), identified as a work by Huang Tingjian, is dated 1107, two years after Huang's death.[148]

The anthology goes beyond earlier imperial compendia in the reproduction of 210 colophons and numerous collectors' seals that accompany the primary works—a practice first initiated in the many compilations of private collections published during the late-Ming period.[149] Thus, in addition to serving as an orthodox canon, the anthology documents the history of connoisseurship and transmission of this body of masterworks.

Aside from the scholarship required to select a reliable group of originals for reproduction, the Qianlong anthology is extraordinary both in its scale and in the technical virtuosity of its carving. Records preserved in the imperial archive make it possible to reconstruct step-by-step the process of creation. Wan-go Weng has described the process by which the original manuscripts would have been engraved into stone and then reproduced in the form of rubbings:

> *The best printing technique available in eighteenth-century China for such undertakings was the painstaking method of ink rubbing from stone engravings. This involved tracing the original in ink onto paper soaked in oil and thoroughly dried to make it translucent. The tracing was then reproduced on the back of the paper in cinnabar ink and the cinnabar tracing transferred onto a finely polished flat stone. The characters were engraved into the stone following the cinnabar tracings; next, paper was laid over the stone, dampened, and pressed*

carefully into the engraved lines. Finally, ink was patted over the surface of the paper but did not reach the paper pressed into the intaglio-carved characters, which appear white against black on the printed sheet.[150]

The rubbings in the *Hall of Three Rarities* anthology are notable for their precise carving style and glossy black finish, as well as the way in which streaks of the brush (see pl. 9d) and seals impressed over the writing (see pl. 9c) have been suggested. But the resulting images are still thrice removed from the original. In making a tracing copy, the outline of each stroke is followed, but the hairline ligatures that connect some strokes or the streaks of the brush that occur when bristles separate cannot be entirely replicated; thus a certain simplification of the form is introduced. The clarity and nuances of the original are further blunted when the tracing copy is carved into stone. Finally, when a rubbing is made from the engraved stone, not only are the inked areas of the original transformed into the white, uninked areas of the rubbing, but distortions are inevitably introduced when the uninked portions of the paper, which had been pressed into the interstices of the carved stone, are flattened out in the mounting process.

In addition to these unavoidable mechanical limitations of the reproduction process, careful comparison of the rubbings with the original manuscripts reveals that the editors and carvers frequently took liberties in the interpretation of their models. This may be illustrated by comparing the rubbing of Wang Xizhi's *Ritual to Pray for Good Harvest* (*Xingrang tie*; pls. 9e and 9f) from volume one of the compendium with the original manuscript (fig. 46), now in The Art Museum, Princeton University.[151] First, the carvers increased the spacing between some characters (eliminating the subtle interaction between them) to make the two columns of text equal in length; they also narrowed the space between the two columns. Second, the carvers eliminated some collectors' seals and inscriptions, while rearranging others so that they appear in chronological order. The rubbing begins with the two columns of Wang's letter (the small-character inscription and the seals to the right of these two lines belong to the preceding entry in the anthology). Next follows a title strip, placed above three seals belonging to Emperor Huizong. But the title strip is not that of Huizong, which on the original appears as a blue strip of silk with gold writing (now partially illegible) attached to the Song mounting that frames the letter. Instead,

一二五　授才為右券耶　如印必宣和譜印傳流者　視之遠愧焉希代之實　多雖廣以後虞褚諸名家　雲川筆蒼勁魚籀篆之　庄為內殿祕藏無甚楷規　序一類又有宣和政和小印　廟金標品書与西界佳聖教　書譜中詰刻未齊卋宗嶽　為已實也此行襄帖存學　先沒有淳化時未生而宣和　时姑出者二不可盡以王著　五古第一粃在有帖之外降　可知之然人百兩花不售物　滿府内物御府或时代有　銀版故多作先跡中掛　主著不具言覽僅憑倣書

一二五

一二四

一二三

Colophon by Dong Qichang, dated 1604

授才為右券耶　如印必宣和譜印傳流者　視之遠愧焉希代之實　多雖廣以後虞褚諸名家　雲川筆蒼勁魚籀篆之　庄為內殿祕藏無甚楷規　序一類又有宣和政和小印　廟金標品書与西界佳聖教　書譜中詰刻未齊卋宗嶽　為已實也此行襄帖存學　先沒有淳化時未生而宣和　时姑出者二不可盡以王著　五古第一粃在有帖之外降　可知之然人百兩花不售物　滿府内物御府或时代有　銀版故多作先跡中掛　主著不具言覽僅憑倣書　帖不能備載古軍佳書而　育三行襄帖与一也以昌化古　宣和時收右軍先跡百四十　董其昌寶翫弁教

PLATE 9e (above) and **FIGURE 46** (below), continued

140

Colophon by Dong Qichang

Title strip by
Dong Qichang

Colophon to the preceding entry
by the Qianlong emperor

Northern Song
palace seal

Seals of Emperor
Huizong (r. 1101–25)

Ritual to Pray for Good Harvest,
attributed to Wang Xizhi

Colophon by Dong Qichang:
a transcription of Wang Xizhi's text

Title strip by Emperor Huizong

Title strip by
Dong Qichang

Colophons by the Qianlong
emperor, dated 1748

Encomium of the
Qianlong emperor

PLATE 9e (above) *Model Calligraphies from the Hall of Three Rarities and the Shiqu Baoji Collection*, second half of the 18th century. Detail. *Volume One*: Colophon by the Qianlong emperor (r. 1736–95) to preceding entry; and *Ritual to Pray for Good Harvest*, attributed to Wang Xizhi (303–361), and colophons by Dong Qichang (1555–1636)
FIGURE 46 (below) *Ritual to Pray for Good Harvest*, attributed to Wang Xizhi (303–361). Tang-dynasty tracing copy of a letter, mounted as a handscroll, ink on *yinghuang* paper; letter, 9 ⅝ × 3 ½ in. (24.4 × 8.9 cm); entire scroll, 11 ⅞ × 146 ½ in. (30 × 372 cm). The Art Museum, Princeton University. Bequest of John B. Elliott, Class of 1951 (1998–140.1). Photo Credit: Bruce M. White. Detail, including colophons by the Qianlong emperor and Dong Qichang

Beginning of next entry: *Sightseeing,* after Wang Xizhi

Colophons by the Qianlong emperor, dated 1748

End of colophon
by Dong Qichang
dated 1604

Yuyi seal (misplaced from the following entry)

Beginning of colophon by Dong Qichang, dated 1609

PLATE 9f (above) *Model Calligraphies from the Hall of Three Rarities and the Shiqu Baoji Collection,* second half of the 18th century. Detail. *Volume One*: Colophons by the Qianlong emperor (r. 1736–95) to *Ritual to Pray for Good Harvest;* and opening section of *Sightseeing,* after Wang Xizhi (303–361) **FIGURE 46** (below) *Ritual to Pray for Good Harvest,* attributed to Wang Xizhi (303–361). Detail. Colophons by Dong Qichang (1555–1636)

the editors have substituted the title written by Dong Qichang, which on the original scroll appears along the right side of a later mounting brocade. In the rubbing, not only has Dong's title usurped that of Huizong, but the characteristic disposition of Huizong's seals at the four corners of the original piece of paper has been disregarded.[152] The rubbing version next presents three inscriptions by Dong Qichang, but Dong's fourth inscription (fig. 46), written in large running script, and an inscription by Sun Chengze (1592–1676) have been eliminated. The rubbing ends with the two inscriptions by the Qianlong emperor that on the original precede Dong's inscriptions. These two imperial inscriptions are accompanied by the seals used on the original, but all the other collectors' seals—including some of those of the Qianlong emperor—have been omitted. The most notable omissions are the seals of the collector Wu Ting (active ca. 1575–1625), who first published the letter in an anthology of rubbings in 1614, and the Korean salt merchant An Qi (ca. 1683–ca. 1744), the source of many of the finest pieces in the imperial collection.[153] Thus the history of the letter's transmission has been truncated and distorted in the rubbing.[154]

The texts and seals of the preceding and following entries in the anthology crowd those of the Wang Xizhi letter so that they often share space on the same or facing page without any device for demarcating the break between the works. This format, probably adopted to conserve space, can lead to confusion as to what colophon or seal belongs with what text. For example, the rubbing shows a collector's seal with the legend *yuyi* occupying the space between the third Dong Qichang inscription and the first Qianlong inscription. This seal, however, actually belongs to the next entry, Wang Xizhi's letter *Sightseeing* (*Youmu tie*), where its original position was just to the right of Wang's first

FIGURE 47 After Wang Xizhi (303–361). *Sightseeing.* Letter mounted as a handscroll, ink on paper (destroyed during World War II). Photograph courtesy of The Art Museum, Princeton University. *Yuyi* seal indicated by circle

character (fig. 47).[155] In rearranging the seals for this entry, the *yuyi* seal evidently became separated from its original context and was mistakenly inserted in the preceding entry.

According to the research of the modern scholar Wan Yi, a rough chronology of the creation of the *Hall of Three Rarities* anthology can be reconstructed from evidence in the imperial archives. The project was inaugurated around January 1748, when the emperor composed his preface. The selection process took about one and a half years, and tracing copies began to be made in the seventh lunar month of 1749. A year later, in the seventh month of 1750, the editors composed their postface for the anthology. The work of carving seems to have been completed in 1752, but payment for this work was not issued until the third month of 1753.[156] By mid-1753 the 495 stones used in the project, each measuring approximately three and a half feet in length, were installed in the Tower for Viewing Antiquity, a specially built twenty-five-bay, two-story structure situated on White Dagoba Hill in the imperial gardens adjacent to the Forbidden City, in what is now Beihai Park (the stones remain on view in this location). In the first month of 1754 the imperial court issued a first edition of fifty-two sets of rubbings, each set consisting of thirty-two volumes.[157]

Numerous additional sets of rubbings were made in subsequent years until 1839 (the nineteenth year of the Daoguang reign era), when a major restoration of the stones was undertaken, a project that included the recutting of a number of the characters and the addition of a decorative border around each stone (fig. 48). A full inventory of the anthology's contents was conducted as part of the restoration. According to the Daoguang inventory, the number of characters contained in the anthology totals 99,643: 76,472 one-inch characters; 21,586 two-inch characters; and 1,585 three- and four-inch characters. The inventory also records a total of 1,642 seals reproduced in the anthology.

FIGURE 48 *Model Calligraphies from the Hall of Three Rarities and the Shiqu Baoji Collection.* Rubbing made after 1839 when ornamental borders were added. Detail. *Volume One: Clearing Skies Before Snow*, attributed to Wang Xizhi (303–361). Photo after Wan Yi 1980, fig. 4, p. 75

PLATE 9g (right) *Model Calligraphies from the Hall of Three Rarities and the Shiqu Baoji Collection*, second half of the 18th century. Detail. Unidentified scribe for Dong Bangda (1699–1769). Colophon on front end-sheet, Volume Two. Ink on yellow mounting paper **PLATE 9h** (left) *Model Calligraphies from the Hall of Three Rarities and the Shiqu Baoji Collection*, second half of the 18th century. Detail. Unidentified scribe for Dong Bangda (1699–1769). Colophon on front end-sheet, Volume Seven. Ink on yellow mounting paper

The date of the Weill set of rubbings requires further study. Each volume in the set is mounted with yellow front and back end-sheets and provided with a wooden cover (Catalogue, pl. 9i, page 185) into which the title and volume number have been incised and filled in with a green pigment, as is customary in Qing imperial mountings. Furthermore, each volume of the set bears the following inscription on the front end-sheets (pls. 9g and 9h):

> *On the solstice in the* renshen *year of the Qianlong reign era* [*June 21 or December 21, 1752*], *Honorary Palace Attendant and Vice Minister of Rites, recorded seven times* [*for meritorious service*], *Dong Bangda.*

Dong Bangda (1699–1769), an eminent official and scholar-painter, served as one of the proofreaders in the project. If the inscriptions are reliable, the Weill set predates the first

official edition of rubbings produced in 1754 and must have been made so that Dong could fulfill his role as proofreader. Curiously, however, the inscriptions were not written by Dong Bangda, but by two assistants whose contributions are distinguishable by differences in their handwriting. Each of these scribes also used a different set of Dong's seals. Eighteen volumes (1–4, 8, 16, 21–32) were inscribed by one assistant, who used one set of seals (pl. 9g); the remaining fourteen volumes (5–7, 9–15, 17–20) were inscribed by a second assistant in somewhat smaller characters and using a different set of seals (see pl. 9h). Whether or not the Weill set of rubbings originally belonged to Dong Bangda, the seals (see pl. 9a) belonging to Dong Bangda's son, Dong Gao (1740–1818), which have been stamped on the first and last pages of each volume, appear reliable.[158]

Even without the benefit of this evidence, the Weill set may still be securely dated to the Qianlong era. According to Wan Yi, in 1792 volume eighteen of the anthology was amended by the insertion of a note at the end of the volume, identifying *Epitaph for Wei Yiren* (*Wei Yiren muzhi*), a calligraphy signed Zhao Mengfu, as a forgery. Furthermore, rubbings made after 1839 typically show the ornamental border carved into the stones at that time (see fig. 48). The Weill set of rubbings includes neither this note nor the border, clear indications that it was made prior to 1792. Indeed, the sharpness of the carving and the crisp quality of the rubbings support the likelihood that the set was one of the first to be made from the stones.

ZHANG DAQIAN

Zhang Daqian (Chang Dai-chien, 1899–1983), or Zhang Yuan, was one of the leading collectors, connoisseurs, and artists of the twentieth century. A native of Neijiang, Sichuan Province, Zhang learned to paint flowers as a child from his mother. At the age of nineteen he went to Kyoto to study textile weaving and dyeing. Returning to China in 1919, Zhang lived briefly as a Buddhist novice, adopting the name Daqian, before moving to Shanghai, where he studied painting and calligraphy with the Qing loyalist painters Zeng Xi and Li Ruiqing (1867–1920).[159]

For the next two decades Zhang supported himself through painting and dealing in Shanghai and nearby Suzhou. Trapped in Beijing at the outbreak of the Sino-Japanese war in 1937, Zhang escaped to his native province of Sichuan in the guise of a monk

PLATE 10 Detail

PLATE 10 Zhang Daqian (1899–1983). *Red Orchid*, datable to 1950. One of a pair of folding fans mounted as an album leaf, ink and color on gold paper, 5 ¼ × 17 in. (13.5 × 43 cm). The Metropolitan Museum of Art. Promised Gift of Marie-Hélène and Guy Weill

and eventually made his way to the remote Buddhist cave-temple site of Dunhuang in northwestern Gansu Province. Between 1940 and 1943 he studied, catalogued, and made copies of the brilliantly colored wall paintings there, most of which date from the fifth to the tenth century. In late 1949 Zhang fled the Communist revolution and moved to Hong Kong. Responding to an invitation to exhibit his works in New Delhi, he traveled to India in January 1950, remaining there for more than a year before settling in São Paulo, Brazil.[160]

Zhang Daqian's exposure to varied traditions of flower painting is conveyed by *Red Orchid* (pl. 10), a painting originally mounted on a folding fan that may be dated to the period when Zhang was sojourning in Darjeeling, a semitropical part of India situated on the southern slopes of the Himalayas. According to his inscription, "Darjeeling produces numerous orchids, but the red orchid is the most outstanding." The orchid, precisely delineated, colored with a heavy application of mineral pigments, and spread

PLATE 11 Zhang Daqian (1899–1983). *Poem*, dated 1950. One of a pair of folding fans mounted as an album leaf, ink on gold paper, 5 ¼ × 17 in. (13.5 × 43 cm). The Metropolitan Museum of Art. Promised Gift of Marie-Hélène and Guy Weill

out flat against the screenlike folds of the fan, recalls Zhang's images of lotus and other blossoms painted during the late 1940s.[161] In such paintings, Zhang synthesized the precise, descriptive style of the Chinese academic tradition of bird-and-flower paintings with the vivid palette and use of gold background favored by Japanese artists of the Rimpa and Nihonga traditions.[162]

In *Red Orchid* Zhang does not employ shading to model his forms. Instead, he relies entirely on supple outlines to define the twisting and bending leaves and petals; a further sense of three-dimensionality is imparted by the occasional overlapping of forms. The outlines of the orchid petals are reinforced in gold, a stunning accent that functions not as naturalistic highlighting but as ornamental embellishment. While Zhang's inscription suggests that he derived inspiration from the local flora, the sumptuous style he has used to capture the flower's likeness comes from his synthesis of Chinese and Japanese flower-painting techniques.

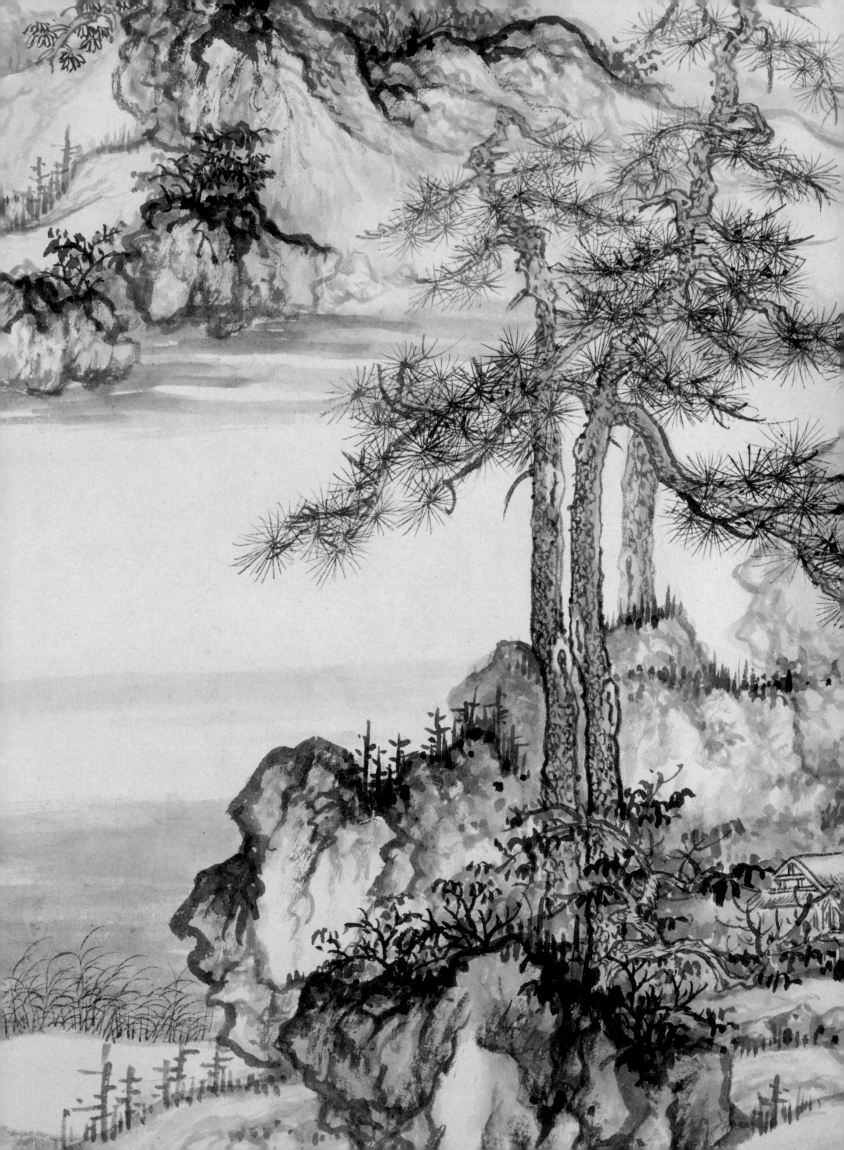

A second, longer inscription by Zhang (see Catalogue, page 187, for the translation of the inscription), originally mounted on the reverse side of the fan but now mounted as a separate album leaf, still accompanies the painting (pl. 11).

WANG JIQIAN

Wang Jiqian (Wang Chi-ch'ien, born 1907), better known in the West as C. C. Wang, formed one of the most important private assemblages of Chinese old master paintings in the twentieth century. A resident of New York City since 1949, Wang has been a major source of Chinese paintings in American public collections, including some sixty works at the Metropolitan Museum. Wang does not think of himself primarily as a collector; instead, his interest in collecting was an integral part of deepening his expression as a painter. Indeed, Wang epitomizes the Chinese scholarly tradition of combining collecting with creativity, acquiring works of art as a way of learning from the past.

During the 1930s and 1940s Wang, a native of Suzhou, resided in Shanghai, where he came in contact with many of the leading artists and collectors of the day. Under the tutelage of a fellow native of Suzhou, the traditionalist artist and connoisseur Wu Hufan (1894–1968), Wang studied painting by copying the styles of the Orthodox school canon of old masters. Through his mentor, Wang gained access to many important private collections, notably that of Pang Yuanji.[163] As advisor to the selection committee for the 1935–36 exhibition of Chinese art held at Burlington House, the Royal Academy of Arts in London, he had the extraordinary opportunity to study firsthand masterworks in the collection of the Chinese Palace Museum.[164]

Wang's exposure to antique masterpieces is reflected in *Landscape after Guo Xi* (pl. 12), painted in the summer of 1937. A rare early work, it shows the artist still painting under the influence of Wu Hufan (fig. 49). Wu, the grandson of Wu Dacheng (1835–1902), perpetuated the Orthodox school ideal of learning from the intensive study of ancient masters. Benefiting from his family collection and contact with other collectors, Wu was able to study and collect works by earlier masters canonized by Dong Qichang. He passed on this knowledge to a number of his students, including both Wang Jiqian and Xu Bangda (born 1911), who would become the leading connoisseur of painting at the Palace Museum, Beijing.

PLATE 12 Detail

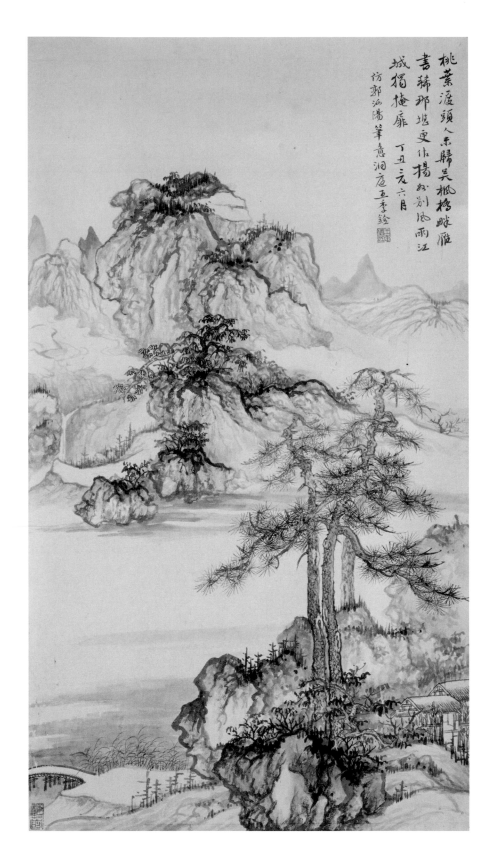

Wu Hufan's album leaf *Twin Pines, Secluded Valley after Zhao Mengfu* (fig. 49), dated 1933, is the kind of painting that Wang Jiqian would have seen in his mentor's studio. A free interpretation of the style of the Yuan scholar-artist Zhao Mengfu, Wu's painting may be compared with Zhao's *Twin Pines, Level Distance* (fig. 50), which was later owned by Wang. Zhao's painting represents a dramatic reinterpretation of the landscape style of the Northern Song master Guo Xi (fig. 51). Purging his painting of the ink washes employed by Guo Xi to model surfaces

and suggest the veiling effects of atmosphere, Zhao reduced Guo's landscape forms to a set of self-consciously calligraphic brushstrokes so that his painting would be appreciated in the same way as calligraphy — as self-expression rather than as representation (see fig. 38). While Wu Hufan's painting does not lack calligraphic brushwork, he has retreated from the austere minimalism of Zhao Mengfu and reintroduced a rich variety of ink washes more characteristic of Zhao's model, Guo Xi. The trunks of Wu's pines, for example, show a complex overlapping of lines and dots that begin to function like shading.

Wang Jiqian's landscape, done four years later, takes Guo Xi as its source of inspiration. By this time Wang would have seen Guo's masterpiece, *Early Spring* (fig. 51), dated 1072, now in the collection of the National Palace Museum, Taipei. In spite of his first-hand familiarity with the early master's work, however, Wang's painting shows an even greater commitment to Zhao Mengfu's style of calligraphic brushwork than does Wu Hufan's work. Wu's painting compresses distance, diminishing the sense of intervening space between foreground, middle ground, and far distance. Wang's painting, on the other hand, exaggerates the separation of foreground and distant landforms in a manner more typical of Yuan painting. While Wang is obviously well versed in Guo Xi's rock and tree forms as well as Guo's techniques of using layered ink washes to build up forms, the

PLATE 12 Wang Jiqian (C. C. Wang, born 1907). *Landscape after Guo Xi [ca. 1000–ca. 1090]*, dated 1937. Hanging scroll, ink on paper, 35 ⅞ × 19 ⅞ in. (91 × 50.5 cm). The Metropolitan Museum of Art. Promised Gift of Marie-Hélène and Guy Weill **FIGURE 49** Wu Hufan (1894–1968). *Twin Pines, Secluded Valley after Zhao Mengfu*, dated 1933. Framed album leaf, ink on paper, 16 ⅜ × 13 ¾ in. (41.5 × 35 cm). Collection unknown. (After Sotheby's 1989, lot 14)

assertive linear contours that dominate Wang's forms reflect a much greater interest in calligraphic brushwork. The trunks of Wang's pines, for example, have been tinted with wash but are much more linear and less painterly than Wu's. Wang successfully merges Song and Yuan models—an objective that Wang Hui had pursued nearly three hundred years earlier. In his ability to animate Guo Xi style mountains with the kinesthetic brushwork of the Yuan, Wang reveals his lifelong preference for calligraphic brushwork over descriptive detail.

Although his painting is not based on actual scenery, the poem Wang has inscribed on the painting (see Catalogue, page 188, for the translation of the poem) alludes to several scenic spots in Zhejiang and Jiangsu provinces—all places that he would have been familiar with—and highlights Wang's identification with this region and its scholarly traditions. In his inscription following the poem, he proudly proclaims that he comes from Mount Dongting, a peninsula that juts into Lake Tai, just west of the city of Suzhou.

In 1947, ten years after he painted *Landscape after Guo Xi*, Wang Jiqian made his first trip to the United States, settling in New York City in 1949. Forty years later, when Marie-Hélène and Guy Weill saw the painting at auction, they had already known Wang for more than fifteen years. By that time, he had developed a distinctive manner of his

FIGURE 50 Zhao Mengfu (1254–1322). *Twin Pines, Level Distance*, ca. 1301. Handscroll, ink on paper, 10 ½ × 42 ¼ in. (26.9 × 107.4 cm). The Metropolitan Museum of Art. Ex coll.: C.C. Wang Family, Gift of The Dillon Fund, 1973 (1973.120.5)

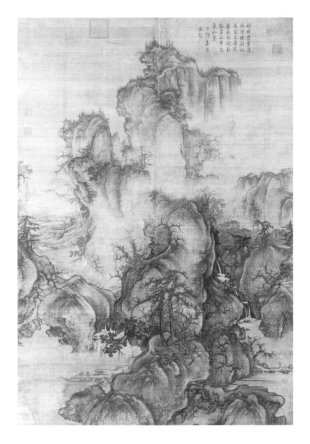

own, first experimenting with the minimalist style of Ni Zan, and later exploring the monumental landscape manner of Fan Kuan and Dong Yuan.[165] Seldom did he return to the idiom of Guo Xi. Nevertheless, the Weill painting represents the thorough grounding in the styles of the early masters that preceded Wang's development of a more personal expression. It also shows that Wang had mastered the ability to incorporate and synthesize varied earlier styles to create new interpretations of the past. That is the hallmark of Chinese scholar-painting: to transform images of nature through the process of learning from past models and then integrating those models to achieve a uniquely personal style—one's own cultivated landscape. Such landscapes are not literal records of nature but refined exercises in transforming natural imagery through the lens of culture and tradition. In Wang's painting, there is no thought of actual landscape; rather, it is a topography shaped by a tradition that has been re-experienced and renewed through the eye and hand of the cultivated practitioner.

To comprehend such a landscape one must unravel its lineage and discover its historical sources. Only those who have studied long and looked deeply can appreciate the messages these images embrace. For the Weills, this journey of self-cultivation has led not only to the creation of a collection that encompasses the ideals of Wang Jiqian and other traditional connoisseurs, but to a profound understanding and love of Asian art. Through thirty years of shared passion, Marie-Hélène and Guy Weill have made a home for themselves within that world. When we look at these cultivated landscapes, we see not only the artists who created them but the collectors who have cherished and preserved them. There, in the heart of the landscape (pl. 51), we might discern two *zhiyinzhe*—connoisseurs whose understanding surpasses all words.

FIGURE 51 Guo Xi (ca. 1000–ca. 1090). *Early Spring*, dated 1072. Hanging scroll, ink and color on silk, 62 3/8 × 42 5/8 in. (158.3 × 108.1 cm). National Palace Museum, Taipei

1 The literature on landscape in Chinese art is extensive. For an introduction and references, see Munakata 1990.

2 The geographer George B. Cressy observed: "More people have lived in China than anywhere else. Upwards of 10 billion human beings have moved across her good earth; nowhere else have so many people lived so intimately with nature. A thousand generations have left their indelible impress on soil and topography, so that scarcely a square foot of earth remains unmodified by man… Few landscapes are more human." See Cressy 1955, p. 3, as cited in Mote 1989, p. 1.

3 Edwards et al. 1976, p. 1.

4 For a discussion of late-Tang and Five Dynasties (907–960) landscape painting, see Hearn and Fong 1999, pp. 12–28, 72–80.

5 See Barnhart 1972 and Harrist 1998.

6 See Sensabaugh 1981, pp. 44–69.

7 See Vinograd 1982.

8 See Cahill 1981.

9 For a description of the Daguan Garden, see Cao Xueqin, vol. 1, pp. 324–47.

10 The standard sources for Shen Zhou's biography are the accounts found in the *Ming shi* and *Wusheng shishi*, which are largely translated in Sirén 1957–59, vol. 4, pp. 148–50 together with other anecdotes and recorded comments as part of a larger treatment of Shen's artistic achievements (pp. 151–64). Sirén's work was expanded in Edwards 1962 and in Edwards' biographical entry under "Shen Chou" in *DMB*, pp. 1173–77. Other valuable evaluations of Shen's life and art are found in Cahill 1978, pp. 80–96; Rogers and Lee 1988, pp. 124–25; Loehr 1980, pp. 276–79; and in two recent studies in Chinese, Chen Zhenghong 1993 and Zheng Bingshan 1982.

11 See Rogers and Lee 1988, p. 124.

12 This translation has benefited both from the translation of Wan-go Weng in Christie's 1988, p. 36, and from the assistance of Shi-yee Liu.

13 For a reproduction of two paintings from this album, formerly in the collection of Zhang Xueliang (1901–2001), and a translation of Shen's inscription, see Cahill 1978, pp. 87–88 and color pls. 4 and 5.

14 For a fuller discussion of this painting, see Cahill 1978, p. 86. Shen Zhou's inscription, dated 1477, states that he painted this work six years earlier. See also Ecke 1965, pl. 44.

15 Shen Zhou's interpretation of Huang Gongwang's style had an important influence on later Wu school

painters and was widely imitated. See, for example, a landscape by Wang Chong (1494–1533) reproduced in Cahill 1978, pls. 124 and 125.

16 According to Cahill, this instability is an innovation that Shen probably learned from an older friend, the Suzhou scholar-artist Liu Jue (1410–1472); see Cahill 1978, p. 81.

17 This translation has benefited from the assistance of Shi-yee Liu.

18 The pictorial content of such collaborative works was often inspired by the patron's sobriquet (*biehao*); see Liu Jiu'an 1990; see also Clapp 1991, pp. 67–100.

19 For biographical information on Wu Kuan, see the entry by Lee Hwa-chou under "Wu K'uan" in *DMB*, pp. 1487–89.

20 See Chen Zhenghong 1993, pp. 134ff.

21 See Cahill 1978, p. 87 and pl. 35.

22 See Fu Shen et al. 1977, p. 133.

23 For biographical information on Wen Zhengming, see Clapp 1975; Edwards et al. 1976; and Cahill 1978, pp. 211–39.

24 See Cahill 1978, pp. 238–39.

25 This translation, which benefited from the assistance of Shi-yee Liu, is after that of Ling-yün Shih Liu and Richard Edwards in Edwards et al. 1976, p. 150.

26 Information about Liu Lin is from Edwards et al. 1976, pp. 150.

27 See *Ming shi, juan* 194, p. 226a as cited in ibid.

28 The calligraphy is in the collection of the Nanjing Museum; see *Zhongguo gudai shuhua mulu* 1989, vol. 7, *Su* 24–0025.

29 Gu Qiyuan (1565–1628), in his *Kezuo zhuiyu* (Idle Talk while Seated with Guests), of 1618, rails against the improprieties of the late-Ming nouveaux riches of Nanjing; see Gu Qiyuan 1618. See also Clunas 1991, pp. 141–65.

30 See Sullivan 1973, pp. 41–67; and Cahill 1982a, pp. 70–105.

31 For Dong's art, theories, and biography, see Ho and Smith 1992.

32 For Zhou's connections to Wang Shimin and Wang Hui, see Kim 1996, pp. 121–37.

33 In his *Guochao huazheng lu* of 1739, Zhang Geng (1685–1760) lists the eight artists customarily known as the "Eight Masters of Jinling," but a 1683 colophon by Cao Rong (1613–1685) mentions the number eight in referring to contemporary Nanjing masters; see Rogers and Lee 1988, no. 47, p. 172. For a listing and discussion of the so-called Eight Masters, see Sirén 1957–59, vol. 5, pp. 128–37.

34 Liu's extant dated works range from 1672 to 1689. Seals and a signature from a work datable to either 1711 or 1651 and published in *Zhongguo shuhuajia yinjian kuanshi* 1987, vol. 1, p. 663, suggest a longer period of activity, but I have not been able to track down this painting. For Liu's published works, see *Zhongguo gudai shuhua mulu* 1990, vol. 4, p. 382, *Hu* 1–2865, and colophon, p. 463, *Hu* 1–2710; vol. 5, p. 135, *Hu* 1–3408; *Zhongguo gudai shuhua mulu* 2000, vol. 23, pp. 38–45, *Jing* 1–5091–96; Shan Guoqiang 1997, nos. 86–88, 102–04; Sirén 1957–59, vol. 7, p. 378; Guo Weiqu 1958, pp. 282, 283, and 294; and Shu Hua 1978.

35 See Zhou Lianggong 1673, *juan* 4, p. 61 in *Huashi congshu* 1963, p. 2095. For a discussion of extant works from Zhou's collection, see Kim 1985 and Kim 1996.

36 See Song Luo 1711, *juan* 28. I am indebted to Yangming Chu for locating this reference.

37 See Song Luo 1688, *juan* 20, pp. 8–10.

38 The album is dated to the tenth lunar month of 1689.

39 See the entry on Liu Yu in *Zhongguo meishujia renming cidian* 1981, p. 605.

40 *Tuhui baojian xuzuan* 1963, vol. 2, p. 890. For a discussion of the term "scholarly spirit," see Kim 1996, pp. 53–55.

41 This translation is from a label text by Joseph Chang, Associate Curator of Chinese art, Freer Gallery of Art and Arthur M. Sackler Gallery, Smithsonian Institution, Washington, D.C., which he kindly shared with me.

42 For Liu Yu's seal (*Liu Yu zhi yin*) and signature accompanying this colophon, which match those on the Weill painting, see *Zhongguo shuhuajia yinjian kuanshi* 1987, vol. 1, p. 663. Zhou Eryan added colophons to several of Wang Hui's paintings, including another scroll also inscribed by Liu Yu; see Wang Hui 1911b, *juan* 6, p. 18.

43 Wang Hui 1911a, vol. 2, p. 29. A reference to this letter was published earlier by Hongnam Kim, who offers a different translation; see Kim 1996, p. 135. I am indebted to Zhixin Sun for help with this translation and for identifying the reference to *Chengxintang* paper.

44 Wang Hui 1911a, vol. 2, p. 29. This translation was done with the help of Zhixin Sun.

45 Translation by Yangming Chu.

46 See Shan Guoqiang 1997, no. 86.

47 See Nishigami Minoru 1981, p. 302. For a reproduction of Shitao's inscription on this album of painting and calligraphy, now in the Shanghai Museum, see *Shitao shuhua quanji* 1995, vol. 1, pl. 95. Shitao refers to Liu by his *hao* "Liu Gonghan" but mistakenly writes the character for *han* as 含 not 韓. Additional evidence for Liu's connection with patrons of other prominent Ming loyalists is provided by a short undated handscroll by Liu that depicts Mount Tianyin, Jiangsu Province. This painting, now in the Shanghai Museum, is mounted together with another painting of the same subject done in 1686 by Dai Benxiao; see *Zhongguo gudai shuhua mulu* 1990, vol. 5, p. 135, *Hu* 1–3408.

48 See Shan Guoqiang 1997, no. 102.

49 For Yun Xiang's influence on Gong Xian, see Cahill 1970, p. 56.

50 For a transcription of Liu Yu's inscription on this painting, see Shan Guoqiang 1997, pp. 251. I am grateful to Zhixin Sun for help with this translation.

51 For the 1672 handscroll, see *Zhongguo gudai shuhua mulu* 2000, vol. 23, pp. 38–39, *Jing* 1–5091.

52 The album may be dated based on the dates of the colophons inscribed on the facing pages; see *Zhongguo gudai shuhua mulu* 2000, vol. 23, pp. 41–42, *Jing* 1–5094. For color reproductions of the paintings, see Shan Guoqiang 1997, pp. 252–56.

53 Qin Zuyong 1864, vol. 1 (*shang*), pp. 22–23. Translated with the assistance of Shi-yee Liu.

54 For a discussion of Wang's 1672 copy of Huang's *Fuchun Mountains*, see Lovell 1970, pp. 217–42.

55 Biographical information about Dai is drawn from Nishigami Minoru 1981, pp. 291–340; the Chinese version of that paper, Nishigami Minoru 1987, pp. 118–78; and Ho and Smith 1992, p. 149. I have also benefited from James Cahill's discussion of Dai in his 1986 draft chapter for a book on early Qing painting, which he generously shared with me; see Cahill 1986.

56 For biographical information on Wang, see the entry by Fang Chao-ying under "Wang Shih-chen" in *ECCP*, pp. 831–33.

57 Cahill 1986, p. 86, citing an inscription by Dai on a long handscroll transcribed and discussed in Nishigami Minoru 1981, pp. 308ff. See also Nishigami Minoru 1987, pp. 136–37.

58 For a discussion of Mount Tiantai and its religious significance, see Fong 1958, especially pp. 15–27. See also Murray 1988, pp. 60–64.

59 For descriptions and photographs of the actual bridge, see Fong 1958, pp. 15–17, pl. 18; and Murray 1988, fig. 10. The geographer-diarist Xu Xiake (1586–1640) visited the bridge in 1613; for a translation of his description of the bridge, see Li Chi 1974, p. 35. For a flowery description of the bridge by the poet Sun

Chuo (ca. 310–397), see Mather 1961, pp. 226–45, especially p. 239.

60 Fong 1958, p. 16.

61 Xu Xiake takes note of Mount Tiantai's distinctive pines in the account of his visit to the site: "Lianzhou and I took the way to the Natural Bridge. We walked five *li* and passed Jinzhu Hill, enjoying as we went along the dwarf pines that cover the hillsides. They have old knotty trunks and lovely green sprays and are the kind of choice pines that one sees in pots in Suzhou"; translation after Li Chi 1974, p. 33.

62 This translation is adapted from Delbanco 1986, p. 96.

63 Cahill 1986, p. 91.

64 See Fu Shen 1976, Chinese text, pp. 579–603; English text, pp. 604–15.

65 For a discussion of Dai's stylistic characteristics, see Xue Yongnian 1987, pp. 293–304.

66 For the stylistic connections between Dai and Dong, see the discussion by Richard Edwards in Ho and Smith 1992, no. 137, pp. 149–51.

67 Mei Qing was born in the third year of the Tianqi reign era, which corresponds roughly to the year 1623 in the Western calendar; most sources, therefore, give Mei's date of birth as 1623. But his actual date of birth, the twenty-fourth day of the twelfth lunar month of that reign year, corresponds to February 11, 1624. See Yang Chenbin 1985, p. 51.

68 Biographical information on Mei Qing is drawn primarily from Yang Chenbin 1985 and 1986 and Rogers and Lee 1988, no. 43.

69 For biographical information on Mei Dingzuo, see the entry by Lienche Tu Fang under "Mei Ting-tse" in *DMB*, pp. 1057–59. He belonged to Mei Qing's father's generation; see Yang Chenbin 1985, p. 50.

70 Yang Chenbin 1985, p. 51.

71 Yang Chenbin 1985, p. 50; Rogers and Lee 1988, no. 43.

72 Translation from Rogers and Lee 1988, no. 43, pp. 165–66. For the Chinese text, see Yang Chenbin 1985, p. 52.

73 For a fan painting done in the winter of 1649 and said by Mei to be in the style of Li Cheng (919–967), see *Semmen taikan* 1915, vol. 3.

74 Yang Chenbin 1985, p. 53. For biographical information on Shi, see the entry by C. Martin Wilbur under "Shih Jun-chang" in *ECCP*, p. 651.

75 Yangming Chu has pointed out that Mei's pavilion name, Pinglü 平綠, literally "level green," a reference to farmlands, may be a pun for pinglü 平廬, which means

"to calm one's thoughts." See *Hanyu da cidian* 1987, vol. 2, p. 942.

76 Yang Chenbin 1985, p. 54. According to Yang, in each of these works Mei's contributions were to the sections on "mountains and rivers," "biographies," and "arts and literature."

77 Mei Qing may also have been influenced by Xiao Yuncong (1596–1673), whom he visited in nearby Wuhu in 1649, but Xiao's paintings of that time were more influenced by late-Ming painting in Suzhou than what came to be known as the Anhui style. For a discussion of Xiao and his 1656 painting of Xuancheng, see Li 1974, no. 43. For Mei's connection to Xiao, see Yang Chenbin 1985, p. 56.

78 For a discussion and illustrations of the entire album, see Ho and Smith 1992, vol. 2, no. 144. The album is dedicated to "Venerable Pei." Mei Chong, a relative who collaborated with Mei Qing in at least one painting, had as his cognomen "Peiyi," so it is possible that he was the recipient of the album. For information on Mei Chong, see *Kaikodo* 2000, no. 10, and the essay by Jane DeBevoise in Cahill 1981, pp. 130–31 and no. 61.

79 For a full reproduction and discussion of Shitao's *Sixteen Luohans*, see Ho and Smith 1992, vol. 1, pl. 153.

80 Yang Chenbin 1985, p. 56.

81 An inscription by Mei on one leaf of his 1693 album *Nineteen Views of Mount Huang*, now in the Shanghai Museum, states specifically that he is following a composition by Shitao; see the translation by Jane DeBevoise in Cahill 1981, p. 127.

82 Mei painted this site again in 1680; see Ho and Smith 1992, vol. 2, no. 145.

83 See Yang Chenbin 1985, p. 55; and Yang Chenbin 1986, p. 86, fig. 3. For biographical information on Xu, see the entry by Tu Lien-che under "Hsü Ch'ien-hsüeh" in *ECCP*, pp. 310–11. For this painting, now in the Tianjin History Museum, see *Zhongguo gudai shuhua mulu* 1990, vol. 8, p. 199, *Jin* 2–082.

84 Yang Chenbin 1986, p. 87, fig. 4.

85 Yang Chenbin 1985, p. 49.

86 Mei created a third related composition in his album dated the fourth lunar month of 1692; see *Zhongguo gudai shuhua mulu* 1990, vol. 4, *Hu* 1–2677 (2).

87 I am grateful to Shi-yee Liu for assistance with this translation.

88 For a discussion of Wu Zhen's painting, see Cahill 1976, pp. 68–74 and 165–66. See also Fong and Watt 1996, pp. 306–11; and Hearn and Fong 1999, pp. 92–100.

89 On the concept of "cave-heavens," see Munakata 1990, pp. 111–12.

90 Mei Qing painted a simplified image of two men in a cave, which he identified as following Hongguzi (Jing Hao, active ca. 870–ca. 930), for a group album with other leaves dated 1694 and 1696, see *Zhongguo gudai shuhua mulu* 1990, vol. 4, pp. 292–93, *Hu* 1–2610.

91 According to the account in the "Tangwen" chapter of the *Liezi*, Boya and Zhong Ziqi lived in the state of Chu during the Spring and Autumn period (770–476 BCE) of the Zhou dynasty (1046–256 BCE). See the entry under "Boya" in *Zhongwen da cidian* 1973, vol. 1, p. 927.

92 I follow the dates for Mei Geng, 1640-after 1716, given in *Kaikodo* 2000, no. 11. James Cahill (Cahill 1986) gives Mei Geng's dates as 1640–1722, citing an unpublished chronology by Hu Yi distributed at the symposium on Anhui school artists held in Hefei in 1984. The *Kaikodo* entry asserts that Mei Geng's grandfather, Mei Shihao, was one of Mei Qing's brothers, but this does not agree with the list of Mei Qing's brothers in Yang Chenbin 1985, p. 51. Mei Shihao's father, Mei Dingzuo, belonged to the same generation as Mei Qing's father, so Shihao was a contemporary of Mei Qing. Mei Geng was two generations younger than Mei Qing, making him a grandnephew.

93 See *Zhongguo gudai shuhua mulu* 1990, vol. 5, pp. 55–56, *Hu* 1–3097, especially leaves 3, 4, 7, and 10.

94 For information on Mei Chong, see *Kaikodo* 2000, no. 10; Cahill 1981, no. 61; and Shih Shou-chien, Fu Shen, James Cahill et al. 2001, no. 39. See also *Zhongguo meishu quanji, Huihua bian 9 shang* 1988, pl. 106, for a pine tree after Liu Songnian that is inspired by similar works by Mei Qing. For a hanging scroll dated 1681 by Mei Wei, who is otherwise unrecorded, see *Zhongguo gudai shuhua mulu* 1990, vol. 5, p. 90, *Hu* 1–3226.

95 Nine of these handscrolls and a fragment of another survive. See Hearn 1990; see also Hearn 1988, pp. 91–189.

96 For example, Wang Yun's *Fanghu Isle of the Immortals*, of 1699, now in the Nelson-Atkins Museum of Art, Kansas City; see Ho and Lee et al. 1980, no. 257.

97 For Zhang Hong and other late-Ming Suzhou artists, see Cahill 1982b, pp. 39–59.

98 See Kim 1996, nos. 1 and 6.

99 There is some basis for Wang Yun's claim; the path winding through a grove of tall trees recalls *Layered Peaks and Dense Forests*, attributed to Juran, now in the National Palace Museum, Taipei; see Fong and Watt 1996, pl. 58.

100 For Dong's theories and the Orthodox school, see Fong 1968a, pp. 1–26.

101 For a discussion of this theme, see Barnhart 1972.

102 I am indebted to Shi-yee Liu for noting this reference. See Catalogue, p. 179, note 4.

103 Translated with the assistance of Shi-yee Liu.

104 For a discussion of Wang Meng's style and his *Simple Retreat*, see Hearn and Fong 1999, pp. 118–24.

105 For a Ni Zan painting that may have served as the model for this image, see Barnhart 1983, fig. 78.

106 For Qian Xuan's painting, see Cahill 1976, fig. 7; for Sun Yuwen's seals on the painting, see *Zhongguo shuhuajia yinjian kuanshi* 1987, vol. 2, p. 861.

107 See Pang Yuanji 1909, *juan* 15, pp. 7–10.

108 For biographical information about Wang Yuanqi, see the entry by J.C. Yang under "Wang Yüan-ch'i" in *ECCP*, pp. 844–45; see also Fong 1969, pp. 180–89; Rogers and Lee 1988, no. 51, pp. 175–77; Sirén 1957–59, vol. 5, pp. 200–208; Cahill 1982a, pp. 184–96.

109 This seal appears on Wang's paintings as early as the tenth lunar month of 1701; for an example, see Xiao Yanyi 1996, no. 73

110 Wang Yuanqi et al. 1718.

111 See Wang Yuanqi ca. 1680. For an English translation of this text, see Sirén 1957–59, vol. 5, pp. 208–11.

112 See Bush 1962, pp. 120–27.

113 See ibid., p. 121.

114 This translation is based on those of Sotheby Parke Bernet 1981, lot 350, and Shi-yee Liu. According to Liu, the *celi* paper that Wang mentions in his inscription was a well-known type of paper produced in the Guangdong area, in the far south of China.

115 Seals with the same legends regularly appear on Wang's paintings from the last fifteen years of his life, and nearly always in the same positions.

116 Biographical information on Li Fangying is drawn from Chuang Su-o 1986, pp. 67–92; Chou and Brown 1985, p. 181; Guan Jingcheng 1981, pp. 14–27; and Nantong Museum 1981, pp. 28–35. This last source points out that, at the time of his birth, Li's family home in Nantong was under the prefectural jurisdiction of Yangzhou. Thus, there is some basis for grouping Li with other Yangzhou "eccentrics," even though he was not a resident of the city proper. For an excellent English summary of the research set forth by Chuang Su-o, the Nantong Museum, and Guan Jingcheng, see Wu 1992, pp. 469–90.

117 For a summary of Li Yuhong's career, see Guan Jingcheng 1981, pp. 15–16.

118 According to Li Jitao, in 1740 Li attended a gathering in Yangzhou to which the painter Gao Fenghan (1683–1748) was also invited; see Li Jitao 1963, p. 23.

119 In the third lunar month of 1746 Li painted a hanging scroll of bamboo and rock in Yangzhou, now in the Wong Nan-p'ing Family Collection; in the fourth lunar month Li was still in Yangzhou, where he painted *Two Fish*, now in the Palace Museum, Beijing. See the entry by Cheng-hua Wang in Barnhart et al. 1994, pp. 226–27, pl. 70 and fig. 65.

120 For the details of Li's service in Hefei and the likely reason for his indictment, see Guan Jingcheng 1981, pp. 19–20.

121 Several of Li's extant paintings bear inscriptions dated as late as the third lunar month of 1753 that indicate that he still spent time in Hefei; see Chuang Su-o 1986, p. 76. Guan Jingcheng has suggested that, during the years the case was being prosecuted, Li may have already settled his family in Nanjing; see Guan Jingcheng 1981, p. 20. This would explain why, in one of his recorded communications with Li, Yuan Mei mentions flowers that Li had planted in the "Borrowed Garden" prior to his departure for Hefei. Both Chuang Su-o and Ju-hsi Chou have interpreted this to mean that Li had already established himself in Nanjing prior to his 1747 appointment to office in Anhui, but Guan's explanation seems more plausible. See Chuang Su-o 1986, p. 74, and Chou and Brown 1985, p. 181, especially note 6.

122 In 1753 Li collaborated with Zheng Xie and Li Shan to paint *Three Friends of Wintry Weather*; see Chuang Su-o 1986, p. 68 and note 8. In the third month of 1755 Li was expecting a visit from Jin Nong; see his inscription on his *Plum Blossoms* in Christie's 1985, lot 80. For a copy of the *Plum Blossoms* painting, see *Shina Nanga taisei* 1935–37, vol. 3, pl. 136.

123 There is some uncertainty about Li Fangying's dates. They are traditionally given as 1695–1754 based on the epitaph composed by his friend Yuan Mei. But the cyclical date of *jiaxu* (1754) given for Li's death in this source is clearly incorrect. Yuan Mei's own correspondence includes poems composed for Li in the following *yihai* year (1755), and Li created several paintings dating to as late as the eighth month of 1755. In that month, Yuan Mei composed a farewell poem for Li as the artist was preparing to leave Nanjing for Nantong. Li probably died a short time later. Li's good friend Ding Youyu (1682–1756), a native of Nantong, records in his funerary ode that Li died within ten days of his return home. Yuan's epitaph records that Li died on the third day of the ninth month. Since there are no paintings, poems, or letters to

or from Li datable to later than 1755, it seems evident that he died in 1755. According to the epitaph and the *Tongzhou Gazetteer*, Li was sixty *sui* (fifty-nine years of age by Western count) at the time of his death; accordingly, his date of birth should be 1696. But members of the Nantong Museum have pointed out that in his funerary ode Ding Youyu wrote: "Qingjiang [Li Fangying] was fifteen years younger than I and we were friends for forty-five years." A portrait of Ding painted in 1756, when he was seventy-five *sui*, establishes Ding's date of birth as 1682 (not 1683 as published in other sources). If Li Fangying was born fifteen years later, his date of birth should be 1697. Assuming that he lived until he was sixty *sui*, his date of death would then be 1756; see Nantong Museum 1981, pp. 29–30. But Chuang Su-o notes that the *Zhili Tongzhou Gazetteer*, published in the autumn of 1755, already records Li's death at the age of sixty *sui*. Chuang therefore concludes that Li's correct dates should be 1696–1755; see Chuang Su-o 1986, p. 69. For Li's *Blossoming Plum*, dated to the eighth lunar month of 1755, now in the Tokyo National Museum, see Suzuki Kei 1982–83, JM1–181.

124 For examples of these subjects, see *Yangzhou bajia huaji* 1994, pls. 169–76.

125 Bickford et al. 1985, p. 128.

126 See ibid., no. 61; see also *Yangzhou bajia huaji* 1994, pls. 1–10.

127 Bickford et al. 1985, p. 130.

128 For evidence that the Plum Blossom Tower was located in Nantong, see Chuang Su-o 1986, p. 74. Li also used this name for a hall in his residence in the "Borrowed Garden" in Nanjing.

129 For a thirteenth-century precursor of this kind of thematic elaboration, see the album *Moments of the Flowering Plum* by Ma Yuan (active ca. 1190–1225), in Bickford et al. 1985, fig. 5.

130 I am indebted to Yangming Chu for assistance in transcribing the poems in the album and to Zhixin Sun, whose translations — including the legends of Li's seals — I follow here.

131 I am indebted to Shi-yee Liu for identifying this reference. See *Zhongwen da cidian* 1973, vol. 1, p. 898.

132 This couplet from Gao Qi's "Poem on Plum Blossoms" (*Meihua shi*), is quoted in ibid. For a study of Gao, one of the Four Talents of Suzhou, see Mote 1962.

133 Bickford et al. 1985, p. 133, citing Yuan Mei, *Suiyuan shihua, juan* 11, as quoted from Gu Linwen 1962, p. 131.

134 For the early role of imperially sponsored anthologies in the promotion of a state-sanctioned orthodoxy,

see McNair 1994, pp. 209–25. See also Harrist 1999, pp. 240–59.

135 For illustrations and a discussion of the hall, see Weng and Yang 1982, pp. 62–67. See also Harrist 1999, p. 254, fig. 13; and Zhang Shiyi 1980, pp. 89–91.

136 For the *Record of the Hall of Three Rarities*, see Wan Yi 1980, p. 72, fig. 1. For reproductions of these three manuscripts, see *Shodō zenshū* 1954–69, vol. 4, pls. 36, 96, and 106.

137 For a brief discussion of these compendia, see McNair 1994, pp. 219–21.

138 See *Shiqu Baoji* 1971. For a brief discussion of the contents and organization, see Lovell 1973, pp. 50–54.

139 Liang Shizheng was called upon to supervise a number of imperial compendia; see his biography by Li Man-kuei under "Liang Shih-cheng" in *ECCP*, p. 503. Wang Youdun served as Grand Councilor from 1745 to 1758; see *ECCP*, p. 943. Jiang Pu was the son of the scholar-official and artist Jiang Tingxi (1669–1732); see Jiang Tingxi's biography by Tu Lien-che under "Chiang T'ing-hsi" in *ECCP*, pp. 142–43.

140 I am indebted to Shi-yee Liu for assistance with this translation.

141 Harrist 1999, p. 250.

142 See McNair 1994, pp. 210–13.

143 Wang Lianqi, "*Sanxi Tang fatie* ji qi ketie de zhenwei" (The Authentication of Engraved Manuscripts in *Model Calligraphies from the Hall of Three Rarities*). In *Zhongguo meishu quanji* (Complete Collection of Chinese Arts), *Beitie bian* (Rubbing and Manuscript Series). Forthcoming. The manuscript was kindly supplied by the author.

144 See McNair 1994, pp. 221–22.

145 For a discussion of this piece's authenticity, see Fong 1992a, p. 142.

146 For Dong Qichang's original transcription of this text, now in the Palace Museum, Beijing, see Ho and Smith 1992, no. 22.

147 See Lovell 1973, pp. 51–54.

148 Wan Yi 1980, p. 76

149 See ibid, p. 73

150 Weng and Yang 1982, p. 217.

151 See Harrist and Fong et al. 1999, no. 2, pp. 92–93 and fig. 1, pp. 242–43.

152 For a discussion of the significance of Huizong's pattern of applying seals to works in his collection, see Barnhart 1984, pp. 61–70.

153 For Wu Ting, see Harrist 1999, p. 254 and fig. 11; for An Qi, see Lawton 1969, pp. 13–35.

154 For a discussion of the history of transmission

and connoisseurship of this letter, see Harrist 1999, pp. 240–59.

155 See ibid., p. 244, fig. 3.

156 See Wan Yi 1980, p. 74. Wan suggests that the carving was not completed until after the third lunar month of 1753, but his interpretation of the palace archives may be mistaken. According to Wan, payments were issued every year in the third month. Work not completed by the third month in a given year was paid for in the following year. Thus, it is possible that the carving of the stones was completed as early as the middle of 1752.

157 In 1795 Chen Zhuo (born 1733) and a team of assistants compiled *Transcriptions of the Model Calligraphies from the Hall of Three Rarities* (*Sanxi Tang fatie shiwen*), a complete regular-script (*kaishu*) transcription of all the texts and seals in the anthology along with a table of contents. For a facsimile reproduction of the 1897 edition, see *Sanxi Tang fatie* 1984, pp. 2589–3220.

158 Wang Lianqi, calligraphy specialist at the Palace Museum, Beijing, in a private communication, has questioned the reliability of the Dong Bangda inscriptions, suggesting that they may have been added at a later date because of the presence of seals belonging to Dong's son, Dong Gao. Wang has also pointed out that the character *xi* in the carved title "Yu ke Sanxi Tang…" on the wooden covers of the Weill set differs from that of the rubbings— an indication that the covers, too, may not be original. For biographical information on Dong Gao, see the entry by Li Man-kuei under "Tung Kao" in *ECCP*, pp. 791–92. Dong Gao's seals match those published in *Zhongguo shuhuajia yinjian kuanshi* 1987, pp. 1315–17.

159 For fuller treatments of Zhang Daqian's biography and art, see Fu Shen 1991, especially pp. 17–31, and Fong 2001, pp. 178–79.

160 See Fu Shen 1991, pp. 184–93.

161 See Fong 2001, pl. 71; Andrews and Shen 1998, cat. 45; and Fu Shen 1991, cat. 35.

162 Rimpa is the name given to a bold decorative style of painting practiced during the Edo period (1615–1868). Nihonga, or "Japanese painting," refers to a style that arose in Japan in the Meiji era (1868–1912) and sought to transform traditional Japanese idioms with modern Western representational techniques. See Fong 2001, pp. 75–79.

163 See Pang Yuanji 1909.

164 See *Catalogue of the International Exhibition of Chinese Art* 1935–36.

165 For a detailed discussion of Wang's artistic development, see Silbergeld 1987.

CATALOGUE

1. SHEN ZHOU 沈周 (1427–1509)

Anchorage on a Rainy Night

Yeyu bozhou tu 夜雨泊舟圖
Dated 1477
Hanging scroll, ink on paper
31 ⅜ × 13 ⅛ in. (79.7 × 33.5 cm)
The Metropolitan Museum of Art
Promised Gift of Marie-Hélène and
Guy Weill

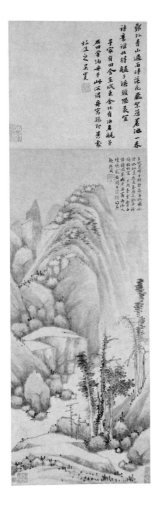

ARTIST'S INSCRIPTION & SIGNATURE
6 columns in running script

East of the ancient city in the setting
 sun's slanting rays,
Swallows fly low over the overflowing
 pond.
Thus I know that tonight the spring rain
 will be plentiful,
How fitting that fish should leap and
 ducks alight.
 On the twentieth day of the last
[lunar] month of spring in the *dingyou*
year (May 2, 1477), I lodged on a boat
to the east of the city with [Zhou] Wei-
de. After the rain, everything grew quiet.
I did this picture and poem to capture
the mood. Shen Zhou[1]

古城東畔日斜時，
燕子低飛水漫池。
知是夜來春雨足，
跳魚浴鴨總相宜。

　　丁酉春季念日與惟德同客城
東舟寓。雨後人境俱寂，爲圖與
詩頗得其趣。沈周

ARTIST'S SEAL
Qi'nan 啓南

COLOPHON (mounted above the painting)
Wu Kuan 吳寬 (1436–1504)
5 columns in running script

When it rains on the green mountains
 beyond the city wall,
Flowers fall, catkins fly, and swallows
 flutter across the pond.
The poetic feeling of spring—who is
 able to capture it?
Boatman's Creek is the most fitting
 place.
 My family has fields and a house to
the east of the city. Beside the house is
Boatman's Creek. Shitian [Shen Zhou]
once anchored a boat at this place—
his so-called boat lodging. I suspect that
it is just this place that he has [painted].
Wu Kuan[2]

郭外青山過雨時，
落花飛絮燕差池。
一春詩意誰收得，
艇子浜頭恐最宜。

　　予家有田舍在城東。舍外有
浜艇子，石田嘗泊舟于此。所謂舟
寓，疑即其處故及之。吳寬

COLOPHON WRITER'S SEAL
Yuanbo 原博

COLLECTORS' SEALS

Yao Hongdao 姚弘道 (unidentified)
Yao Hongdao yin 姚弘道印

Pan Meilin 潘梅林 (unidentified)
Meilin Pan shi jia cang 梅林潘氏家藏

Hua Qi 華綺 (unidentified)
Xishan Hua Qi Tianhe jia cang
　　錫山華綺天和家藏

Zhang Daqian 張大千 (1899–1983)
Zhang Yuan 張爰
Daqian shu 大千鉥
Nan bei dong xi zhi you xiang sui
　　wu bie li 南北東西只有相隨無
　　別離
Dafeng Tang zhencang yin 大風堂珍
　　藏印

REFERENCES

Zhang Daqian 1955–56, vol. I, pl. 22;
Sirén 1957–59, vol. 7, "Annotated
Lists," p. 224; *Yiyuan duoying* 1995,
p. 3; Toda Teisuke and Ogawa Hiromitsu
1998, A42-016

RECENT PROVENANCE

Zhang Daqian (1899–1983); Frank
Caro, New York; Christie's, New York,
June 2, 1988 (sale 6616), lot 30

NOTES

1 The Weide mentioned in Shen's
inscription is very likely Zhou Weide,
a man for whom Shen executed
an important album of twenty-two
paintings that he began in 1477 and
completed five years later, in 1482;
see Cahill 1978, pp. 87–88 and color
plates 4 and 5. This translation has
benefited from the previous work of
Wan-go Weng (Christie's 1988, lot 30,
p. 36) and the assistance of Shi-yee Liu.
2 I am grateful to Shi-yee Liu for
her assistance in transcribing this
inscription.

2. WEN ZHENGMING 文徵明 (1470–1559)

Living Aloft: Master Liu's Retreat
Lou ju tu 樓居圖
Dated 1543
Hanging scroll, ink and color on paper
37 ½ × 18 in. (95.2 × 45.7 cm)
The Metropolitan Museum of Art
Promised Gift of Marie-Hélène and
Guy Weill

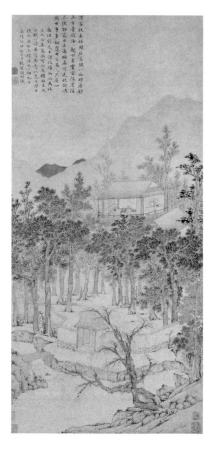

ARTIST'S INSCRIPTION & SIGNATURE
9 columns in standard script

Immortals have always delighted in
　pavilion-living,
Windows open on eight sides—
　eyebrows smiling.
Up above, towers and halls well up,
Down below, clouds and thunder are
　vaguely sensed.
Reclining on a dais, a glimpse of Japan,
Leaning on a balustrade, the sight of
　Manchuria.
While worldly affairs shift and change,
In their midst a lofty man is at ease.
　Mr. Liu Nantan [Liu Lin, 1474–
1561] retired from government, and
upon his return home, he planned to
build a dwelling—so you will know
his noble character. Although the
building is not yet completed, in antici-
pation of it I have composed a poem
and sketched its concept. Another day
he can hang it at his right hand to
enrich that pavilion-living. Inscribed
by Zhengming on the sixteenth day
of the seventh [lunar] month in the
autumn of the *guimao* year of the
Jiajing reign era [August 16, 1543].[1]

仙客從來好閣居，
窗開八面眼眉舒。
上方臺殿隆隆起，
下界雲雷隱隱虗。
隱几便能窺日本，
憑欄眞可見扶餘。
摠然世事多翻覆，
中有高人只晏如。

　南坦劉先生謝政歸而欲
爲樓居之念其高尚可知矣。樓
雖未成，余賦一詩并寫其意以
先之。它日張之座右亦樓居之
一助也。時嘉靖癸卯秋七月既
望，徵明識。

ARTIST'S SEALS

Wen Zhengming yin 文徵明印
Zhengzhong 徵仲
Hengshan 衡山
Yulan Tang yin 玉蘭堂印

COLLECTORS' SEALS

Zhao Song 趙松 (born 1464; *jinshi*
 degree, 1493)[2]
Hongxi Zhao Song jian cang
 shu hua yin 洪溪趙松鑑藏書畫印

Two unidentified

Tieling Yingqi pingsheng zhen shang
 鐵嶺瑛榮平生眞賞
Dan Sheng 澹生

REFERENCES

Clapp 1975, pp. 46, 48; fig. 12;
Edwards et al. 1976, no. 41, pp. 150–
51; Cahill 1978, pp. 217–18; color
plate 13; *Yiyuan duoying* 1995, front
cover; Christy 1996, p. 84; Toda Teisuke
and Ogawa Hiromitsu 1998, A42-020

RECENT PROVENANCE

Mr. and Mrs. David Spelman, Great
Neck, New York; Sotheby's, New York,
November 2, 1979 (sale 4296), lot 111

NOTES

1 This translation, which benefited
from the assistance of Shi-yee Liu,
is after that of Ling-yün Shih Liu and
Richard Edwards in Edwards et al. 1976,
p. 150.

2 The authenticity of this seal requires
further research. Given the fact that the
painting was a gift from his friend Wen
Zhengming, it seems unlikely that Liu
Lin would have parted with *Living
Aloft* during his lifetime. However, the
presence of a seal belonging to Zhao
Song (born 1464; *jinshi* degree, 1493)
requires us to believe that Liu gave up
the painting almost immediately. Zhao's
death date is unknown, but he would
have already been nearly eighty in
1543 when Wen executed the painting.
If Liu held onto the painting for ten
years, Zhao would have had to have
lived to the age of ninety to acquire it.

3. LIU YU 柳堉 (active ca. 1660s – ca. 1690s)

Remote Valleys and Deep Forests
Yougu shenlin tu 幽谷深林圖
Dated 1678
Handscroll, ink and color on paper
10 ⅝ × 144 ⅛ in. (27 × 366 cm)
The Metropolitan Museum of Art
Promised Gift of Marie-Hélène and
Guy Weill

PLATES 3a, b Liu Yu. *Remote Valleys and Deep Forests*. Details:
3a: Unidentified, *Label strip* (on brocade wrapper). Ink on paper
3b: Unidentified, *Label strip* (before frontispiece). Ink on paper

ARTIST'S INSCRIPTION & SIGNATURE
1 column in running script

Painted in the wuwu year of the Kangxi reign era [1678] by Liu Yu, Gonghan, of Changgan [Nanjing]

康熙戊午長干柳堉公韓氏寫

ARTIST'S SEALS
Liu Yu zhi yin 柳堉之印
Yugu 愚谷

LABEL STRIP (on brocade wrapper; pl. 3a)
Unidentified, 1 column in running script, undated; 1 seal

Liu Gonghan's [Liu Yu] landscape masterpiece, treasured possession of Xiaoyin of Nanlu; [seal:] *yin*

柳公韓山水精品，南盧小隱珍藏；[印]隱

LABEL STRIP (before frontispiece; pl. 3b)
Unidentified, 2 columns in running script, undated; 1 seal

Liu Yugu's [Liu Yu] landscape handscroll, frontispiece in clerical script by Zheng Gukou [Fu]. Pure plaything of Yang Yan; [seal:] *Jie fen*

柳愚谷山水卷，鄭谷口分書印首。
楊煙清玩；[印]擷芬

FRONTISPIECE (pl. 3c)
Zheng Fu 鄭簠 (1622–1694), 6 characters in large clerical script followed by two lines in running script, dated 1679

"Remote Valleys, Sounds of Waterfalls, Deep Forests"
 Quoting a line from Qinglian [Li Bo (701–762)], in the summer of the *jiwei* year [1679], written by Gukou Zheng Fu

《幽谷泉鳴深林》
 拈青蓮句己未夏谷口鄭簠書

FRONTISPIECE WRITER'S SEALS
Laoshucun 老樹村
Zheng Fu 鄭簠
Gukou Ruqi 谷口汝器

168

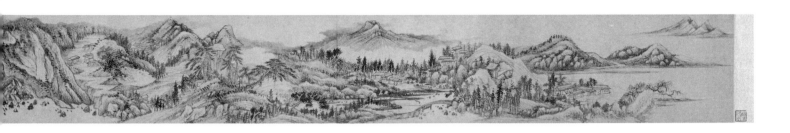

COLOPHON (pl. 3d)

Xi Ying 席瑛 (unidentified, 18th century?), 7 columns in running script, dated *gengzi* year [1720?]

Years ago at my friend Weiqi's place I was able to view an album by Mr. Yugu [Liu Yu] that has lingered in my dreams ever since. This summer [Weiqi] brought out this scroll for me to see. It is truly a work of genius. In its more than twenty feet of paper are limitless wonders and innumerable transformations. Except for someone with natural talent and scholarly capacity, who could have accomplished this? Shamefully unlearned, I can only sigh without hope! It is, however, something I genuinely love. From now on I'll have one more thing to dwell on.

In the early autumn of the *gengzi* year [1720?], Xi Qishi [Xi Ying], your junior colleague, respectfully viewed then recorded this.[1]

前歲於偉奇仁兄處，獲觀愚谷先生畫冊，爲之夢想者數載。今夏又出此卷見示，尤爲神往。以二丈有餘之紙，奇出無窮，變幻莫測。若非天分學力兼到者焉能至此。愧余未學徒增望洋之歎。然性之所好。從此又添一段想思也。

　　庚子新秋後學席豈石拜觀再記。

PLATES 3c, d Liu Yu. *Remote Valleys and Deep Forests*. Details:
3c: Zheng Fu (1622–1694), *Frontispiece*, dated 1679. Ink on paper, 10⅝ × 39¾ in. (27 × 101 cm)
3d: Xi Ying (unidentified, 18th century?), *Colophon*, dated *gengzi* year [1720?]. Ink on paper, 9⅝ × 6⅞ in. (24.5 × 17.5 cm)

3c

3d

COLOPHON WRITER'S SEAL
Xi Ying zhi yin 席瑛之印

COLLECTORS' SEALS
Unidentified
Xun sou 遜叟
Bu gai qi du 不改其度
Hutu yuan yang 糊涂夗央
Zhenqing shending 震青審定

REFERENCES
Yiyuan duoying 1995, p. 33; Toda Teisuke and Ogawa Hiromitsu 1998, A42-004

RECENT PROVENANCE
Sotheby's, New York November 6, 1981 (sale 4724Y), lot 353

NOTE
1 Shi-yee Liu and Yangming Chu assisted with the transcription and translation of this text.

4. DAI BENXIAO 戴本孝 (1621–1693)

The Strange Pines of Mount Tiantai
Tiantai yi song tu 天台異松圖
Dated 1687
Hanging scroll, ink on paper
67 ¼ × 30 in. (170.8 × 76.2 cm)
The Metropolitan Museum of Art
Gift of Marie-Hélène and Guy Weill,
in honor of Douglas Dillon, 1991
(1991.256)

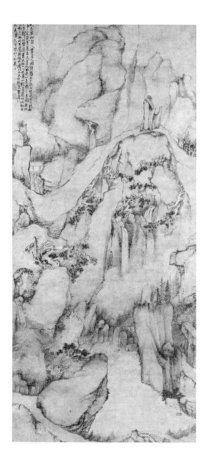

ARTIST'S INSCRIPTION & SIGNATURE
5 columns in running script

The strangely shaped pine trees of
Mount Tiantai have been depicted by
artists of previous periods. Lu Guimeng
[of the Tang dynasty] has recorded and
written a eulogy for one of these paint-
ings. I have seen a copy of this painting
at the home of a collector and was
not impressed by it. Therefore I have
decided to portray this theme drawing
upon my own imagination. I have heard
recently that most of these strange pines
have met the sad fate of extinction. It
seems that once the natural wonders of
the sky, earth, mountains, and rivers are
exposed to the intimate scrutiny of the
dusty world, they do not last long. This
is indeed cause for lamentation.

[Dai] Benxiao, Heavenly Root
Gatherer of Mount Ying'a , did this for
the amusement of old Jun, my elder
brother in the Way. On the summer
solstice of the *dingmao* year [1687].[1]

天台異松前人嘗爲之圖。陸龜蒙記
而贊之。曩從好事家見有摹本，
未善也。因追以意圖之。近聞異
松已多歸於冥漠。蓋天地山川之
奇，一經爲塵眼所狃，自不能久。
如此不覺興嘅也。

　鷹阿山天根樵夫，本孝，似
君老道兄粲鑒。時丁卯長至。

ARTIST'S SEALS
Shi zhen shan 師眞山
Ying'a shan qiao 鷹阿山樵
Benxiao 本孝

REFERENCES
Delbanco 1986, pp. 96–97; *Yiyuan
duoying* 1995, p. 6; Christy 1996, p. 84;
Toda Teisuke and Ogawa Hiromitsu
1998, A1-0294

RECENT PROVENANCE
R.H. Ellsworth Ltd.

NOTE
1 Translation after Delbanco 1986,
p. 96.

5. MEI QING 梅清 (1624–1697)

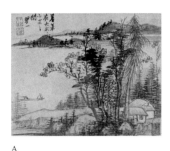
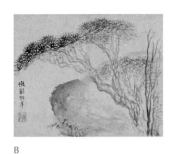
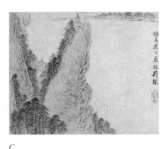

A B C D

Landscapes after Ancient Masters for Zeweng

Wei Zeweng fang ge jia shanshui tu
為澤翁倣各家山水圖
Dated 1693
Album of twelve paintings and a one-leaf artist's postscript, ink and ink and color on paper
Each leaf: 9¾ × 11¾ in. (24.8 × 29.8 cm)
The Metropolitan Museum of Art
Promised Gift of Marie-Hélène and Guy Weill

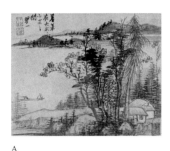

PLATE 5n Mei Qing. *Landscapes after Ancient Masters for Zeweng*. Detail: Unidentified (20th century), *Label strip* (on brocade cover). Ink on paper

ARTIST'S INSCRIPTIONS & SIGNATURES

Leaf A: *Landscape in the Manner of Mi Fu and Mi Youren.* Ink and color on paper (5 columns in running script)

These brushstrokes are between "Elder Mi" [Mi Fu, 1052–1107] and "Younger Mi" [Mi Youren, 1074–1151], [signed] Qushan

著筆在大米小米之間，瞿山

Leaf B: *Landscape after Liu Songnian.* Ink on paper (1 column in running script)

After Liu Songnian
[active ca. 1175–after 1207]

倣劉松年

Leaf C: *Landscape after Ma Yuan, Jing Hao, and Guan Tong.* Ink and color on paper (1 column in running script)

After Ma Yaofu [Ma Yuan, active ca. 1190–1225] and also imitating Jing [Hao, active ca. 870–ca. 930] and Guan [Tong, active ca. 907–23]

倣馬遙父兼效荊關

Leaf D: *Landscape after Li Cheng.* Ink on paper (1 column in running script)

After Li Yingqiu
[Li Cheng, 919–967]

倣李營丘

Leaf E: *Landscape after Fan Kuan.* Ink on paper (1 column in running script)

After Fan Kuan
[active ca. 990–1030]

倣范寬

Leaf F: *Landscape after Wu Zhen.* Ink on paper (1 column in running script)

After Meihua Daoren
[Wu Zhen, 1280–1354]

倣梅花道人

Leaf G: *Landscape after Shen Zhou.* Ink and color on paper (1 column in running script)

After Shitian Laoren
[Shen Zhou, 1427–1509]

倣石田老人

5. (continued)

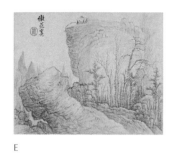

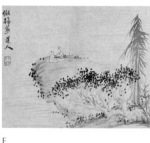

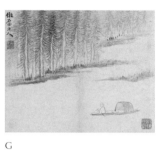

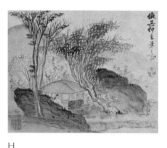

E F G H

Leaf H: *Landscape after Wu Zhen.* Ink on paper (1 column in running script)

After the brush idea of Wu Zhonggui [Wu Zhen, 1280–1354]

倣吳仲圭筆意

Leaf I: *Landscape after Guo Xi.* Ink and color on paper (2 columns in running script)

After the brush idea of Guo Heyang [Guo Xi, ca. 1000–ca. 1090]

倣郭河陽筆意

Leaf J: *Landscape after Li Cheng.* Ink on paper (2 columns in running script)

After the brush idea of Li Xianxi [Li Cheng, 919–967]

倣李咸熙筆意

Leaf K: *Landscape after Zhongren.* Ink and color on paper (1 column in running script)

After Huaguang Laoren [Zhongren, died 1123]

倣華光老人

Leaf L: *Landscape after Wang Meng,* dated 1693. Ink and color on paper (1 column in running script and 4 columns in running script)

After the Yellow Crane Mountain Wood Gatherer [Wang Meng, ca. 1308–1385]

倣黃鶴山樵

In the tenth [lunar] month of the *guiyou* year [October 29–November 26, 1693], I imitated the brush ideas of twelve masters to send to Master Zeweng for his instruction. Qushan Mei Qing

癸酉十月倣十二家筆意寄澤翁先生大教，瞿山梅清

Leaf M: *Artist's Postscript,* dated 1693. Ink on paper (10 columns in running script)

I raise my head toward Yunmen [south of Yidu, Shandong Province] a thousand miles away,
Where you set a fine example in governing the prefecture.
Your brilliance extends from the sea to the mountains like an everlasting spring,
Your fame grows in Qing [present-day Yidu] and Qi [present-day Ji'nan,

Shandong] where your praises abound.
A great talent from the capital,
You are like a swift-footed steed that descends from heaven.
Contemplating [the world], you should be pleased with your accomplishments in your official career,
So in your dreams why would you turn to the *Six Essentials* [of painting]?[1]
In the tenth [lunar] month of the *guiyou* year [October 29–November 26, 1693], presented to Master Zeweng for his instruction; drafted by Qushan Mei Qing

翹首雲門千里遙，
使君佐郡見芳標。
光連海岳春常滿，
望聳青齊譽並饒。
奕奕鴻材原闕里，
翩翩驥足自層霄。
臨風每切登龍願，
夢寐何當托六要。
　　癸酉十月奉寄澤翁先生教之，瞿山梅清稿

M

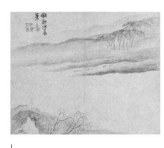

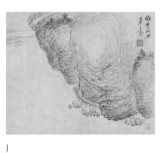

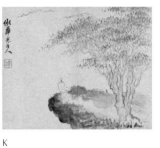

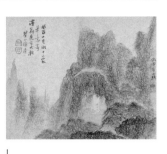

I

J

K

L

ARTIST'S SEALS

		LEAVES
Bojian shankou renjia	柏枧山口人家	A, F
Mei Qing si yin	梅清私印	A
Hua song	畫松	B
Ke wei zhizhe dao	可爲知者道	C
San mei you	三昧遊	D
Mei chi	梅癡	E
Youxi san mei	遊戲三昧	G
Lao Qu Qing	老瞿清	H
Zizhen zhi yi	子眞之裔	I
Jingting	敬亭	J
Qushan	瞿山	K
Quxing Shanren	瞿硎山人	L
Chen Qing; Qushan	臣清，瞿山	L
Chaxia Caotang	茶峽草堂	M
Quxing Qing	瞿硎清	M
Yuangong	淵公	M

COLLECTORS' SEALS

Unidentified

		LEAVES
Yingzhou Kong shi shijia cang shu hua ji	瀛州孔氏世家藏書畫記	A
Pingqiao zeng jie yi guan	平橋曾借一觀	D, G, H
Cao Zhongrong shending zhen pin zhi yin	曹仲榮審定珍品之印	M
Tongyin Zhai yin	通隱齋印	M
Cheng Zhai jian cang	澄齋鑒藏	M

LABEL STRIP (on brocade cover; pl. 5n)
Unidentified (20th century), 1 column
in standard script, undated

Mei Qushan's imitations of the
ancients, twelve leaves, [and]
one leaf with poem

梅瞿山仿古十二幀，附詩一幀

REFERENCES

Yiyuan duoying 1995, pp. 16–19; Toda
Teisuke and Ogawa Hiromitsu 1998,
A42-008

RECENT PROVENANCE

The Eccentrics Studio, Hong Kong

NOTE

1 This translation is based on that of
Zhixin Sun with the further assistance
of Shi-yee Liu. According to Liu, the
Six Essentials were first enumerated by
the Northern Song theorist Liu Daochun
(active 11th century); see Liu Daochun
ca. 1040.

6. WANG HUI 王翬 (1632–1717), YANG JIN 楊晉 (1644–1728), GU FANG 顧昉 (active ca. 1690–1720),

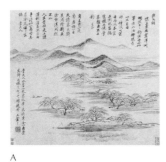

A

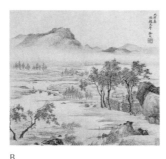

B

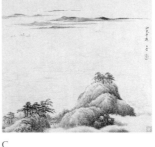

C

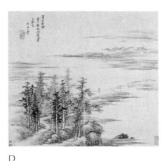

D

Landscapes after Ancient Masters

Shidi fanggu shanshui tu 師弟仿古
山水圖
Dated 1692
Album of sixteen paintings, ink and
ink and color on paper
Each leaf: 11 × 12 ⅛ in. (28 × 30.7 cm)
The Metropolitan Museum of Art
Gift of Marie-Hélène and Guy Weill,
2000 (2000.665.2)

ARTISTS' INSCRIPTIONS & SIGNATURES
Leaf A: Wang Hui. *Fishing Village
after Guan Daosheng.* Ink on paper
(24 columns in running script)

"Fisherman's Song"

On the Zhenze Marsh [of Lake Tai,
 Jiangsu Province] in the southeast,
My fishing boat crosses the misty waves
 day by day.
Mountains appear verdant;
Wine looks gleaming—
In my drunken eyes, the mountains
 aren't so free [as I].
On the misty expanse of waves is
 a tiny boat,
In the west wind leaves fall, as autumn
 arrives on the Five Lakes [Lake Tai].
Bonding with gulls and egrets,
Slighting princes and nobles,
Who cares that the sea-perches don't
 come for the bait!
 Zi'ang [Zhao Mengfu (1254–1322)]

Living in Mt. Yan [Hebei Province] near
 the imperial palace,
Day and night I think of returning to
 Eastern Wu [Wuxing region].
To drink tasty wine;
To cook fresh fish—
Without leisure, nothing feels good.
The highest status one can attain in life
 is that of a prince or noble,

But their wealth and fame are fleeting
 and they have no freedom.
How can [such a life] compare with
 that in a tiny boat.
Appreciating the moon, chanting in
 the wind, and living at home in
 retirement!
 Madame Guan [Guan Daosheng
 (1262–1319)][1]

The brush concepts of Lady Guan's
authentic small monochrome hand-
scroll painting are elegant, and she takes
[the Song monk-artist] Huichong [ca.
965–1017] as her mentor. Therefore
I have recreated it and also transcribed
its inscriptions. Wang Hui

《漁父詞》

儂在東南震澤洲，
煙波日日釣漁舟。
山似翠，酒如油，
醉眼看山不自由。
渺渺煙波一葉舟，
西風木落五湖秋。
盟鷗鷺，傲王侯，
管甚鱸魚不上鈎。
 子昂

WANG YUN 王雲 (1652– after 1735), and XU MEI 徐玫 (active ca. 1690 – 1722)

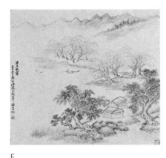

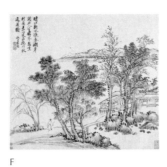

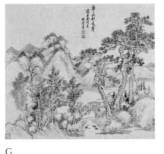

E

F

G

H

身在燕山近帝居，
歸心日夜憶東吳。
斟美酒，繪新魚，
除卻清閒總不如。
人生貴極是王侯，
浮利浮名不自由。
爭得似，一扁舟，
弄月吟風歸去休。
　　管夫人

管夫人水墨小卷眞跡筆意纖秀，
全以惠崇爲師，因倣其意并錄題
句。王翬

Leaf B: Xu Mei. *Water Village after Zhao Lingrang*. Ink and color on paper (2 columns in standard script)

"Water Village" after Zhao Danian [Zhao Lingrang, active ca. 1070–after 1100], Xu Mei

《水村圖》，倣趙大年。徐玫

Leaf C: Wang Yun. *River and Sky: Level Distance*. Ink on paper (1 column in standard script)

"River and Sky: Level Distance," Wang Yun

《江天平遠》。王雲

Leaf D: Wang Yun. *Shadowy Summer Grove after Juran*, dated 1692. Ink on paper (4 columns in standard script)

"Shadowy Summer Grove," [painted] by a rainy window in early autumn of the *renshen* year [1692], studying the [brush] concepts of Juran [active ca. 960–95], Wang Yun of Hanjiang [Yangzhou]

《夏木垂陰》。壬申新秋，雨窗學巨然意。邗江王雲

Leaf E: Yang Jin. *Fishing Cottage Under a Clear Autumn Sky after Zhao Mengfu*, dated 1692. Ink on paper (2 columns in standard script)

"Fishing Cottage Under a Clear Autumn Sky," [painted] on the sixteenth day of the seventh [lunar] month of the *renshen* year [August 27, 1692], following the brush [manner] of Zhao Wenmin [Zhao Mengfu, 1254–1322], Yang

《漁莊秋霽》。壬申七月既望撫趙文敏筆。楊晉

Leaf F: Yang Jin. *Landscape after Shen Zhou*. Ink on paper (4 columns in standard script)

In the sunlit river fresh waters have swollen the spring tide,
In the thatched studio a recluse sits alone.
Suddenly he recalls his pure-minded friend from south of the village,
Just as he crosses the bridge carrying a bamboo staff.[2]
　　After Baishiweng [Shen Zhou, 1427–1509]

晴江新水漲春潮，
草閣幽人坐寂寥。
忽憶村南素心友，
正托竹杖過溪橋。
　　倣白石翁

Leaf G: Yang Jin. *Landscape after the Poetic Idea of Wang Wei*. Ink on paper (3 columns in standard script)

"Beneath tall pines the summer feels cool."[3]
　　Sketching the poetic idea of the Assistant Director of the Right [Wang Wei, 699–759], Wild Crane, Jin

《落落長松夏寒》。
　　寫右丞詩意。野鶴晉

6. (continued)

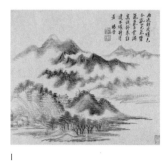

I

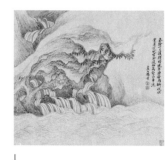

J

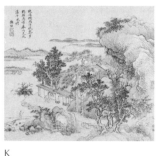

K

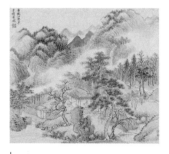

L

Leaf H: Yang Jin. *Bamboo and Rock after Guan Daosheng.* Ink on paper (7 columns in standard and running script)

The lady [Guan] sketches bamboo the
 way she writes characters,
And doesn't sink into painters'
 shortcuts.
Her inspiration comes from a mountain
 dwelling on a bright moonlit night,
Suddenly the [painted] leaves rustle in
 the autumn wind.
 Studying Guan Zhongji's [Guan
Daosheng, 1262–1319] ink bamboo,
Shuixi Jin

夫人寫竹如寫字，
不墮畫家蹊逕中。
料得山房明月夜，
儵然葉葉動秋風。
 學管仲姬墨竹。水西晉

Leaf I: Yang Jin. *Cloudy Mountains.* Ink on paper (6 columns in standard script)

Dawn's light emerges as the rain lifts
 from the wilderness expanses,
Revealing the azure mists of the scat-
 tered mountains' primal breath.
White clouds fill the table as I unroll
 the scroll,

Who says they cannot be sent to a
 friend?[4]
 Yang Jin

雨過郊原曙色分，
亂山元氣碧氤氳。
白雲滿案從舒卷，
誰道不堪持寄君？
 楊晉

Leaf J: Yang Jin. *Mountain Waterfall.* Ink on paper (3 columns in standard script)

For ten days spring clouds have
 obscured the stream,
In the middle of the night a west wind
 brings the rain to an end.
Feeling only the roar of the rolling thun-
 der in the empty valley,
From a distance I know that the myriad
 gorges are vying in their flows.[5]
 Yang Jin of Yushan

春陰十日溪頭暗，
夜半西風雨腳收。
但覺奔霆吼空谷，
遙知萬壑正爭流。
 虞山楊晉

Leaf K: Gu Fang. *Landscape with Temple.* Ink on paper (4 columns in standard script)

In the evening I pass the temple south
 of the bridge,
Leaning on my staff I lightly trod the
 wilderness path.
Birds cry, the spring rain is plentiful,
Flowers fall, the midday breeze is fair.
 Gu Fang

晚過橋南寺，
扶黎步野輕。
鳥啼春雨足，
花落午風晴。
 顧昉

Leaf L: Gu Fang. *Reading in a Thatched Studio after Wang Meng.* Ink and color on paper (2 columns in standard script)

[After] the Yellow Crane Mountain Wood Gatherer's [Wang Meng, ca. 1308–1385] "Reading in a Thatched Hall"

黃鶴山樵《草堂讀書圖》

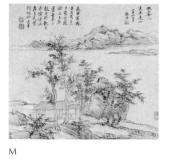

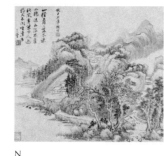

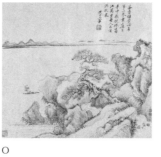

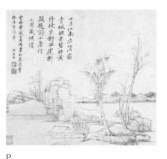

M

N

O

P

Leaf M: Gu Fang. *Pavilion by a Stream with Distant Mountains after Wang Fu*, dated 1692. Ink on paper (4 columns in standard script)

After Drafter Wang's [Wang Fu, 1362–1416] "Pavilion by a Stream with Distant Mountains," autumn, the seventh [lunar] month [August 12– September 10], in the *renshen* year [1692], Gu Fang

倣王舍人《溪亭遠山》。壬申秋
七月，顧昉

Wang Hui inscription (9 columns in running script)

In his studio in Chang'an [i.e., the capital, Beijing], from morning till night Ruozhou [Gu Fang] and I daily discuss calligraphy and famous paintings until the second drum [9–11 p.m.] when we retire. Watching him paint, [his works] truly rival those of the Yuan masters. Wang Hui

長安寓齋與若周晨夕聚首，較論
法書名畫，每至二鼓方臥。觀其染
翰揮洒，眞與元賢頡頏也。王翬

Leaf N: Gu Fang. *Landscape after Juran*. Ink on paper (1 column in standard script)

After Juran's [active ca. 960–95] brush [manner], Gu Fang

倣巨然筆。顧昉

Wang Hui inscription
(5 columns in cursive script)

Mountain path, whistling wind,
 the scattered trees part,
Small bridge, flowing water,
 a thatched hut in a grove.
Autumn wind, yellow leaves,
 travelers are scarce,
I don't hear chickens or dogs,
 I only read my book.
 Wang Hui

山徑蕭蕭落木疏，
小橋流水限林廬。
秋風黃葉少人跡，
雞犬不聞唯讀書。
 王翬

Leaf O: Wang Hui. *Landscape with Sailboat*. Ink on paper (6 columns in running script)

Dozing with the fragrance of tea,
 not a care in the world,
In my hand a scroll of the *Yellow Court* [*Sutra*].
Leaning on a pillow, the blinds rolled up, I look out on the myriad miles of river,
The boatmen don't talk as the wind fills our sails.
 Shigu Wang Hui

茶香睡覺心無事，
一卷黃庭在手中。
欹枕捲簾江萬里，
舟人不語滿帆風。
 石谷王翬

6. (continued)

Leaf P: Wang Hui. *Landscape after a Painting by Ni Zan.* Ink on paper
(7 columns in standard and running script)

Tenth month in Jiangnan, frost has yet to fall,
The green maple turns red, the emerald *wutong* tree yellows.[6]
Stopping the oars I face the Western mountains as evening falls,
Newly [arrived] wild geese inscribe a poem as the little authors pass by.
In the *jiyou* year [1369], Ni Zan

Yunlin [Ni Zan, 1306–1374] studied Guan Tong's [active ca. 907–23] use of slanted brush the way Dongpo [Su Shi, 1037–1101] studied Xu Hao's [703–782] bent brush. Shiguzi [Wang Hui]

十月江南未隕霜，
青楓欲赤碧梧黃。
停橈坐對西山晚，
新鴈題詩小著行。
　　己酉歲，倪瓚

雲林學關仝用側筆如東坡學徐浩
用偃筆。石谷子

PLATES 6q, 6r Wang Hui and disciples.
Landscapes after Ancient Masters. Details:
6q: Yinhu (unidentified, 20th century), *Label strip* (on brocade cover), dated 1912. Ink on paper
6r: Sun Yuwen (died 1899), *Label strip* (on the interior title page), dated 1895. Ink on paper

ARTISTS' SEALS
Wang Hui
Wang Hui zhi yin 王翬之印 Leaves A, M, P
Shiguzi 石谷子 Leaves M, O, P
Wang Hui 王翬 Leaf N

Xu Mei
Xu Mei si yin 徐玫私印 Leaf B

Wang Yun
Wang Yun 王雲 Leaf C
Chen Yun 臣雲 Leaf D
Hanzao 漢藻 Leaf D

Yang Jin
Yang Jin 楊晉 Leaves E, F, G, H, J
Yang Jin zhi yin 楊晉之印 Leaf I
Zihe shi 子鶴氏 Leaf I

Gu Fang
Gu Fang 顧昉 Leaves K, L, M, N
Ruozhou 若周 Leaf K

6q　　　6r

LABEL STRIP (on brocade cover; pl. 6q)
Yinhu 印瓠 (unidentified, 20th century), 2 columns in standard script, dated 1912

Sixteen-leaf Collaborative Work of Master Wang Shigu [Wang Hui] and His Disciples.
　　[Formerly] collected and appreciated in the Xuzhai Studio [of Pang Yuanji, 1864–1949]. Yinhu inscribed this title in winter, the tenth [lunar] month [November 17–December 15] of the *renzi* year [1912] [seal:] *Yinhu jushi*

《王石谷師弟合璧十六葉》
　　盧齋鑑藏。壬子冬十月，印
瓠題籤［印］印瓠居士

LABEL STRIP (on the interior title page; pl. 6r)
Sun Yuwen 孫毓汶 (died 1899), 2 columns in standard script, dated 1895

Sixteen-leaf Album of Master Shigu [Wang Hui] and His Disciples.
　　Shigu, three [leaves]; Zihe [Yang Jin], six [leaves]; Ruozhou [Gu Fang], four [leaves]; Hanzao [Wang Yun], two [leaves]; Cairuo [Xu Mei], one [leaf].
　　Chiweng [Sun Yuwen] recorded this in winter, the tenth [lunar] month [November 17–December 15] of the *yiwei* year [1895]

《石谷師弟十六葉冊》石谷三；
子鶴六；若舟四；漢藻二；采若一
　　乙未冬十月，遲翁記

COLLECTORS' SEALS

Sun Yuwen 孫毓汶 (died 1899)[7]

Yuwen	毓汶	Leaves A–P
Chi'an shending	遲庵審定	Second label strip
Laishan zhen shang	萊山眞賞	Second front-sheet (pl. 6t, top)
Jiang lao si you zui	將老斯遊最	Second front-sheet (pl. 6t, bottom)
Laishan shending zhenji	萊山審定眞跡	Second end-sheet (pl. 6v)

Pang Yuanji 龐元濟 (1864–1949)

Pang Laichen zhenshang yin	龐萊臣珍賞印	Leaves A, B, D, F, K, M
Xuzhai jian shang	虛齋鑑藏	Leaves C, E, G, J, L, O
Xuzhai shending	虛齋審定	Leaves H, I, N, P
Laichen xinshang	萊臣心賞	First front-sheet (pl. 6s, top)
Wuxing Pangshi zhen cang	吳興龐氏珍藏	First front-sheet (pl. 6s, bottom)
Xuzhai mi wan	虛齋祕玩	First end-sheet (pl. 6u, top)
Laichen shen cang zhenji	萊臣審藏眞跡	First end-sheet (pl. 6u, bottom)

6s

6t

6u

6v

REFERENCES

Pang Yuanji 1909, *juan* 15, pp. 7–10;[8] Hearn 1990, pp. 180–84, figs. 11–12; *Yiyuan duoying* 1995, pp. 38–39 (4 leaves illustrated: a, b, j, m); Toda Teisuke and Ogawa Hiromitsu 1998, A42-006; The Metropolitan Museum of Art 2001, p. 77.

RECENT PROVENANCE

Sotheby's, New York, December 12, 1987 (sale 5648), lot 89

PLATES 6s–v Wang Hui and disciples. *Landscapes after Ancient Masters.* Details:
6s: Collector's seals on first front-sheet
6t: Collector's seals on second front-sheet
6u: Collector's seals on first end-sheet
6v: Collector's seals on second end-sheet

NOTES

1 Translated by Shi-yee Liu.

2 Translated with the assistance of Shi-yee Liu.

3 Shi-yee Liu has identified this line as coming from the fourth of seven poems in the series *Tianyuan le*; see *Quan Tang shi* 1960, p. 1305. For a list of English translations of the poem, see Fung and Lai 1984, p. 522.

4 Shi-yee Liu notes that the reference is to the Daoist sage Tao Hongjing (451–536) who regretted that he could not send the emperor Liang Wudi (r. 502–49) the white clouds that often surrounded his residence. See "Poem composed in response to the emperor Qi Gaodi's question, 'What is in the mountains?'" in Shen Deqian 1973, p. 327.

5 Translated with the assistance of Shi-yee Liu.

6 The *wutong* tree is identified as Sterculia platanifolia.

7 Sun Yuwen also owned Qian Xuan's (ca. 1235–before 1307) *Dwelling in the Floating Jade Mountains*; see *Zhongguo shuhuajia yinjian kuanshi* 1987, vol. 2, p. 861.

8 This publication arranges the album leaves by artist in their relative order of importance and does not reflect their sequence as mounted.

7. WANG YUANQI 王原祁 (1642 – 1715)

Landscape for Zhanting

Wei Zhanting hua qifa miaoji tu
爲瞻亭畫七發妙劑圖
Dated 1710
Hanging scroll, ink and color on paper
37 ½ × 18 ½ in. (95.2 × 47 cm)
The Metropolitan Museum of Art
Promised Gift of Marie-Hélène and
Guy Weill

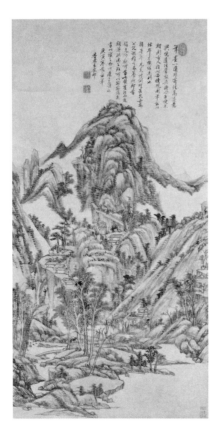

ARTIST'S INSCRIPTION & SIGNATURE
11 columns in running script

The way of brush and ink is such that if it is not the product of lofty and profound ideas and a happy and relaxed mood, when [the artist] adds dots and washes, his mind and hand will not respond to one another. In accord with this principle, the ancients would put away their inkstones and lay aside their brushes, often for years at a time, if the right occasion did not arise.

My colleague Zhanting entrusted me with some *celi* paper a long time ago, but I was distracted by official business. This spring I was recuperating from illness at home. Mr. Zhanting's marvelous medicinal compound worked like the seven stimulants. I recovered immediately, feeling fully vitalized, and was able to fulfill my old promise. I note this in hopes that he will not admonish me for my tardiness.

Written before the Cold Meal Festival of the *gengyin* year [about April 2, 1710], Wang Yuanqi of Loudong.[1]

筆墨一道非寄託高遠,意興悅適,
經營點染時,心手便不相關。古
人於此每檳硯閣筆,動以經年,
亦機緣未到也。

瞻亭年兄見付側理甚久,每
爲公冗所稽。今春養病邸舍,瞻
兄妙劑可當七發。霍然而起,頗
得淋漓之致,可以踐宿諾矣。

書以識之勿以遲之見誚也。
庚寅寒食前筆,婁東王原祁

ARTIST'S SEALS
Yu shu: huatu liu yu ren kan 御書,
畫圖留與人看
Wang Yuanqi yin 王原祁印
Lutai 麓臺
Xilu houren 西廬後人

COLLECTOR'S SEAL
Shu shou shu jia zhen cang
菽壽樞家珍藏

LABEL STRIP (on exterior of the mounting; pl. 7c)
Wu Hufan 吳湖帆 (1894 – 1968), one column in running script, dated 1948

Authentic traces of Wang Lutai's [Wang Yuanqi's] "Seven Stimulants Marvelous Medicine" painting for Mr. Zhanting. The ninth month of the *wuzi* year [September, 1948], Wu Hufan inscribed

王麓臺爲瞻亭畫七發妙劑圖眞
跡。戊子九月,吳湖帆題

LABELS & STAMPS (on exterior of the mounting)

United States Immigration and Customs Service label (affixed adjacent to Wu Hufan's label strip; pl. 7c)

Supervisory Customs Inspector
Outside Section (I&C)
[signed:] L.L. Jaeger
[stamped:] Jul 29, 1958

United States Immigration and Customs Service Stamp (impressed on the back of the mounting directly behind the upper left corner of the painting)

C. J. Colomes, Jr., Acting Appraiser

REFERENCES
Yiyuan duoying 1995, p. 14; Toda Teisuke and Ogawa Hiromitsu 1998, A42-009

RECENT PROVENANCE
The painting bears a United States Immigration and Customs Service label indicating that it entered the United States on July 29, 1958; Sotheby Parke Bernet, New York, May 8, 1981 (sale 4603Y), lot 350

NOTE
1 Translation based on those of Sotheby Parke Bernet 1981, lot 350, and Shi-yee Liu.

PLATE 7c Wang Yuanqi. *Landscape for Zhanting*. Detail. Wu Hufan (1894–1968), *Label strip* (on exterior of the mounting), dated 1948. Ink on paper; United States Immigration and Customs Service label, dated 1958. Ink on paper

8. LI FANGYING 李方膺 (1696–1755)

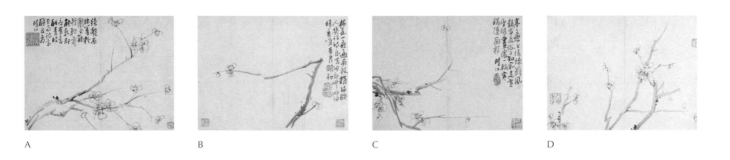

A B C D

Ink Plum

Momei tu 墨梅圖
Dated 1742
Album of eight paintings, ink on paper
Each leaf: 9¾ × 12½ in. (24.7 × 31.7 cm)
The Metropolitan Museum of Art
Promised Gift of Marie-Hélène and
Guy Weill

ARTIST'S INSCRIPTIONS & SIGNATURES

Leaf A (10 columns in running script):

Exquisite beauty does not rely on
makeup,
It's like jade, but soft and light;
like snow, but powdery.
Willing to reward the admiring poet,
She lends herself to his intoxicated gaze.[1]
Qingjiang [Li Fangying]

絕艷原非著粉團，
玉能輕軟雪能乾。
卻應有意酬青眼，
長與詩家醉後看。
　　晴江

Leaf B (3 columns in running script):

Overnight, plum blossoms have filled
the southern branches,
The enchanted poet composed numer-
ous poems.
No good lines have been written since
court-attendant He [He Xun,
died ca. 527],[2]
Only the bright moon appreciates their
subtle fragrance.

梅花一夜遍南枝，
銷得騷人幾許詩。
自去何郎無好詠，
暗香唯有月明知。

Leaf C (4 columns in running script):

An elegant figure stands by the garden
fence,
How can a country bumpkin appreciate
her grace?
She is best portrayed at dusk,
When a cool moon hangs over
the southern branches.
Qingjiang [Li Fangying]

亭亭瘦玉倚疏籬，
風韻寧教俗子知？
最是黃昏堪畫處，
一輪寒魄墮南枝。
　　晴江

Leaf D: No inscription

Leaf E (1 column in running script)

Painted in the eighth [lunar] month
[August 30–September 28] of the sev-
enth year of the Qianlong reign era
[1742] at the Green Wutong
Tree Dwelling

乾隆七年八月寫於碧梧居。

Leaf F: No inscription

E F G H

Leaf G (1 column in running script):

Qingjiang [Li Fangying] painted this at the Plum Blossom Tower

晴江寫於梅花樓。

Leaf H (9 columns in running script):

A reclusive beauty blooms alone in the
 deep woods,
Where snow falls and moss encroaches.
As messengers no longer come and the
 music has ceased to play,
With whom can I share my feelings dur-
 ing the wintry season?
 Written on the fifth day of the eighth
[lunar] month of the seventh year of the
Qianlong reign era [September 3, 1742]
at the Plum Blossom Tower. Qingjiang
Li Fangying

幽芳獨秀在山林，
密雪無端苔見侵。
驛使不來羌管歇，
與誰共話歲寒心？
 乾隆七年八月五日，寫於梅
花樓，晴江李方膺

ARTIST'S SEALS **LEAVES**

Hua yi mu ji 畫醫目疾 A
Lu pang jing shang 路旁井上 B
Qingjiang 晴江 C
Xian Li 仙李 D
Yi jiu wei ming 以酒爲名 E
He fang bai bu neng
 何妨百不能 F
Lue xian da yi 略見大意 G
Qingjiang shu hua 晴江書畫 H
Yi wai shu miao 意外殊妙

COLLECTORS' SEALS **LEAVES**
Unidentified
Cao shi ceng cang 曹氏曾藏 A, G
Ying He zhi yin 英和之印 B, D
Xiu yan zhan de 秀嚴暫得
Neige xueshi 內閣學士 C
Yu Lou 雨樓 F

REFERENCES
Yiyuan duoying 1995, p. 9; Toda Teisuke and Ogawa Hiromitsu 1998, A42-007

RECENT PROVENANCE
Sotheby's, New York, December 5, 1985 (sale 5405), lot 61

NOTES
1 Transcription of the poems on leaves A, B, C, and H was made with the assistance of Yangming Chu. Translations are after those of Zhixin Sun.
2 I am indebted to Shi-yee Liu for identifying this reference. He Xun was noted for his poems on the blossoming plum. Here, Li Fangying quotes a line from "Poem on Plum Blossoms" (*Mei-hua shi*) by the late-Yuan poet Gao Qi (1336–1374), one of the Four Talents of Suzhou: "No good lines have been written since court-attendant He / Alone in the spring wind, how many more times will [the plum] bloom?" See *Zhongwen da cidian* 1973, vol. 1, p. 898.

9. MODEL CALLIGRAPHIES FROM THE HALL OF THREE RARITIES AND THE SHIQU BAOJI COLLECTION

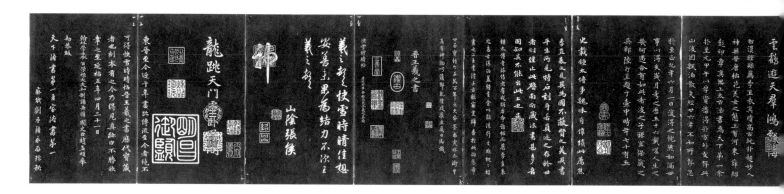

Model Calligraphies from the Hall of Three Rarities and the Shiqu Baoji Collection

Sanxi Tang Shiqu Baoji fatie
三希堂石渠寶笈法帖
Set of rubbings mounted in 32 albums;
ink on paper
Second half of the 18th century
Each page: 11 ¼ × 7 in. (28.6 × 17.8 cm)
The Metropolitan Museum of Art
Gift of Marie-Hélène and Guy Weill,
1984 (1984.496.1–32)

WOODEN ALBUM COVERS (see pl. 9i)
Unidentified, 1 column in clerical script

Imperially Engraved Model Calligra-
phies from the Hall of Three Rarities
and the Shiqu Baoji Collection,
Volume One [– Thirty-two]

御刻三希堂石渠寶笈法帖，第一
[–三十二]冊

COLOPHONS

Two unidentified scribes (scribe A, vols.
1–4, 8, 16, 21–32; scribe B, vols. 5–
7, 9–15, 17–20), 2 columns of stan-
dard script on yellow mounting paper
at the front of each volume

On the solstice in the *renshen* year
of the Qianlong reign era [June 21
or December 21, 1752], Honorary
Palace Attendant, Vice Minister of
Rites, and recorded seven times [for
meritorious service], Dong Bangda
[1699–1769]

乾隆歲在壬申長至月，賜內廷供
奉禮部右侍郎記錄七次，臣董邦
達

COLOPHON SEALS

Chen Dong Bangda
臣董邦達
vols. 1–4, 8, 16, 21–32

Bi zhan en yu
筆霑恩雨
vols. 1–4, 8, 16, 21–32

Chen Bangda yin
臣邦達印
vols. 5–7, 9–15, 17–20

Qing hua shicong
清華侍從
vols. 5–7, 9–15, 17–20

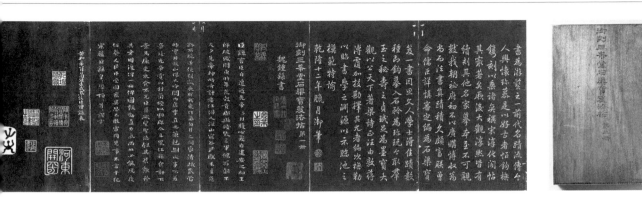

COLLECTORS' SEALS

Dong Gao 董誥 (1740–1818)

Chen Gao gong cang	臣誥恭藏	vols. 1–32, last page
Fuchun Dong shi shoucang shu hua ji	富春董氏收藏書畫記	vol. 1, p. 1;
		vol. 32, p. 40

Zhao Xiaonong 趙筱農 (unidentified)

Guanzhong Zhao Xiaonong	關中趙筱農	vols. 1–32, last page
Xiaonong	筱農	vols. 1–32, first page
Chen Enxiang yin	臣恩祥印	vols. 1–32, first page
Ren zai Weichuan zhu mu zhong	人在渭川竹畝中	vols. 1–32, last page
Jia zai Wei zhi yang Taihua zhi jian	家在渭之陽太華之間	
		vols. 5, 13, 21, 29, 1st page

Li Shen 李愼 (unidentified)

Li Shen jian cang	李愼鑑藏	vol. 1, first page
Li shi Yixi	李氏意西	vol. 1, pp. 2, 5b; vol. 2,
		pp. 7, 18, 20
Liaodong Li shi	遼東李氏	vol. 32, last page

Unidentified

Xue xu jing shi	學須靜室	vol. 1, first page
Bosun zhenshang	柏孫珍賞	vol. 32, last page
Qing xian jiafeng	清獻家風	vols. 8, 16, 24, 32, 1st page
Yanshan Caotang cang shu	硯山草堂藏書	vols. 1, 9, 17, 25, first page
Yanshan Caotang	研山草堂	vols. 3, 11, 19, 27, 1st page
Yi qin yi he	一琴一鶴	vols. 7, 15, 23, 31, 1st page
Wenzhang	文章	vol. 1, last page

PLATE 9i *Model Calligraphies from the Hall of Three Rarities and the Shiqu Baoji Collection,* second half of the 18th century. Detail. Wooden cover to Volume Two. Wood with green pigment

LABEL STRIP (mounted on the inside of vol. 17)
Unidentified, 2 columns in standard script

Imperially Engraved Calligraphies from the Hall of Three Rarities, Volume Seventeen: Song. Not counting the annotated pages at the front and back, there are forty spreads.

御刻三希堂帖，第十七冊，宋。除前後襯頁實四十開。

REFERENCES
Barnhart, Fong, and Hearn 1996, no. 39; Harrist 1999, pp. 255, fig. 16

RECENT PROVENANCE
Sören Edgren

10. ZHANG DAQIAN 張大千 (Chang Dai-chien, 1899–1983)

Red Orchid
Zhu lan tu 朱蘭圖
Datable to 1950
One of a pair of folding fans mounted as an album leaf, ink and color on gold paper
5 ¼ × 17 in. (13.5 × 43 cm)
The Metropolitan Museum of Art
Promised Gift of Marie-Hélène and Guy Weill

ARTIST'S INSCRIPTION & SIGNATURE
9 columns in running-clerical script

Darjeeling [India] produces numerous orchids, but the red orchid is the most outstanding. Written to present to third aunt Duanhua for pure enjoyment.[1]

大吉嶺產蘭甚夥，而朱蘭爲最
上品。寫奉端華三姑清拂。大
千弟爰

ARTIST'S SEALS
Zhang Yuan 張爰
Daqian 大千

COLLECTOR'S SEALS
Unidentified
Wang 王
Wenshan 聞善

RECENT PROVENANCE
Christie's, New York, June 29, 1984 (sale 5598A), lot 917A

NOTE
1 Translated with the assistance of Shi-yee Liu.

11. ZHANG DAQIAN 張大千 (Chang Dai-chien, 1899–1983)

Poem

Xingshu shi 行書詩
Dated 1950
One of a pair of folding fans mounted
as an album leaf, ink on gold paper
5 ¼ × 17 in. (13.5 × 43 cm)
The Metropolitan Museum of Art
Promised Gift of Marie-Hélène and
Guy Weill

ARTIST'S INSCRIPTION & SIGNATURE

seven-character poem in 16 columns of
running-clerical script

A hundred mountains wind around,
 falling and rising,
Ten-thousand-year-old snow illuminates
 the peaks.
The hilltops amid clouds remind me of
 Jing Hao [active ca. 870–ca. 930],
Blossoming branches in the mist recall
 [the poetry] of Du Ling [Du Fu,
 712–770].
As rain showers clear I again look out,
Returning home or leaving the country,
 what can I rely on?
A vagabond, how dare I hope to paint
 the hills and valleys,
I can only adorn the vines, hanging
 seven feet long, with my dreams.
 A poem from the series "Searching
for a Dwelling in the Darjeeling Moun-
tains [India]." Respectfully presented to
Duanhua my third aunt to recite.
Daqian, your junior, Yuan, on a summer
day in the *gengyin* year [1950].[1]

百嶺迴環降復昇，
萬年老雪耀崚嶒。
雲中山頂思荊浩，
霧裏花枝識杜陵。
乍雨復晴看反覆，
還鄉去國竟何憑？
流離敢冀寫丘壑，
掛夢聊文七尺藤。
 大吉嶺卜居之一。呈似端華
三姑吟定。大千弟爰庚寅夏日

ARTIST'S SEALS

Zhang Yuan changshou 張爰長壽
Zhang Daqian changnian daji you ri li
張大千長年大吉又日利

COLLECTOR'S SEAL

Unidentified
Wenshan 聞善

RECENT PROVENANCE

Christie's, New York, June 29, 1984
(sale 5598A), lot 917B

NOTE

1 Translated by Shi-yee Liu.

12. WANG JIQIAN 王季遷 (己千) (Wang Chi-ch'ien; C.C. Wang, born 1907)

Landscape after Guo Xi
Fang Guo Xi shanshui 倣郭熙山水
Dated 1937
Hanging scroll, ink on paper
35 7/8 × 19 7/8 in. (91 × 50.5 cm)
The Metropolitan Museum of Art
Promised Gift of Marie-Hélène and
Guy Weill

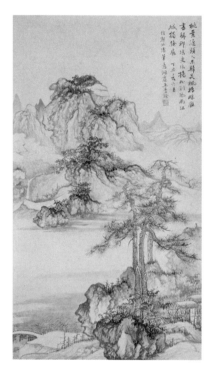

ARTIST'S INSCRIPTION & SIGNATURE
4 columns in running script

At Peach Leaf Ferry no one has
 returned,[1]
Beside Suzhou's Maple Bridge lines
 of geese are scarce.
How could one bear another parting
 in Yangzhou,
Amid the wind and rain of the river
 city I shut my door in solitude.[2]
 Summer, the sixth month of the
dingchou year [1937], following the
brush concepts of Guo Heyang [Guo
Xi, ca. 1000–ca. 1090], Wang Jiquan
of [Mount] Dongting [near Suzhou][3]

桃葉渡頭人未歸，
吳楓橋畔雁書稀。
那堪更作揚州別，
風雨江城獨掩扉。
 丁丑夏六月，仿郭河陽筆
意，洞庭王季銓

ARTIST'S SEALS
Wang Jiqian 王季遷
Bu zhuo shan fang 補拙山房

LABEL STRIP (on exterior of the mounting;
pl. 12a)

Unidentified, 1 column in standard
script

Wang Jiquan, *Landscape after
Guo Xi*
王季銓仿郭熙山水

RECENT PROVENANCE
Sotheby's, New York, May 31, 1989
(sale 5862) lot 14

NOTES
1 Peach Leaf Ferry takes its name from
Peach Leaf (Taoye), a beloved concubine
of Wang Xianzhi (344–388), who bid
her farewell there by composing a
poem. See *Zhongwen da cidian* 1973,
vol. 5, p. 190.
2 Translated with the assistance of
Shi-yee Liu.
3 Wang was originally given the name
Jiquan, but began using Jiqian as early
as 1932. See Silbergeld 1987, p. 13.

PLATE 12a Wang Jiqian. *Landscape
after Guo Xi [ca. 1000–ca. 1090].*
Detail. Unidentified, *Label strip*
(on exterior of the mounting). Ink
on paper

BIBLIOGRAPHY AND INDEX

BIBLIOGRAPHY

The following abbreviations have been used in the notes
and the short-reference list:
DMB Dictionary of Ming Biography
ECCP Eminent Chinese of the Ch'ing [Qing] Period

Andrews and Shen 1998. Andrews, Julia F. and Kuiyi
Shen. *A Century in Crisis: Modernity and Tradition in
the Art of Twentieth-Century China.* Exh. cat. New York:
Guggenheim Museum, 1998.

Barnhart 1972. Barnhart, Richard M. *Wintry Forests,
Old Trees: Some Landscape Themes in Chinese Painting.*
Exh. cat. New York: China House Gallery, China Institute
of America, 1972.

Barnhart 1983. Barnhart, Richard M. *Peach Blossom
Spring: Gardens and Flowers in Chinese Painting.* Exh.
cat. New York: The Metropolitan Museum of Art, 1983.

Barnhart 1984. Barnhart, Richard M. "Wang Shen and
Late Northern Sung Landscape Painting." In *International
Symposium on Art Historical Studies, 2d, 1983, Kyoto,*
pp. 61–70. Kyoto, 1984.

Barnhart et al. 1993. Barnhart, Richard M., et al.
*Painters of the Great Ming: The Imperial Court and
the Zhe School.* Exh. cat. Dallas: Dallas Museum of
Art, 1993.

Barnhart et al. 1994. Barnhart, Richard M., et al. *The
Jade Studio: Masterpieces of Ming and Qing Painting
and Calligraphy from the Wong Nan-p'ing Collection.*
Exh. cat. New Haven: Yale University Art Gallery, 1994.

Barnhart, Fong, and Hearn 1996. Barnhart, Richard M.,
Wen C. Fong, and Maxwell K. Hearn. *Mandate of
Heaven, Emperors and Artists in China: Chinese Painting
and Calligraphy from The Metropolitan Museum of Art,
New York.* Exh. cat. Zürich: Museum Rietberg, 1996.

Bickford et al. 1985. Bickford, Maggie, et al. *Bones of
Jade, Soul of Ice: The Flowering Plum in Chinese Art.*
Exh. cat. New Haven: Yale University Art Gallery, 1985.

Bush 1962. Bush, Susan. "Lung-mo, K'ai-ho, and
Ch'i-fu: Some Implications of Wang Yüan-ch'i's Three
Compositional Terms." *Oriental Art* 8, no. 3 (Autumn
1962), pp. 120–27.

Bush 1971. Bush, Susan. *The Chinese Literati on
Painting: Su Shih (1037–1101) to Tung Ch'i-ch'ang
(1555–1636).* Harvard-Yenching Institute Studies, 27.
Cambridge, Mass.: Harvard University Press, 1971.

Bush and Shih 1985. Bush, Susan, and Hsio-yen Shih.
Early Texts on Chinese Painting. Cambridge, Mass.:
Harvard University Press, 1985.

Cahill 1970. Cahill, James. "The Early Styles of Kung
Hsien." *Oriental Art* 16, no. 1 (Spring 1970), pp. 51–71.

Cahill 1976. Cahill, James. *Hills Beyond a River:
Chinese Painting of the Yüan Dynasty, 1279–1368.* New
York and Tokyo: Weatherhill, 1976.

Cahill 1978. Cahill, James. *Parting at the Shore: Chinese
Painting of the Early and Middle Ming Dynasty, 1368–
1580.* New York and Tokyo: Weatherhill, 1978.

Cahill 1981. Cahill, James, ed. *Shadows of Mount
Huang: Chinese Painting and Printing of the Anhui
School.* Berkeley: University Art Museum, 1981.

Cahill 1982a. Cahill, James. *The Compelling Image:
Nature and Style in Seventeenth-Century Chinese
Painting.* Cambridge, Mass. and London: Harvard
University Press, 1982.

Cahill 1982b. Cahill, James. *The Distant Mountains:
Chinese Painting of the Late Ming Dynasty, 1570–1644.*
New York and Tokyo: Weatherhill, 1982.

Cahill 1986. Cahill, James. "The Anhui School." Draft
chapter for a book on early Qing painting. Circulated
in manuscript form, 1986.

Cao Xueqin. Cao Xueqin (ca. 1717–1763). *The Story of
the Stone.* Translated by David Hawkes. 5 vols.
Harmondsworth: Penguin, 1973–1986.

***Catalogue of the International Exhibition of Chinese Art
1935–36.*** London: Royal Academy of Arts, 1935.

Chen Zhenghong 1993. Chen Zhenghong. *Shen Zhou
nianpu* (Chronology of Shen Zhou). 1993

Chou and Brown 1985. Chou, Ju-hsi, and Claudia
Brown. *The Elegant Brush: Chinese Painting Under the
Qianlong Emperor, 1735–1795.* Phoenix: The Phoenix
Art Museum, 1985.

191

Christy 1996. Christy, Anita. "Marie-Hélène and Guy A. Weill: Travelers Amid Mountains and Streams." *Orientations* 27, no. 10 (November 1996), pp. 81–85.

Christie's 1984. Christie's, New York. *Fine Classic and Contemporary Chinese Paintings and Calligraphy.* June 29, 1984 (sale 5598A).

Christie's 1985. Christie's, New York. *Fine Chinese Paintings.* December 3, 1985 (sale 5910).

Christie's 1988. Christie's, New York. *Fine Chinese Paintings and Calligraphy.* June 2, 1988 (sale 6616).

Chuang Su-o 1986. Chuang Su-o. "Li Fangying de shengping he jiashi" (The Life and Family Background of Li Fangying). *National Palace Museum Research Quarterly* 4, no. 1 (Autumn 1986), pp. 67–92.

Clapp 1975. Clapp, Anne de Coursey. *Wen Cheng-ming: The Ming Artist and Antiquity.* Ascona: Artibus Asiae, 1975.

Clapp 1991. Clapp, Anne De Coursey. *The Painting of T'ang Yin.* Chicago and London: The University of Chicago Press, 1991.

Clunas 1991. Clunas, Craig. *Superfluous Things: Material Culture and Social Status in Early Modern China.* Urbana-Champaign: University of Illinois Press, 1991.

Contag and Wang 1966. Contag, Victoria, and Wang Chi-ch'ien. *Seals of Chinese Painters and Collectors.* Revised edition. Hong Kong: Hong Kong University Press, 1966.

Cressy 1955. Cressy, George B. *The Land of the Five Hundred Million: A Geography of China.* New York: McGraw-Hill, 1955.

Delbanco 1986. Delbanco, Dawn Ho. "The Strange Pines of Mount Tiantai." In *Selections of Chinese Art from Private Collections*, no. 38, p. 96. Exh. cat. New York: China House Gallery, China Institute in America, 1986.

DMB. Goodrich, L. Carrington, and Chaoying Fang, eds. *Dictionary of Ming Biography, 1368–1644.* New York and London: Columbia University Press, 1976.

ECCP. Hummel, Arthur W., ed. *Eminent Chinese of the Ch'ing Period (1644–1911).* Washington, D.C.: U.S. Government Printing Office, 1943–44.

Ecke 1965. Ecke, Gustav. *Chinese Painting in Hawaii in the Honolulu Academy of Arts and in Private Collections.* Honolulu: University of Hawaii Press for the Honolulu Academy of Arts, 1965.

Edwards 1962. Edwards, Richard. *The Field of Stones.* Washington, D.C.: Freer Gallery of Art, 1962.

Edwards et al. 1976. Edwards, Richard, et al. *The Art of Wen Cheng-ming (1470–1559).* Exh. cat. Ann Arbor: Museum of Art, University of Michigan, 1976.

Fong 1958. Fong, Wen C. *The Lohans and a Bridge to Heaven.* Freer Gallery of Art Occasional Papers, vol. 3, no. 1. Washington, D.C.: Smithsonian Institution, 1958.

Fong 1967. Fong, Wen C. "The Orthodox Master." *Art News Annual* 33 (1967), pp. 132–39.

Fong 1968a. Fong, Wen C. "Tung Ch'i-ch'ang and the Orthodox Theory of Painting," *National Palace Museum Quarterly* 3, no. 3 (January 1968), pp. 1–26 (Chinese text, pp.1–18).

Fong 1968b. Fong, Wen C. "Wang Hui chih chi ta-ch'eng" (Wang Hui: The Great Synthesis). *National Palace Museum Quarterly* 3, no. 2 (October 1968), pp. 5–10.

Fong 1969. Fong, Wen C. "Wang Hui, Wang Yüan-ch'i and Wu Li." In *In Pursuit of Antiquity: Chinese Paintings of the Ming and Ch'ing Dynasties from the Collection of Mr. and Mrs. Earl Morse*, by Roderick Whitfield, pp. 175–94. Exh. cat. Rutland, Vermont and Tokyo: The Art Museum, Princeton University and Charles E. Tuttle Co., 1969.

Fong 1970. Fong, Wen C. "Orthodoxy and Change in Early Ch'ing Landscape Painting." *Oriental Art* 16, no. 1 (Spring 1970), pp. 38–44.

Fong 1992a. Fong, Wen C. *Beyond Representation: Chinese Painting and Calligraphy 8th–14th century.* New York: The Metropolitan Museum of Art, 1992.

Fong 1992b. Fong, Wen C. "Remembering Chang Dai-chien (1899–1983)." Paper given at a symposium held in conjunction with the exhibition *Challenging the Past,*

Arthur M. Sackler Gallery, Smithsonian Institution, Washington, D.C., November 22, 1992.

Fong 2001. Fong, Wen C. *Between Two Cultures: Late-Nineteenth- and Twentieth-Century Chinese Paintings from the Robert H. Ellsworth Collection in The Metropolitan Museum of Art.* New York: The Metropolitan Museum of Art, 2001.

Fong and Watt 1996. Fong, Wen C., James C.Y. Watt, et al. *Possessing the Past: Treasures from the National Palace Museum, Taipei.* New York: The Metropolitan Museum of Art and National Palace Museum, Taipei, 1996.

Fu Shen 1976. Fu Shen C. Y. "Ming Qing zhi ji de kebi goule fengshang yu Shitao de zaoqi zuopin" (An Aspect of Mid-seventeenth Century Chinese Painting: The 'Dry Linear' Style and the Early Work of Shih-t'ao). *The Journal of the Institute of Chinese Studies of the Chinese University of Hong Kong* 8, no. 2 (1976), pp. 579–603 (English text, pp. 604–15).

Fu Shen 1991. Fu Shen C. Y., with Jan Stuart. *Challenging the Past: The Paintings of Chang Dai-chien.* Washington, D. C.: Arthur M. Sackler Gallery, Smithsonian Institution, 1991.

Fu Shen et al. 1977. Fu Shen C. Y., et al. *Traces of the Brush: Studies in Chinese Calligraphy.* Exh. cat. New Haven: Yale University Art Gallery, 1977.

Fung and Lai 1984. Fung, Sydney S. K., and S. T. Lai. *25 T'ang Poets: Index to English Translations.* Hong Kong: The Chinese University Press, 1984.

Gu Linwen 1962. Gu Linwen, ed. *Yangzhou bajia shiliao* (Historical Materials on the Eight Masters of Yangzhou). Shanghai, 1962.

Guan Jingcheng 1981. Guan Jingcheng. "Li Fangying xuzhuan" (A Chronicle of Li Fangying). In *Qingdai Yangzhou huapai yanjiu ji* (Collection of Essays on the Yangzhou School of Painting of the Qing Dynasty), vol. 2, pp. 14–27. Yangzhou: Yangzhou shi wenxue yishu gongzuozhe lianhe hui and Qingdai Yangzhou huapai yanjiu hui, 1981.

Guo Weiqu 1958. Guo Weiqu. *Song, Yuan, Ming, Qing shuhuajia nianbao* (Chronology of Calligraphers and Painters of the Song, Yuan, Ming, and Qing Dynasties). Beijing: Renmin meishu chubanshe, 1958.

Gu Qiyuan 1618. Gu Qiyuan. *Kezuo zhuiyu* (Idle Talk while Seated with Guests), 1618. Reprint. In *Yuan Ming shiliao biji congkan* (Compendium of Writings on the History of the Yuan and Ming Dynasties). Beijing: Zhonghua shuju, 1987.

Hanyu da cidian 1987. *Hanyu da cidian* (Dictionary of Chinese). Hong Kong: Sanlian shudian Xianggang fendian, Shanghai cishu chubanshe, 1987.

Harrist 1998. Harrist, Robert E., Jr. *Painting and Private Life in Eleventh-Century China: Mountain Villa by Li Gonglin.* Princeton: Princeton University Press, 1998.

Harrist 1999. Harrist, Robert F., Jr., "A Letter from Wang Hsi-chih and the Culture of Chinese Calligraphy." In *The Embodied Image: Chinese Calligraphy from the John B. Elliott Collection,* by Robert E. Harrist, Jr., Wen C. Fong, et al., pp. 240–59. Princeton: The Art Museum, Princeton University, 1999.

Harrist and Fong et al. 1999. Harrist, Robert E., Jr., Wen C. Fong, et al. *The Embodied Image: Chinese Calligraphy from the John B. Elliott Collection.* Exh. cat. Princeton: The Art Museum, Princeton University, 1999.

Hearn 1988. Hearn, Maxwell K. "Document and Portrait: The Southern Inspection Tour Paintings of Kangxi and Qianlong." In *Chinese Painting under the Qianlong Emperor: The Symposium Papers in Two Volumes,* edited by Ju-hsi Chou and Claudia Brown. *Phoebus* 6, no. 1 (1988), pp. 91–189.

Hearn 1990. Hearn, Maxwell K. "The *Kangxi Southern Inspection Tour*: A Narrative Program by Wang Hui." Ph.D. diss., Princeton University, 1990.

Hearn and Fong 1999. Hearn, Maxwell K., and Wen C. Fong. *Along the Riverbank: Chinese Paintings from the C. C. Wang Family Collection.* Exh. cat. New York: The Metropolitan Museum of Art, 1999.

Ho and Lee et al. 1980. Ho, Wai-kam , Sherman E. Lee, et al. *Eight Dynasties of Chinese Painting: The Collections of the Nelson Gallery-Atkins Museum, Kansas City, and The Cleveland Museum of Art.* Exh. cat. Cleveland: The Cleveland Museum of Art, 1980.

Ho and Smith 1992. Ho, Wai-kam, and Judith G. Smith, eds. *The Century of Tung Ch'i-ch'ang, 1555–1636.* 2 vols.

Exh. cat. Kansas City: The Nelson-Atkins Museum of Art, 1992.

Kaikodo 2000. *Kaikodo Journal* 17 (Autumn 2000).

Kim 1985. Kim, Hongnam. "Chou Liang-kung and his 'Tu-hua-lu' (Lives of Painters): Patron-critic and Painters in Seventeenth Century China." Ph.D. diss., Yale University, 1985.

Kim 1996. Kim, Hongnam. *The Life of a Patron: Zhou Lianggong (1612–1672) and the Painters of Seventeenth-Century China*. Exh. cat. New York: China Institute in America, 1996.

Kong Shangren. Kong Shangren. *The Peach Blossom Fan (T'ao-hua-shan)*. Translated by Chen Shih-hsiang and Harold Acton, with the collaboration of Cyril Birch. Berkeley: University of California Press, 1976.

Lawton 1969. Lawton, Thomas. "The *Mo-yüan hui-kuan* by An Ch'i." *National Palace Museum Quarterly*, special issue no. 1: *Symposium in Honor of Dr. Chiang Fu-tsung on His 70th Birthday* (1969), pp. 13–35.

Li 1974. Li, Chu-tsing. *A Thousand Peaks and Myriad Ravines: Chinese Painting in the Charles A. Drenowatz Collection*. 2 vols. Ascona, Switzerland: Artibus Asiae Publishers, 1974.

Li Chi 1974. Li Chi. *The Travel Diaries of Hsü Hsia-k'o.* Hong Kong: The Chinese University of Hong Kong, 1974.

Li Jitao 1963. Li Jitao. *Gao Fenghan*. In *Zhongguo huajia congshu* (Compendium of Chinese Painters). Shanghai: Renmin meishu chubanshe, 1963.

Liu Daochun ca. 1040. Liu Daochun. *Shengchao minghua ping* (Commentary on Famous Paintings of the Present [Song] Dynasty), ca. 1040. Reprint. In *Zhongguo hualun leibian* (Classified Compilation of Writings on Chinese Painting), ed. Yu Jianhua, pp. 408–09. Hong Kong, 1973.

Liu Jiu'an 1990. Liu Jiu'an. "Wumen huajia zhi biehao tu ji jianbie juli" (Illustrations of Sobriquets by Suzhou Painters and Some Examples of How to Recognize Them). *Gugong Bowuyuan yuankan* (Palace Museum Journal) 1990/3, pp. 54–61.

Liu Tao 1991. Liu Tao, ed. *San Guo Liang Jin Nan Bei Chao bian, Wang Xizhi, Wang Xianzhi juan*. In *Zhong-guo shufa quanji* (Complete Collection of Chinese Calligraphy). Vols. 18–19. Beijing: Rongbao Zhai, 1991.

Loehr 1980. Loehr, Max. *The Great Painters of China.* New York: Harper and Row, 1980.

Lovell 1970. Lovell, Hin-cheung. "Wang-Hui's 'Dwelling in the Fu-ch'un Mountains': A Classical Theme, Its Origins and Variations." *Ars Orientalis* 8 (1970), pp. 217–42.

Lovell 1973. Lovell, Hin-cheung. *An Annotated Bibliography of Chinese Painting Catalogues and Related Texts.* Michigan Papers in Chinese Studies, 16. Ann Arbor: Center for Chinese Studies, University of Michigan, 1973.

Mather 1961. Mather, Richard B. "The Mystical Ascent of the T'ien-t'ai Mountains: Sun Ch'o's Yu-T'ien-t'ai-shan fu." *Monumenta Serica* 20 (1961), pp. 226–45.

McNair 1994. McNair, Amy. "The Engraved Model-letters Compendia of the Song Dynasty." *Journal of the American Oriental Society* 114, no. 2 (April–June 1994), pp. 209–25.

Mote 1962. Mote, Frederick W. *The Poet Kao Ch'i, 1336–1374.* Princeton: Princeton University Press, 1962.

Mote 1989. Mote, Frederick W. *Intellectual Foundations of China.* 2d edition. New York: McGraw Hill, 1989.

Munakata 1990. Munakata, Kiyohiko. *Sacred Mountains in Chinese Art.* Exh. cat. Urbana: Krannert Art Museum, University of Illinois at Urbana-Champaign, 1990.

Murray 1988. Murray, Julia K. "Tiantai Shan: A Chinese Buddhist Centre." *Orientations* 19, no. 12 (December 1988), pp. 60–64.

Nantong Museum 1981. Nantong Museum. "Li Fang-ying shiliao kao" (Study of Historical Materials on Li Fangying). In *Qingdai Yangzhou huapai yanjiu ji* (Collection of Essays on the Yangzhou School of Painting of the Qing Dynasty), vol. 2, pp. 28–35. Yangzhou: Yangzhou shi wenxue yishu gongzuozhe lianhe hui and Qingdai Yangzhou huapai yanjiu hui, 1981.

Nishigami Minoru 1981. Nishigami Minoru. "Tai Honkō ni tsuite" (On Dai Benxiao). In *Chūgoku kaigashi ronshū: Suzuki Kei Sensei kanreki-kinen* (Essays on the History of Chinese Painting: Festschrift for Professor Suzuki Kei), pp. 291–340. Tokyo: Yoshikawa kōbunkan, 1981.

Nishigami Minoru 1987. Nishigami Minoru. "Dai Benxiao yanjiu" (A Study of Dai Benxiao). In *Lun Huangshan zhu huapai wenji* (Collection of Essays on the Schools of Painting in the Huangshan Region), pp. 118–78. Shanghai: Renmin meishu chubanshe, 1987.

Pang Yuanji 1909. Pang Yuanji. *Xuzhai minghua lu* (Record of Famous Paintings in the Studio of Emptiness). Shanghai, 1909.

Qin Zuyong 1864. Qin Zuyong. *Tongyin lunhua* (Discussion of Paintings in the Shade of the Tong Tree), 2 vols., 1864.

Qingren shiming 1988. *Qingren shiming biecheng zihao suoyin* (Index of Names and Alternate Appellations for Qing Dynasty Personnages). Shanghai: Shanghai guji chubanshe, 1988.

Quan Tang shi 1960. *Quan Tang shi* (Complete Compendium of Tang Poetry). Beijing: Zhonghua shuju, 1960.

Rogers and Lee 1988. Rogers, Howard, and Sherman E. Lee. *Masterworks of Ming and Qing Painting from the Forbidden City*. Exh. cat. Lansdale, Pa: International Arts Council, 1988.

Sanxi Tang fatie 1984. *Sanxi Tang fatie* (Model calligraphies from the Hall of Three Rarities). Facsimile reprints of a Qianlong-era set of rubbings and the 1897 transcription. Haerbin: Heilongjiang renmin chubanshe, 1984.

Semmen taikan 1915. Kyoto: 1915.

Sensabaugh 1981. Sensabaugh, David A. "Life at Jade Mountain: Notes on the Life of the Man of Letters in Fourteenth-Century Wu Society." In *Chūgoku kaigashi ronshū: Suzuki Kei Sensei kanreki-kinen* (Essays on the History of Chinese Painting: Festschrift for Professor Suzuki Kei), pp. 44–69. Tokyo: Yoshikawa kōbunkan, 1981.

Shan Guoqiang 1997. Shan Guoqiang, ed. *Jinling zhujia huihua* (Painting of the Jinling Region). In *Gugong Bowuyuan cang wenwu zhenpin quanji* (The Complete Collection of Treasures of the Palace Museum), vol. 10. Hong Kong: Commercial Press, 1997.

Shen Deqian 1973. Shen Deqian. *Gu shi yuan* (Anthology of Ancient Poetry). Reprint. Hong Kong: Zhonghua shuju, 1973.

Shih Shou-chien, Fu Shen, James Cahill et al. 2001. Shih Shou-chien, Fu Shen, James Cahill et al. *Yuemu: Zhongguo wanqi shuhua* (Enchanting Images: Late Chinese Painting and Calligraphy from the Shih-t'ou Shu-wu Collection). Taipei: Shitou Publications, 2001.

Shina Nanga taisei 1935–37. *Shina Nanga taisei* (Conspectus of Chinese Paintings of the Southern School). 16 vols. and 6 supplementary vols. Tokyo: Kabunsha, 1935–37.

Shiqu Baoji 1971. Zhang Zhao et al., comps. *Shiqu Baoji* (Treasured Boxes of the Stony Moat [Catalogue of Painting and Calligraphy in the Qianlong Imperial Collection]). Facsimile reprint of an original manuscript published in 1745. Taipei: National Palace Museum, 1971.

Shitao shuhua quanji 1995. *Shitao shuhua quanji* (Complete Collection of Shitao Paintings and Calligraphy). 2 vols. Tianjin: Tianjin renmin meishu chubanshe, 1995.

Shodō zenshū 1954–69. *Shodō zenshū* (Compilation of Calligraphic Works). New series. 26 vols. Tokyo: Heibonsha, 1954–69.

Shu Hua 1978. Shu Hua. "Jinling gejia huace" (Painting Album by Individual Nanjing Masters). *Gugong Bowuyuan yuankan* (Palace Museum Journal) 1978/2, pp. 82–83.

Silbergeld 1987. Silbergeld, Jerome. *Mind Landscape: The Paintings of C.C. Wang*. Exh. cat. Seattle: University of Washington Press, 1987.

Sirén 1957–59. Sirén, Osvald. *Chinese Painting: Leading Masters and Principles*. 7 vols. New York: The Ronald Press Company, 1957–59.

Song Luo 1688. Song Luo. *Jinjin Shanren shiji* (Collected Poems of Jinjin Shanren [Song Luo]), preface dated 1688. Reprint. Shanghai: Guji shudian, ca. 1983.

Song Luo 1711. Song Luo. *Xipo leigao* (Thematically Arranged Manuscripts of Xipo [Song Luo]). 1711 edition.

Sotheby Parke Bernet 1981. Sotheby Parke Bernet, *Fine Chinese Ceramics, Works of Art and Paintings*, New York, May 8, 1981 (sale 4603Y).

Sotheby's 1989. Sotheby's. *Fine Chinese Painting*, New York, May 31, 1989 (sale 5862).

Sullivan 1973. Sullivan, Michael. *The Meeting of Eastern and Western Art, from the Sixteenth Century to the Present Day.* London: Thames and Hudson, 1973.

Suzuki Kei 1982–83. Suzuki Kei, comp. *Chūgoku kaiga sogo zuroku.* (Comprehensive Illustrated Catalogue of Chinese Paintings). 5 vols. Tokyo: University of Tokyo Press, 1982–83.

The Metropolitan Museum of Art 2001. "Recent Acquisitions: A Selection, 2000–2001." *The Metropolitan Museum of Art Bulletin* 59, no. 2 (Fall 2001).

Toda Teisuke and Ogawa Hiromitsu 1998. Toda Teisuke and Ogawa Hiromitsu, comps. *Chūgoku kaiga sōgō zuroku.* (Comprehensive Illustrated Catalogue of Chinese Paintings). Second Series, vol. 1: American and Canadian Collections. Tokyo: University of Tokyo Press, 1998.

***Tuhui baojian xuzuan* 1963.** Mao Dalun, Lan Ying, Xie Bin, et al., eds. *Tuhui baojian xuzuan* (Sequel to Precious Mirror of Painting). Reprint. In *Huashi congshu* (Compendium of Painting Histories), ed. Yu Anlan, vol. 2, pp. 851–947. Shanghai: Renmin meishu chubanshe, 1963.

Vinograd 1982. Vinograd, Richard. "Family Properties: Personal Context and Cultural Pattern in Wang Meng's *Pien Mountains* of 1366," *Ars Orientalis* 13 (1982), pp. 1–29.

Wan Yi 1980. Wan Yi. "*Sanxi Tang fatie* zatan" (Miscellaneous Comments on *Hall of Three Rarities Model Calligraphies*). *Gugong Bowuyuan yuankan* (Palace Museum Journal) 1980/2, pp. 72–78.

Wan Yi 1984. Wan Yi. "*Sanxi Tang fatie* jishi er ze" (Notes on Two Points Concerning *Hall of Three Rarities Model Calligraphies*). *Gugong Bowuyuan yuankan* (Palace Museum Journal) 1984/1, pp. 74–75.

Wang Hui 1911a. Wang Hui, comp. *Qinghui Ge zengyi chidu* (Letters Written to Wang Hui). Shanghai: Fengyu lou [of Deng Shi], 1911.

Wang Hui 1911b. Wang Hui, comp. *Qinghui zengyan* (Colophons on Works by Wang Hui). Shanghai: Fengyu lou [of Deng Shi], 1911.

Wang Yuanqi ca. 1680. *Yuchuang manbi* (Desultory Jottings by a Rainy Window), ca. 1680. Reprint. In *Zhongguo hualun leibian* (Classified Compilation of Writings on Chinese Painting), ed. Yu Jianhua, pp. 169–73. Hong Kong, 1973.

Wang Yuanqi et al. 1718. Wang Yuanqi, et al. *Wanshou shengdian quji* (Magnificent Record of Long Life, First Collection). 1718.

Weng and Yang 1982. Weng, Wan-go, and Yang Boda. *The Palace Museum, Peking: Treasures of the Forbidden City.* New York: Harry N. Abrams, Inc., 1982.

Whitfield 1969. Whitfield, Roderick. *In Pursuit of Antiquity: Chinese Paintings of the Ming and Ch'ing Dynasties from the Collection of Mr. and Mrs. Earl Morse.* Rutland, Vt. and Tokyo: The Art Museum, Princeton University and Charles E. Tuttle Co., 1969.

Wilson 1969. Wilson, Marc. "Kung Hsien: Theorist and Technician in Painting," *The Nelson Gallery and Atkins Museum Bulletin* 4, nos. 9/10 (1969), pp. 1–52.

Wu 1992. Wu, Marshall P. S. "Error Begets Error—A Plum Blossom Scroll Attributed to Li Fang-ying." In *International Colloquium on Chinese Art History, 1991, Proceedings: Painting and Calligraphy, Part 2*, pp. 469–90. Taipei: National Palace Museum, 1992.

Xiao Yanyi 1996. Xiao Yanyi, ed. *Si Wang Wu Yun huihua* (Paintings by Wang Shimin, Wang Jian, Wang Hui, Wang Yuanqi, Wu Li, and Yun Shouping). In *Gugong Bowuyuan cang wenwu zhenpin quanji* (The Complete Collection of Treasures of the Palace Museum), vol. 12. Hong Kong: Commercial Press, 1996.

Xu Xiake 1928. Xu Xiake. *Xu Xiake youji* (Travel Diaries of Xu Xiake [1586–1641]). Edited by Ding Wenjiang (V. K. Ting). Shanghai: Shangwu yinshuguan, 1928.

Xue Yongnian 1987. Xue Yongnian. "Zui mohu chu zui fenming—tan Dai Benxiao de hua" (The Most Vague Place is the Clearest—Discussing Dai Benxiao's Painting). In *Lun Huangshan zhu huapai wenji*, pp. 293–304. Shanghai: Renmin meishu chubanshe, 1987.

Yang Chenbin 1985. Yang Chenbin. "Mei Qing shengping ji qi huihua yishu" (Mei Qing's Life and Art). *Gugong Bowuyuan yuankan* (Palace Museum Journal) 1985/4, pp. 49–57.

Yang Chenbin 1986. Yang Chenbin, "Mei Qing sheng-ping ji qi huihua yishu" (Mei Qing's Life and Art). *Gugong Bowuyuan yuankan* (Palace Museum Journal) 1986/2, pp. 84–93.

Yangzhou bajia huaji 1994. *Yangzhou bajia huaji* (Collected Paintings of the Eight Masters of Yangzhou). Tianjin: Tianjin renmin meishu chubanshe, 1994.

Yiyuan duoying **1995.** *Yiyuan duoying* (Plucked Flowers from the Garden of Art) no. 50 (August 1995). Shanghai: Peoples Art Publishing Company.

Yu Zhouyun 1982. Yu Zhouyun. *Zijincheng gongdian* (*Palaces of the Forbidden City*). New York, Viking Press, 1982.

Zhang Daqian 1955–56. Zhang Daqian. *Dafeng Tang mingji* (Taifudo meiseiki; Masterpieces of Chinese Painting from the Dafeng Tang [Great Wind Hall] Collection). 3 vols. Kyoto: Benrido, 1955–56.

Zhang Geng. Zhang Geng. *Guochao huazheng lu* (Painters of the [Qing] Dynasty), preface dated 1739. In *Huashi congshu* (Compendium of Painting Histories), ed. Yu Anlan. Shanghai: Renmin meishu chubanshe, 1963.

Zhang Shiyi 1980. Zhang Shiyi. "Sanxi Tang" (Hall of Three Rarities). *Gugong Bowuyuan yuankan* (Palace Museum Journal) 1980/4, pp. 89–91.

Zheng Bingshan 1982. Zheng Bingshan. *Shen Shitian.* 1982.

Zhongguo gudai shuhua mulu. Group for the Authentication of Ancient Works of Chinese Painting and Calligraphy, comp. *Zhongguo gudai shuhua mulu* (Catalogue of Authenticated Works of Ancient Chinese Painting and Calligraphy). Beijing: Wenwu chubanshe, 1986–. 1987, vol. 2: Shanghai Museum; 1987, vol. 3: Shanghai Museum; 1990, vol. 4: Shanghai Museum; 1990, vol. 5: Shanghai Museum; 1989, vol. 7: Nanjing Museum; 1990, vol. 8: Tianjin History Museum and others; 2000, vol. 23: Palace Museum, Beijing.

Zhongguo meishujia renming cidian **1981.** *Zhongguo meishujia renming cidian* (Dictionary of Chinese Artists' Names). Shanghai: Renmin meishu chubanshe, 1981.

Zhongguo meishu quanji **1986–89.** *Zhongguo meishu quanji* (Complete Collection of Chinese Arts), *Huihua bian* (Painting Series). Beijing: Renmin meishu chuban-she, 1986–89.

Zhongguo shuhuajia yinjian kuanshi **1987.** Shanghai Bowuguan, ed. *Zhongguo shuhuajia yinjian kuanshi* (Seal Inscriptions of Chinese Calligraphers and Painters). 2 vols. Beijing: Wenwu chubanshe, 1987.

Zhongwen da cidian **1973.** *Zhongwen da cidian* (Encyclopedic Dictionary of the Chinese Language). Taipei: Zhonghua xueshuyuan, 1973.

Zhou Lianggong 1673. Zhou Lianggong. *Duhua lu* (Record of Reading Paintings), postface dated 1673. Reprint. In *Huashi congshu* (Compendium of Painting Histories), ed. Yu Anlan. Shanghai: Renmin meishu chubanshe, 1963.